secular art with sacred themes

ABINGDON PRESS
Nashville
New York

On title page:
Marc Chagall, Christ: detail from CALVARY, 1912
Collection, the Museum of Modern Art, New York,
acquired through the Lillie P. Bliss Bequest.

secular art with sacred themes

Jane Dillenberger

SECULAR ART WITH SACRED THEMES

Standard Book Number: 687-37272-0

Library of Congress Catalog Card Number: 76-87026

Scripture quotations unless otherwise noted are from the
Revised Standard Version of the Bible, copyrighted 1946
and 1952 by the Division of Christian Education, Na-
tional Council of Churches, and are used by permission.

The lines from "For the Time Being" are from *The
Collected Poetry of W. H. Auden,* copyright © 1945 by
W. H. Auden. Reprinted by permission of Random House,
Inc., and Faber and Faber, Ltd.

The lines from "The Family Reunion" and "Choruses
from 'The Rock'" are from *The Complete Poems and
Plays 1909-1950* by T. S. Eliot, copyright, 1950, by T. S.
Eliot. Reprinted by permission of Harcourt, Brace & World,
Inc., and Faber and Faber, Ltd.

The chapter on Barnett Newman first appeared in *Religion
in Life* in the summer of 1969.

SET UP, PRINTED, AND BOUND BY THE
PARTHENON PRESS, AT NASHVILLE,
TENNESSEE, UNITED STATES OF AMERICA

In Memory of Christopher
whose full life included
delight in the artists
represented in these pages

1950-1968

contents

illustrations

introduction

This is a book about works of art with religious subject matter by major artists of the twentieth century. The selection covers the period from the early twentieth century to the present, ranging from before the First World War, through the post–World War II period, and into the decade of the 60's. Within this range, the first consideration was excellence of the piece as a work of art; indeed, all the paintings and sculptures are by artists of acknowledged greatness. The second factor in the selection was that of subject matter, defined as themes from biblical sources or subjects associated with the traditional liturgy. Some of the specific choices were determined by the presence of the work of art in a museum or a collection in this country, where readers may have the opportunity to confront and study it. Some were chosen out of knowledge and affection, and others because the writer wanted to live with them, to know them, to keep them in the mind's eye.

Given these criteria for selection, and in particular that of excellence as a work of art, the number of examples from which to choose is small indeed. It is sad to discover how few of these are to be found in synagogues and churches. With the exception of Manzù's DOOR OF DEATH at St. Peter's in Rome, which was created with the encouragement and approval of Pope John XXIII, the sculptures and paintings reproduced here are to be found in museums and in private collections. Many of them are still owned by the artists who created them. The churches of the twentieth century have only sporadically and timidly acknowledged the presence of the great artists in their midst. The secular world, rather than the synagogue or the church, has been the milieu in which the artist pursued the truths he perceived. And it is the secular world to which he committed himself in the search for new forms.[1]

Therefore, instead of beginning with tiresome and awkward definitions about Christian art, or religious art, the reader is invited to begin with a brief orientation to twentieth-century art, and then move immediately to a

[1] See Roger Hazelton's interesting discussion of "Art as Disclosure" in his *Theological Approach to Art* (Nashville: Abingdon Press, 1967), pp. 13-49.

direct examination of the paintings and sculpture, allowing the method and terminology to emerge from the seeing of the work of art. This draws the reader directly into the work of art itself, allowing him to check the descriptions, affirmations, and questions of the text against the evidence of his own eyes and his own sensibilities.

The reader who attentively pages through the illustrations may be startled by the variety of styles represented and wonder how coherence can be given to a study of these odd bedfellows. But the overwhelming diversity of creative gifts and individual styles of twentieth-century art must be underlined, even in such a limited selection. Hence, variety is necessarily a part of the scheme of the book.

In making an analysis of painting or sculpture, we are compelled to verbalize that for which there is no verbal counterpart. Language thus must be probing and pointing rather than definitive. Most important of all, the language must focus on the work of art itself, rather than on ideas about the work of art. It must compel the reader to become a viewer. It is only after the long searching of the painting in and for itself that further interpretation can be indulged in without violating the work of art *as* a work of art.

The traditional method of analysis used in this book and derived from a methodology developed to discuss the art of earlier periods, notably the Renaissance and post-Renaissance styles, has the advantage of separating specific facets of the work of art (iconography, style, and content) and analyzing these facets before considering the work of art as an entity. Since the selection was made partly on the basis of subject matter, it is helpful to have a methodology which leads to a consideration of this particular facet at several levels. And the method does compel a continued intensive study of the work of art from successive, coherently related focuses. The focus is kept on the paintings and sculptures rather than on extraneous ideas, associations, and interpretations.

This method can be pursued with relative ease with reference to a realistic painting like Eakins' CRUCIFIXION and the paintings of the early twentieth century. But with the development of post-World War II styles, we find that iconography, style, and content tend to converge. Nevertheless, the method continues to be a helpful tool even for abstract expressionist works of art.

The heart of the book is the photographs of the works of art. The text is but an invitation to the thoughtful study of these illustrations, in order that the viewer may yield up his accustomed ways of seeing and reacting, and go to school to another spirit—that of the painter or sculptor, the creator of the work of art. The text builds slowly around the experience of seeing each work of art, and as each new painting or sculpture is discussed, comparisons and contrasts are made with the foregoing works. When these comparisons and contrasts are made in the text, the appropriate illustration numbers will be noted again, so that readers may repeatedly return to viewing. The reward of this reiterated re-viewing is a *new* seeing.

The same kind of study with analogous problems could be pursued in other twentieth-century artistic expressions—drama, music, poetry. So by studying closely a few chosen works of art, we also arrive at some characteristic features of the diverse cultural expressions of our own day. And the attentive reader will be quick to understand Kandinsky's observation, "To each spiritual epoch corresponds a new spiritual content, which that epoch expresses by forms that are new, unexpected, surprising, and in this way aggressive." Through study of forms that are "new, unexpected, surprising," the spiritual content of our own epoch is revealed to the eyes of the beholder.

 the visible world and the Artist in the Twentieth Century

CHANGES IN THE WAYS OF SEEING THE VISIBLE WORLD

Many of us daily hold a handsome bit of sculpture in the palm of our hands and touch it with our fingers. We know it well by size, weight, shape, contour, and texture, and with alacrity can distinguish our own ten-cent piece from other similar coins in a heap of coins of all nations. Yet when we are asked to describe the coin—what symbols and images, what words, what numbers appear on the dime—a surprised silence usually follows the query. We *look at* the world about us during waking hours, but we reserve *seeing* for a few selected occasions. *Looking at* is sufficient for identification; it is a complex process in which visual cues are matched to the immense storehouse of optical memories, allowing an almost instantaneous recognition to take place.

Seeing, on the other hand, draws less upon optical recollections and more upon the whole range of experience and the wellsprings of one's being. *Seeing* ranges from the momentary experience of suddenly perceived beauty to the sustained, searching study of a beloved face or a once familiar scene.

The artist is important to both of these processes. He is a shaper of the visual environment in which we live, a creator of the data at which we look. Gertrude Stein has told us how she and her friend Pablo Picasso were walking through the streets of Paris during the First World War when a camouflaged truck went by; "Picasso amazed looked at it and then cried out, yes it is we who made it, that is cubism." [1] The artist shapes the world about us, what Gertrude Stein called "the composition in which we

[1] Gertrude Stein, *Picasso* (Boston: Beacon Press, 1959), p. 11. Cubism is a style of painting evolved and practiced by Picasso and Braque in Paris in the seven years immediately prior to World War I. Though specific objects and persons were pictured in Cubist paintings, they were presented as fragmented in flat planes and in muted tones of gray, brown, and black. The camouflage technique of painting trucks and tanks in irregular flat areas of muted browns and grays was used in order to make them merge into the background and thus conceal them when seen from a distance. Picasso saw this technique as an adaptation of visual patterns invented by the Cubists.

live." He forms what we look at and what we see.

The "composition in which we live" changed decisively in the first decade of the twentieth century when a new understanding of the visible world emerged simultaneously in several spheres of knowledge. Einstein's theory of relativity and Planck's quantum theory were both enunciated during this decade. These discoveries in the fields of physics and mathematics demonstrated that the world as we experience it through our senses is a partial, limited, and distorted fragment of a larger and, for the most part, an unseen "reality." But these heights and depths can only be experienced by us vicariously, through images which allow us to relate our actual sensual experience by analogy to the wider, "unseeable," unknowable "reality"—our larger encompassing medium, our true residence.

These discoveries in the fields of mathematics and physics—which expanded into an inconceivably complex structure of relationships what had been an objective, verifiable reality comfortably called the world—were paralleled by a similar contribution in the field of psychology. Freud's *Interpretation of Dreams* was published in 1900. Though Freud's theories have been criticized and revised, his basic contribution was to reveal the multilayered structure of consciousness. Freud and his followers demonstrated that knowledge of ourselves is only partially accessible through the seeable and the verifiable and that each individual's sensorium gives only a very small, and often distorted picture of the complex deposit and process we call the self. This aspect of his understanding of the self has greatly influenced writers and artists of our century.

The dichotomy between objective and subjective, appearance and reality, has emerged as the central problem in literature of the twentieth century. The creators of the modern novel, Joyce and Proust, Virginia Woolf, and André Gide, and the dramatists, notably Edward Albee and Harold Pinter, have made this split a central theme in their writings. The artist reflects and gives expression to such shifts. How much the artist consciously knows of the discoveries in physics, psychology, and literature is not an issue for us here, for the coincidence of such basic changes in "the ground of reality" would indicate a pervasiveness and vitality to the new understandings which far exceed the range of their theoretical formulations. It is this which the particular form of the artist's sensitivity reflects.

Daniel-Henry Kahnweiler, the friend, dealer, entrepreneur, and interpreter of the Cubist painters of the period before the First World War, wrote of their art:

> *What occurred at that time in the plastic arts will be understood only if one bears in mind that a new epoch was being born, in which man (all mankind, in fact) was undergoing a transformation more radical than any other known within historical times. The enormous change that took place during these seven years in painting and sculpture went down to the very roots. . . . What is certain is that the direct visual study of the exterior world that European humanity had demanded of its painters and sculptors since the Renaissance ceased to be the aim of the artists. . . . One realizes how great a spiritual revolution this was, an "introvert" art after six centuries of "extrovert."* [2]

Since the time of the Renaissance, artists had written of their techniques and viewpoints, referring to the visible world as nature. In a curious passage in his *Notebooks*, Leonardo da Vinci wrote: "We may call it [painting] the grandchild of nature; for all visible things derive from nature, and from these same things is born painting. So

[2] Kahnweiler, *Les Années héroiques du cubisme* (Paris: Braun & Cie, 1950), n. p.

therefore we may justly speak of it as the grandchild of nature and as related to God Himself." [3] The artist, created by God, creates a work of art, which therefore becomes the grandchild of nature and thus of God himself.

Though many shifts occurred between the Renaissance and the late nineteenth century in the way nature is seen by the artists, and therefore in the styles of the works of art, still an artist like the Philadelphia painter Thomas Eakins (1844-1916) had much in common with Leonardo da Vinci (1452-1519). Leonardo exulted in his achievements in dissection and his discoveries in anatomy. Eakins was a keen student of anatomy. Leonardo experimented with the *camera obscura,* and Eakins too experimented with photography and made discoveries which anticipated the motion picture camera. Further, both artists were exponents of the theory and practice of perspective.

It will be noted that these lines of inquiry, which absorbed both the Renaissance master and the nineteenth-century American painter, all relate to nature, i.e., the visible world as an objective reality which can be pictured in the work of art with a high degree of verisimilitude. Eakins' statement that he studied anatomy and dissection in order to discover "how beautiful objects are put together to the end that he may be able to imitate them," [4] might have been written by Leonardo, though four hundred years separate their lives.

But the "confidence in nature," which Eakins sensed in the great old masters and which he also felt, began to diminish by the turn of the century. Less than fifty years separate Eakins' statements from these words of the "impatient titan" of the twentieth century, Pablo Picasso: "Nature and art, being two different things, cannot be the same thing. Through art we express our conception of what nature is not." [5] Though Picasso distorted, fragmented, and fractured the forms of nature in his art, he never abandoned the representation of the visible world. Indeed, he avers that there is no such thing as abstract art in the non-representational sense. The artist always starts with something, and while all traces of concrete reality may be removed by him, "the idea of the object will have left an indelible mark. . . . Ideas and emotions will in the end be prisoners in his work." [6] Picasso has spoken of using common objects for his still-life paintings, just as Christ used the parables: "They're what I wrap up my thought in," he has said.[7] These statements by Picasso show a decisive shift away from the objective, visible world of nature, as Eakins and Leonardo understood it, to Picasso's selective appropriation of a portion of nature which is then transformed to express his thought. Picasso declared, "A painter paints to unload himself of feelings and visions." [8]

Paul Klee, a slightly younger contemporary of Picasso, was a gentler spirit. He taught at the famous Bauhaus School of Design and, as artist and teacher meditated deeply on the problems of the twentieth-century artist.[9] His short treatise on modern art is one of the most delightful, lucid, and eloquent apologias for modern art. In it, he says:

I would like to . . . try to show how it is that the artist frequently arrives at what appears to be such an arbitrary "deformation" of natural forms.

[3] Robert Goldwater and Marco Treves, eds., *Artists on Art from the XIV to the XX Century* (New York: Pantheon Books, 1958), p. 49.
[4] *Ibid.,* p. 355.

[5] *Ibid.,* p. 417.
[6] *Ibid.,* p. 420.
[7] Françoise Gilot, *Life with Picasso* (New York: McGraw-Hill, 1946), p. 68.
[8] *Artists on Art,* p. 421.
[9] The Bauhaus was established in 1918-19 at Weimar, Germany, by architect Walter Gropius for training architects, artists, and industrial designers. It was closed by Hitler in 1933.

First, he does not attach such intense importance to natural form as do so many realist critics, because, for him, these final forms are not the real stuff of the process of natural creation. For he places more value on the powers which do the forming than on the final forms themselves. . . .

He surveys with penetrating eye the finished forms which nature places before him.

The deeper he looks, the more readily he can extend his view from the present to the past, the more deeply he is impressed by the one essential image of creation itself, as Genesis, rather than by the image of nature, the finished product.

Then he permits himself the thought that the process of creation can today hardly be complete and he sees the act of world creation stretching from the past to the future. Genesis eternal! . . .

This being so, the artist must be forgiven if he regards the state of outward appearances in his own particular world as accidentally fixed in time and space. And as altogether inadequate compared with his penetrating vision and intense depth of feeling.[10]

Two points made by Klee are of particular interest in regard to the problem of the artist's relationship with the visible world. First, creation continues ceaselessly; the creative powers which form the things of this world are of greater value than the things themselves. Thus the work of art is no longer simply a statement of an understanding of

[10] Klee (pronounced "clay"), *On Modern Art* (London: Faber and Faber, 1948), pp. 43-47.

reality and, by implication, of man's place in this reality. Second, as the artist recognizes the changing and partial character of what is apprehended by his senses, he shifts his focus from the external forms to creativity itself. Since the artist's intense depth of feeling becomes the motivating force for his paintings, it is natural that the works of art should be more subjective in character and more varied in style. The artist is recording how he understands reality, how *he* sees it. Subjective and varied styles are indeed characteristic of twentieth-century art, as can be seen by paging through even so restricted a selection as the illustrations of paintings and sculptures in this volume.

It must be noted that the struggles attendant to this shift were largely outside the church. During the period of the decisive twentieth-century developments in the visual arts, the churches were on the whole unaware of the creative convulsions taking place in the artistic cultural millieu about them. Cézanne, though a churchgoing Catholic, left a large oeuvre of drawings and paintings, but his entire subject matter was secular. His letters recorded his pained, persistent, lonely struggle with "nature" and his craft. During the years before the First World War, Matisse, Picasso, Braque, Chagall, Derain, and Kandinsky forged new patterns, articulating in their writings the objective-subjective problems. Among their works there are great masterpieces of painting and sculpture, but none of them were commissioned by the churches. Only in the decade of the 1940's did a few individuals in the churches recognize the genius of these artists. But as the result of the influence of the indefatigable Dominican Père Couturier in France, an astonishing number of commissions were given to France's great artists by mid-twentieth century. The excellence and diversity of these works of religious art are heartening evidence of what can be done

when the church seeks and accepts the artist's gifts.[11] More than this, they show what can be done when the church has informed and impassioned leadership. Committees on religious art are helpful in educating and awakening interest and awareness on the part of the laity and clergy; but they are not often the source of inspired commissions. Though the secular world rather than the church was the arena for the struggle with the issues of appearance and reality, objective versus subjective, nature versus art, the implications of this conflict and its potential significance for dimensions of religious faith are apparent. Indeed, some of the artists were conscious of these implications. In 1910, Kandinsky, creator of the first consciously nonobjective paintings, wrote his treatise *Concerning the Spiritual in Art*:

The artist's life is not one of pleasure. He must not live irresponsibly; he has a difficult work to perform, one which often proves a crown of thorns. He must realize that his acts, feelings and thoughts are the imponderable but sound material from which his work is to rise; he is free in art, but not in life.

Compared with non-artists the artist has a triple responsibility; (1) he must return the talent which he has; (2) his actions, feelings and thoughts, like those of every man, create a spiritual atmosphere which is either pure or infected; (3) his actions and thoughts are the material for his creations, which in turn influence the spiritual atmosphere. . . .

If the artist be guardian of beauty, beauty can be measured only by the yardstick of internal greatness and necessity.

That is beautiful which is produced by internal necessity, which springs from the soul.[12]

Though the arena for the artist is now the secular world, he undertakes his task with the dedication of spirit which in other eras was the mark of the priest and the seer.

Since a work of art reflects what is thought, known, and felt at the deeper levels of meaning, what does it communicate in an era when the churches, which for so long ignored the transformation, are now themselves undergoing powerful structural (style) changes and theological (content) reorientations? There has always been change, of course. The traditional symbols and images of religious art have had their meanings over the centuries. They acquired additional accretions which enriched and enlivened them, or they became encased within elaborate meanings which petrified them, causing them to slip into obsolescence. But in the great ages of faith in the past, symbols sprang from a common soil. Now, when twentieth-century artists are no longer rooted in this soil, the artist who works with biblical subject matter creates his own symbols. There are a few artists who worship in liturgically and symbolically oriented churches, or who, like Derain, studied the religious art of the old masters and have appropriated some of the traditional symbols. These artists so transform the ancient symbols by their style and context that they take on new meanings. Thus the resultant meanings are often ambiguous or contradictory. But ambiguity and contradiction are so much a part of the great literature of our day that, were the art expressions explicit in mean-

[11] For discussions and illustrations of these works of art, see William S. Rubin, *Modern Sacred Art and the Church of Assy* (New York: Columbia University Press, 1961), and Jane Dillenberger, *Style and Content in Christian Art* (Nashville: Abingdon Press, 1965).

[12] *Concerning the Spiritual in Art* (New York: George Wittenborn, 1947), p. 75.

ing, we would be prompted to ask if, indeed, the art is a valid expression of our day, or only an academic repetition of traditional formulas.

When asked what he means by certain images in a painting or poem, the contemporary artist is most typically evasive, turning the question back to the beholder or the reader. This story is told of one of our contemporary dramatists. On the opening night of one of his plays, a critic, who was irritated by the interpretation given to a particular part by the actor playing it, sought out the dramatist and complained that he had read the play many times and did not at all see the character as the actor was interpreting the part! The dramatist calmly agreed that he too had imagined the character differently. "But," he added, "if the actor *sees* this character this way, it *must* be in the play!"

The playwright and the artist create the drama or the work of art, bringing it to completion. Then they allow us to lay hold of it in whatever ways and at whatever levels we are capable of receiving its multiplicity of meanings. We become co-creators as the various meanings, and perhaps contradictory meanings, provide a heightened sense of being, as we enter into conversation with the work of art itself. We leave the work of art, having experienced pleasures and perplexities, having received insights that excite with their clarity and authority; but our questions may remain unanswered. The work of art remains, awaiting our further scrutiny, promising richer meanings from its inexhaustible resources.

THOMAS EAKINS' CRUCIFIXION

In 1880 the Philadelphia artist Thomas Eakins painted a life-size Crucified Christ (Illustration 1) which is unique in the history of American painting. Portraits, landscapes, and genre paintings form the major categories in American art; whereas paintings with religious subject matter are so few in number and of such sporadic distribution in time and space that they can hardly be said to form a group.

The CRUCIFIXION stands alone in Eakins' work as well. Strolling through the galleries devoted to his work at the Philadelphia Museum or paging through books and catalogs on the artist's life and paintings, we are arrested by his portraits of family and friends—faces caught in reverie or in an austere composure and quietude. Among these portraits are several sober, realistic, reticent portraits of Catholic clergy and a fresh, spontaneous, sketchy study of his friend, the poet Walt Whitman. There are scenes of men sculling on the quiet waters of the Schuylkill River, a carefully composed painting of adolescent, leggy boys at a swimming hole, paintings of boxing and wrestling matches. Most impressive of all are the two large paintings of surgery —THE GROSS CLINIC (painted in 1875 and now owned by Jefferson Medical College) and THE AGNEW CLINIC (painted in 1889 and now owned by the University of Pennsylvania). Both these paintings show the head surgeon, instrument in hand, discoursing to a theater of medical students as the surgery progresses in the foreground before our eyes. These two paintings, one painted before and one after the CRUCIFIXION, provide clues for the interpretation of the CRUCIFIXION. The somber yet detached documenting of the scene, and the detailed yet unimpassioned rendering of the visual data are characteristic of the CRUCIFIXION as well.

The choice of subject matter for the CLINIC paintings may seem eccentric to us, but it must have appeared a natural one to the artist. Rembrandt, an artist Eakins greatly admired, had created two major paintings with similar subject matter. Eakins had at one time thought he might become a surgeon. As an art student at the Pennsylvania

Academy he had studied anatomy at Jefferson Medical School. When he was made professor of anatomy at the Art Academy he taught dissection to his pupils. It will be recalled that Eakins believed that dissection increased his knowledge of how beautiful objects are put together to the end that he might be able to imitate them.

Eakins' insistence on the use of the "absolute nude" model brought him into conflict finally with the Academy, and he resigned over his "advanced" views. Many students remained loyal to their much admired teacher and they formed the Pennsylvania Art Students' League in which Eakins taught without remuneration, thereby easing the financial problems of the new school. Self-portraits of the artist from this period in his life show worn features, a somewhat dogged expression, and intent and fearless eyes, full of self-knowledge.

Seen in the light of Eakins' life and interests, his choice of subject matter for the painting of the CRUCIFIXION is not as easily understood as the two medical scenes. The CRUCIFIXION is conspicuously large in size when compared with his other paintings, and thus a major work in his total output. There is nothing provisional, sketchy, or exploratory about its conception or execution. The painting is as carefully composed and fully realized as if it were done for a particular commission. Yet it seems unlikely that it was created for a particular place, and it is quite certain that it was done without reference to any religious body or beliefs. Eakins was an agnostic. Though he had friends on the Catholic faculty of St. Charles Borromeo Seminary whom he sometimes bicycled out to see, and to whom he loaned the painting of the CRUCIFIXION for some years, he was not a member of any church or denomination.

Though no church affiliation or specific conviction seem related in any way to the painting, a great masterpiece of religious art may very well have been the source for the subject matter and a point of departure for the artist's conception. Eakins had studied in Paris at the Ecole des Beaux Arts for four years, and had then gone to Madrid, where he was greatly impressed by the paintings of the seventeenth-century Spanish masters, Velásquez and Ribera. He must have seen Velásquez' CHRIST ON THE CROSS (Illustration 2) while in Spain, and been impressed by the composition. Eakins' painting is approximately the same size, and both artists bring the viewer in close to the isolated figure of the Crucified. Paintings of the Crucifixion done before the seventeenth century often included John the Evangelist and Mary the Mother of Jesus. During late medieval and early Renaissance times artists represented whole groups of witnesses and bystanders, and even subsidiary episodes such as the dicing at the foot of the cross for the coat woven throughout without seam, or the piercing of Jesus' side by the centurion. Eakins, like Velásquez, focuses our attention upon the body on the cross, allowing no diversion of interest.

If we confined ourselves to the description of the iconography of the painting (the symbols and images which tell us what it is about), the Velásquez painting and Eakins' CRUCIFIXION are similar. In both the figure of Jesus is suspended from the horizontal beam of a wooden cross, his bowed head encircled by a crown of thorns, his lower torso girdled by a loincloth, his feet nailed side by side on an inclined support. In both cases blood issues from the hands and feet, though more copiously in the Velásquez painting. We note that Eakins had not depicted the wound in the side as did Velásquez, whose seventeenth-century Spanish setting was closer to the ancient iconographic traditions and the teachings of the church. Both paintings have Pilate's title, but Velásquez has all three forms neatly in-

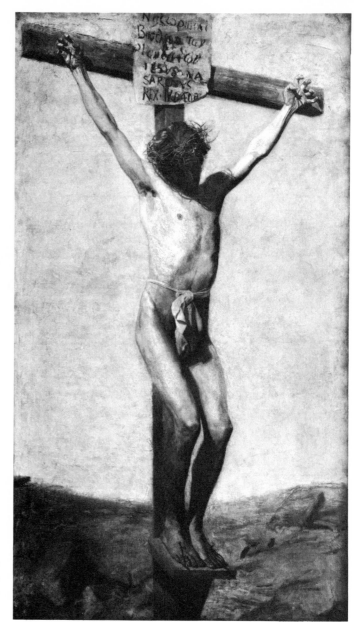

1. Thomas Eakins, THE CRUCIFIXION, 1880.
Oil on canvas, 96″ x 54″.
Courtesy of the Philadelphia Museum of Art.

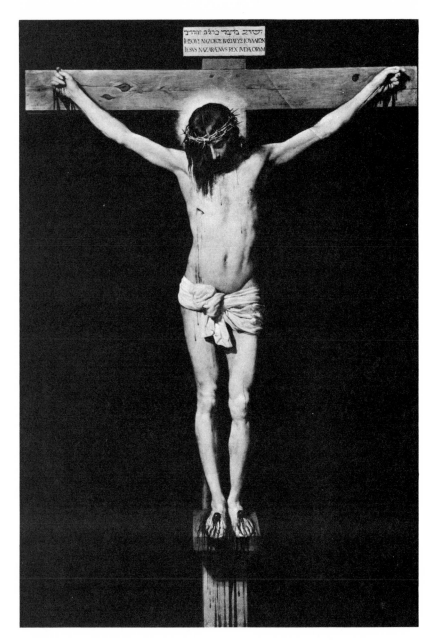

2. Diego Velásquez, CHRIST ON THE CROSS, c. 1631-32.
Oil on canvas, about 98″ x 67″.
Madrid, The Prado.
Courtesy of Anderson-Art Reference Bureau.

scribed; whereas only part of the Greek and the full Latin inscription are visible on the crumpled document above the bowed head in Eakins' painting. The Christ of Velásquez is set against what appears to be a deep, velvety black background. (The painting had a landscape which is hardly detectable now because of the darkening of the paint.) In Eakins' painting Jesus is seen in full, pale sunlight, a bleak and rocky landscape visible in the background.

Such a factual description exhausts the similarities, for one is increasingly aware in studying the paintings how dramatically the two interpretations of the theme do indeed differ. The changes in the composition, the shift in our viewpoint, the detailing of the anatomy are subtly different. All of these taken together result in a difference in content, or communication of meaning to the beholder. Whereas Velásquez places the Christ directly in front of us, the arms stretched forth in a shallow curve upward, the body with its weight balanced and seeming to stand poised before us, Eakins' figure of Jesus sags visibly, hanging from a narrower crossbeam set diagonally to us. Our eye level for the Velásquez Christ focuses at the level of his head (the crossbar of the cross is at our eye level); whereas in Eakins' painting we are considerably below the head, our eye-level being at the knees of the Crucified. The figure seems to loom above us, and the painful stretching of muscles and tendons of the back and legs is experienced empathetically by the viewer.

The Velásquez Christ, by contrast, seems stable and balanced. It resembles the Corpus on a liturgical cross, the body nailed to the Cross for all earthly time, a reminder of the continuing sacrifice, yet victorious in death, the halo about the dark bowed head a promise of glory to come.

Returning to Eakins' painting with its brittle, restless, diagonals, we feel his realism, his particularity in dealing with his model. And one is not surprised to learn that a student of Eakins, John Laurie Wallace, posed for this painting strapped to a cross in the out-of-doors. Wallace, who later became a teacher of anatomy, was a friend of Eakins for many years. In addition to the CRUCIFIXION, he posed for a portrait, and for several other paintings. A letter from Eakins' wife to Wallace, referring to the artist's portrait of Wallace, has a paragraph which may refer to the CRUCIFIXION: she speaks of "the grim strong work. You [Wallace] are picturesque now and you were the same in earlier years. So many think it is the Spanish work. Tom was never influenced by any painters work, but he did admire the old Spanish painters like Ribera and Velásquez . . . you will remember he said, always 'work from nature,' try to do as good work as has been done and try to do even better." (Mrs. Eakins' letter, dated December 14, 1934, is in the collection of the Joslyn Art Museum, Omaha, Nebraska.) Wallace posed for the painting near Pensauken Creek in New Jersey, not far from Kensington, Philadelphia. Later, according to Margaret McHenry, he posed strapped to a cross on the roof of Eakins' third floor back studio, while Eakins painted from the studio which formed the fourth floor at the front of the Mt. Vernon Street house in Philadelphia.[13] The young man's body is rendered with unimpassioned accuracy; the irregularities and harsh junctures of bone and muscle in the upper arms are painted with a steady realism, eschewing either the idealizing tendency present in Velásquez' work or the kind of expressionistic exaggeration present in the famous Grünewald CRUCIFIXION.

Looking back now at the two paintings, we find that Velásquez' painting tends to emphasize the theological and

[13] Margaret McHenry, "Thomas Eakins, Who Painted," unpublished document, 1946.

liturgical conception of the Crucifixion, as his countryman the poet and philosopher Miguel de Unamuno perceived. Unamuno's volume of lyric poetry, inspired by this painting and entitled *The Christ of Velásquez,* addresses the image on the cross:

> For Thou art the Christ,
> the only Man who did willingly die,
> the conqueror over death, that to life
> through Thee was elevated. And since then
> through Thee that death of thine gives to us life.[14]

John Mackay, in his essay on Miguel de Unamuno, has affirmed Unamuno's place in the development of existentialism, indeed as one of the first Europeans to read and be influenced by Kierkegaard. He also regards him as one of the greatest men of letters of the twentieth century. Born in 1864, Unamuno lived most of his life in Salamanca, and for fourteen years was rector of the medieval university of that city; but he was deposed as "the greatest heretic and teacher of heresy." After a six-year exile in France, he returned to his chair, and later to his post as rector. He is best known in America for his prose writings which have been translated into English: *The Tragic Sense of Life, The Agony of Christianity,* and his philosophical essays. But he wrote prolifically in all classes—novels, drama, essays and poetry.[15]

Eakins' CRUCIFIXION, on the other hand, has a forthright realism. It seems to be a study of a particular death of a finite human being, recorded without love or pity, and outside any embracing larger context or meaning.

[14] *The Christ of Velásquez* (Baltimore: The Johns Hopkins Press, 1951), p. 7.
[15] John Mackay's essay was published in *Christianity and the Existentialists,* ed. Carl Michalson (New York: Charles Scribner's Sons, 1956).

Yet the bowed head and face wholly hidden in the deepest shadow, the clawlike fingers with their soft, torn palms, and a certain tenderness as well as austerity in the rendering of the torso command our interest and perplex our judgment. The crown of thorns and Pilate's title do not seem iconographic additions to a figure posed as the Crucified; they are at one with the artist's total conception. What Eakins painted is *the* Crucifixion, not simply a crucifixion.

But if we were to use the ancient categories of sacred and profane art—the sacred art being that which is within the temple, the profane or what we now would call the secular, that which is outside the temple—then Velásquez' CHRIST ON THE CROSS remains a work of sacred art and Eakins' CRUCIFIXION is a profane work of art. Eakins' *style* reflects the ideas and ideals of the past—the Renaissance and the Baroque eras. Yet in the *content* or the meaning of his painting, we experience the ambiguity and complexity characteristic of much twentieth-century art. His CRUCIFIXION bespeaks a strongly individual interpretation —"This is how I see it." His painting expresses loneliness and finitude, the humanity and pathos of individual suffering borne with dignity in the secular world.

In contrast to Eakins' CRUCIFIXION, the seventeenth-century painting by Velásquez is of the Christ, who Unamuno addresses as "the conqueror over death . . . whose death gives to us life." Thus Velasquez' painting is sacred art; whereas Eakins' painting, by the ancient definition, is profane art. It is in the latter category, however, that much of the distinguished religious art of our own century belongs. This is notably true in the United States, where the churches have been indifferent or hostile to the gifts of their artists. The artists, estranged from the churches and no longer nurtured in the ancient union of art and liturgy, express the great themes in tersely secularized images.

2

the last supper
by André Derain

Eakins painted during the first decade of the twentieth century and died in 1916. The decisive developments for twentieth-century art took place within his lifetime but were related more to the art of his French contemporary, Paul Cézanne than to the Philadelphia artist. (Cézanne [1839-1906] was born only five years before Eakins and died only ten years before he did.) On first reading Cézanne's letters, we are reminded of Eakins' "confidence in nature," for Cézanne too doggedly studied nature. He wrote to a friend, "Painters must devote themselves entirely to the study of nature," and again, "The real and immense study that must be taken up is the manifold picture of nature." [1] Yet, whereas Eakins revealed the qualities of persons and objects through description, Cézanne revealed something of the structure of the forms that lie beneath appearances. His often-quoted statement, "Treat nature by the cylinder, the sphere, the cone," [2] suggests that Cézanne

[1] Rewald, John, ed. *Cézanne's Letters* (London Cassirer, 1946), pp. 236, 271.
[2] *Ibid.*, p. 234.

used the word "nature" with a different intention that did Eakins. While Eakins saw nature as an objective reality to be studied through dissection, analysis, and photography, Cézanne looked for the abstract components of nature beneath the shifting appearance of visible reality. Cézanne's insights and pictorial inventions prepared the ground for the more radical transformation of seeing introduced by the style of Cubism. In the seven years prior to the First World War, a few artists, scarcely known then even to art circles, began what Gertrude Stein called "the long struggle not to express what could be seen but to express those things *not* seen," "not appearances but reality." Picasso was the leader in this long, lonely struggle. It was a landscape painting by his friend Braque which was described by a critic as made up of "little cubes," and thus the term Cubism was born. André Derain was also a member of the group, a friend of Picasso and of the Matisses, and of the group of artists and writers who mingled at Gertrude Stein's Paris residence. In her autobiography, Gertrude Stein told of visiting the Independents exhibit in Paris,

where Cubist paintings were first exhibited. After looking at many paintings, she found two friends seated in front of two large paintings by Braque and Derain, greatly puzzled by the "strangely formed rather wooden blocked figures" in the paintings. Gertrude put a hand on their shoulders, burst out laughing, and said, "You have seated yourselves admirably, . . . right here in front of you is the whole story." Right in front of them were two of the first Cubist paintings, paintings which showed the struggle to express those things not seen—not "appearances but reality." Derain's relationship with the artists who formulated Cubism was close for a brief period only. Kahnweiler, the young art dealer and interpreter for the Cubist artists, signed a contract with Derain in 1907 for an exhibit at his new art gallery in Paris, the gallery where Picasso and Braque were later to exhibit. Like Picasso, Derain studied and was influenced by African Negro sculpture. But the major influence on Derain's art derived from Cézanne and only briefly was his style influenced by Cubism.

André Derain's LAST SUPPER (Illustration 3) with its "strangely formed rather wooden blocked figures" is like the paintings Gertrude's friends were contemplating. In this monumental painting the massive, simplified figures have cylindrical necks and arms, conical hands, and ovoid heads. Only a few geometric strokes suggest the placement of eyes, nose, and mouth. All the irregularities of feature which make memorable the particular finite human features have been eliminated. Any suggestion of emotional or dramatic relationship, all that is descriptive or storytelling, has been avoided as well. Neutral, diagrammatic figures with trancelike gestures and attitudes are grouped about a central, static, hieratic figure in a barren room in Derain's LAST SUPPER.

Again, as in the case of Eakins' CRUCIFIXION (Illustration 1) we are confronted with a major work of art by a master whose total output falls in other categories. Derain was a productive artist, and our museums and private collections are rich with his landscapes, portraits, still-life compositions, and his delectable paintings of opulent nudes. There are, however, only a few smaller paintings with religious subject matter. This LAST SUPPER, on the other hand, is large in size, being over seven feet high and almost twelve feet wide. Like Eakins' CRUCIFIXION, it is characterized by a carefully composed and articulated design which has none of the unresolved patterns or irresolute forms of a provisional sketch.

The familiar subject matter of the Last Supper is recognizable, though it takes on a new guise in Derain's painting. The twelve apostles are grouped about the central figure of Jesus, who is distinguished both by his white robe and by the archway above, which serves as a nimbus and as the focal emphasis for his head and body. John, the disciple "whom Jesus loved," is seen "lying close to the breast of Jesus," and Derain may have had Simon Peter in mind when painting the figure on Jesus' right. The figure in the lower left, whose face is turned obliquely away from the Christ and whose hand reaches toward the dish on the table, is Judas: "Behold the hand of him who betrays me is with me on the table." "Jesus said, 'Truly, I say to you, one of you will betray me, one who is eating with me.' they began to be sorrowful, and to say to him one after another, 'Is it I?' He said to them, 'It is one of the twelve, one who is dipping bread in the same dish with me.'" (Mark 14:18-19.) Judas' face is turned away from Jesus, and his expression is difficult to interpret. He seems to glance, Janus-like, both toward Jesus and toward the spectator. Next to him in the center foreground is a small table with a vessel and empty bowl, reminiscent of the credence table traditionally placed near the altar and used for the elements in the Eucharistic service. The only other object

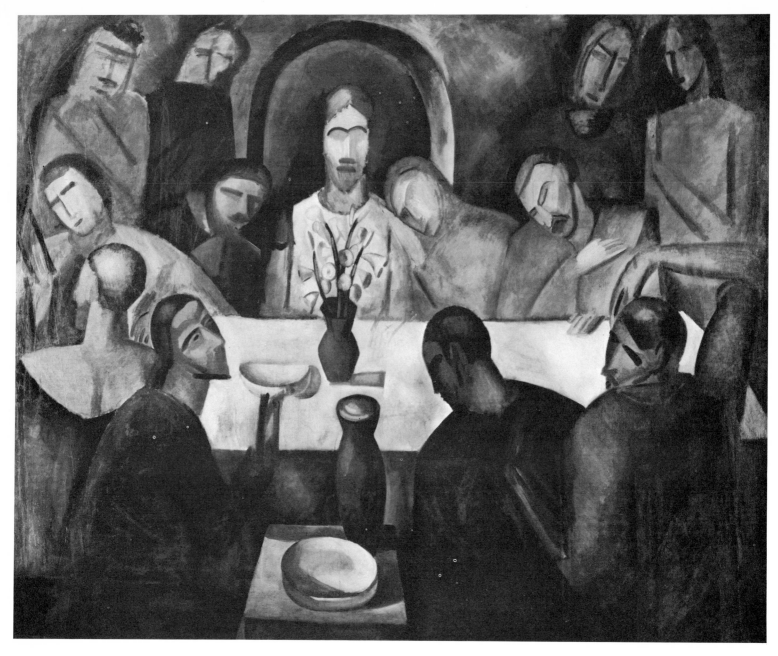

3. André Derain, THE LAST SUPPER, 1911.
Oil on canvas, 89″ x 113″.
Courtesy of the Art Institute of Chicago;
gift of Mrs. Frank R. Lillie.

on the center table is a vase filled with what appear to be lilies (Illustration 4). The vase of flowers on the table in lieu of bread or the cup of wine noted in the Gospel accounts gives an individual twist to the iconography of the scene.

The lily has long been associated with the Incarnation and the Annunciation. The Old Testament Song of Solomon, with all the splendor of its love imagery, was interpreted by the church as an analogy of the yearning love of the creature for the Creator. It is from this sensuous and tender love poetry that the lily as an emblem of Mary, the Mother of Christ, comes. This symbol, like the others for Mary—the sun and moon, the star of the sea, the rose of Sharon, the enclosed garden, the Cedar of Lebanon— is from the Litanies of the Virgin, and from certain Canticles, and is interpreted as a symbolic allusion to the Virgin.

> *I am a rose of Sharon,*
> *a lily of the valleys.*
> *My beloved is mine and I am his,*
> *he pastures his flock among the lilies.*

In paintings depicting the Annunciation, the lily, often seen in the hand of the angel Gabriel or in a vase near Mary, derives from these passages.

Derain's depiction of this symbol of the lily in a scene of the Last Supper is puzzling indeed, since it is associated traditionally with the Incarnation. Did the artist intend a symbol of life's beginning at life's imminent end? Mary's virginity was symbolized by the white lily: is it here a reference to the purity and probity of this one selfless life lived in this world? The lily of course, is widely used for Eastertide, and here the analogy of the cycle of nature becomes symbolic of the life, death, and resurrection of Jesus Christ. Or perhaps the ancient interpretations are transmuted and

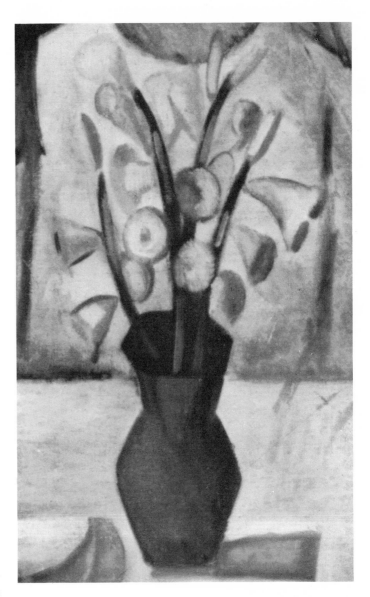

4. Derain, Vase of Lilies:
detail from THE LAST SUPPER, Illus. 3.

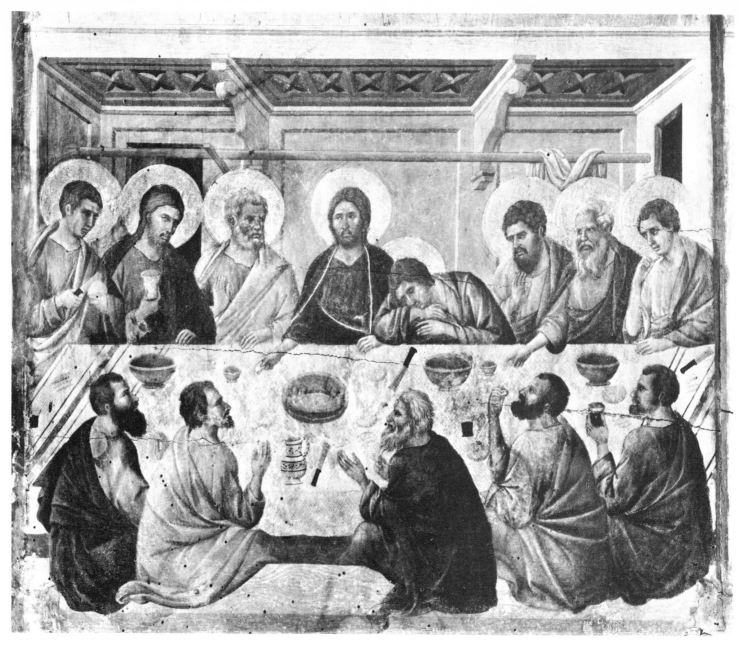

5. Duccio di Buoninsegna, THE LAST SUPPER, 1308-11.
Tempera on wood panel, about 15″ x 17″.
Siena, Opera del Duomo.
Courtesy of Anderson-Art Reference Bureau.

here the lily is associated only with the cycle of nature—life, death, and rebirth.

Though Derain certainly knew Leonardo da Vinci's famous LAST SUPPER through the early copy of this painting in the Louvre, his composition for the LAST SUPPER is certainly closer to that of the early Sienese artist Duccio (Illustration 5). Duccio lived before the cultural flowering which we call the Renaissance, and his paintings reflect much which is still Byzantine. But the typical Byzantine diagramming of persons and things against a spaceless-timeless gold background is not what we see in this LAST SUPPER. In this painting Duccio charmingly presents to our eyes a scene in which thirteen men are represented about a tipped-up table in what appears to be a very small, low-ceiling alcove. All the apostles and Christ are seen as if each were directly in front of us, and yet we simultaneously look down upon the table and up toward the coffered ceiling.

Most of this description also fits Derain's LAST SUPPER, though the side walls and ceiling which define and limit Duccio's space are not present in Derain's painting. Almost six hundred years separate the pre-Renaissance artist Duccio and the post-Renaissance artist Derain, but Derain's depiction of space is interestingly analogous to that of Duccio. There are other minor but rather fascinating similarities between the paintings—notably the position and gesture of Judas, and the similarity between the proportions and angle from which Derain's large foreground bowl is seen and the serving dish in front of Christ in Duccio's painting.

With the exception of the vase of flowers, the iconography of the two paintings is familiar and is based both on the biblical accounts and on a long tradition in the history of painting. But even though the number of persons and their positions are similar, when we look from one to the

other and find ourselves responding differently to each, we realize how the style of the work of art transforms its imagery, creating a new mood and new meanings. This is what Kandinsky referred to as "a new spiritual content."[3]

Viewing Derain's LAST SUPPER, now as a composition, we note that the focal point for the whole group is certainly the head of Jesus (Illustration 6). Derain first draws the beholder's eyes to this narrow, hieratic face by giving more complexity of design to it; second, by contrasting the hairline which descends in an abrupt diagonal on the right side, to the steplike line on the left side of the forehead; and third, by more clearly defining the features of Jesus than of any of the disciples about him. These are the artist's means of compelling our interest to focus on this face. The lightest tones are used in this area too, and they are contrasted with the decisive dark tone of the double-arching brows and the rich and resonant dark shades which form inky shadows to the left of the cheek, neck, and shoulder of the Christ. The flowers continue this focal area. Their small oval and cone-shaped forms create a restless, staccato, dark-and-light accent amid the larger forms of the apostles' bodies and the simple planes of the tabletop and the wall behind.

Derain has created a basic, simple shape for the scaffolding of the composition, a cross which has the tabletop as its horizontal member. The vertical axis of this cross shape begins with the arch which encloses the head and shoulders of Christ and continues through the vase of flowers. Then the foreground vase and the hands of Judas carry this vertical axis to the smaller table and bowl, and it terminates at the lower edge of the painting.

Simple geometric shapes give structure to Derain's LAST SUPPER. A very nearly equilateral triangle has its apex in

[3] *Concerning the Spiritual in Art*, p. 11.

6. Derain, Head of Jesus: detail from THE LAST SUPPER, Illus. 3.

the head of Christ. One side of this triangle is formed by the back and head of Judas, and the other side by the hand and arm of John, who leans upon Jesus' shoulder; it continues across the head and neck of the foreground apostle and the arm of the third foreground figure. We could continue our analysis of the composition, noting the subsidiary triangular forms, the diamond shape created along the two axes, the two buttressing columnlike figures standing at either side behind the group. All these intricate, balanced, yet varied movements give cohesiveness to the composition.

In our study of the composition of Derain's LAST SUPPER —noting the crosslike structure which forms the basic vertical and horizontal axes, and the way in which the triangular forms play across and interlock with these axes—the discussion has been kept to one single plane, that of the canvas itself, or that imaginary but useful non-thing called the picture plane. The picture plane is the plane of the canvas itself, which in painting from the time of the Renaissance to our own century was imagined to be like a transparent opening through which the depicted persons, places, and things are seen. To use the analogy of the traditional theater, it was like the proscenium arch at the edge of the stage. The artist defined the width and height and depth of the stage on which the scene was to take place; he disposed his actors and props in relationship to this space and to each other, and then chose the point in the theater from which he wanted to view the scene. The point from which he decided to see it and paint it automatically became the beholder's viewpoint as well. He might have chosen to have the beholder see the actors from the orchestra pit, and then the figures would be seen with dramatic foreshortenings and oblique recessions. The same grouping of figures seen from above, from near or from far, would give a totally different effect. Thus even within this stage-like spatial framework of naturalistic painting the artist has many options. (The term "naturalism" is used here very broadly to designate the dominant mode of art in the Western world from the time of the High Renaissance through the early phases of Impressionism.)

Derain has chosen to bring the beholders very near to the scene he depicts, and to continue the theater analogy, the edge of the small foreground table seems at the very edge of the stage. Our eye level is level with that of the Christ, and thus we look down upon the tabletops. The breadth and depth of the area delineated by the back wall with its arched opening and by the side limits of the painting seem hardly large enough to contain the massive figures. This upper room *should* appear to us as an uncomfortably small, crowded, claustrophobic space. But strangely it is not. Instead, a feeling of trancelike serenity permeates the room. (Gertrude Stein remarked of Derain that "he had a sense of space that was quite his own." This was perceptive and reluctant praise, for she and Derain had a violent disagreement about philosophy. After this argument she remarks that they seldom saw each other.) [4]

Derain's carefully constructed composition has been structured both in terms of the surface pattern and in terms of the arrangement of the forms in the implied depth. The two major cross-shaped axes around which the forms are organized on the surface of the canvas correspond to a disposition of the forms in depth as well. If a ground plan were drawn for the tables and figures, they too would form a roughly cross-shaped plan. This way of structuring a picture was familiar to painters of the past, and Derain had, in his early years, daily studied the old masters' works while a student painter in the Louvre in Paris. But once we have noted the coincidence of the surface design and the

[4] *The Autobiography of Alice B. Toklas* (Vintage Books; New York: Random House, 1933), pp. 38, 42.

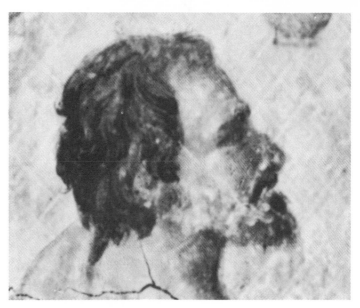

7. Derain, Head of Judas:
detail from THE LAST SUPPER, Illus. 3.

8. Duccio, Head of Judas:
detail from THE LAST SUPPER, Illus. 5.

depth design, we are increasingly aware of how the flattened forms of the figures, the seemingly tipped-up tabletop, the various, inconsistent angles from which we seem to see the figures, all jar against any logical or consistent interpretation of spatial relationships.

The way in which Derain paints the human face and figure differs radically from any of the earlier examples of painting—whether it be Duccio, Velásquez, or Eakins. Derain barely indicated the features, using seemingly arbitrary and sketchy lines (Illustration 7). Shadows and modeling (the progressive darkening of an area in order to suggest shape and volume as it is touched by light or enveloped by shadows) are made up of hatchings in which the separate strokes are clearly visible, giving an appearance

of a "work in progress," a canvas that the artist might return to, continuing to build up and modify the forms.

Whereas the artist Duccio seems to have enjoyed elaborating upon the traditional types for the apostles, differentiating them by gesture and expression, style of beard and cut of hair (Illustration 8), Derain presents them diagrammatically—two straight lines for the brows, another for the nose, another for the mouth. At first glance many faces seem to be eyeless, but with continued study the lines of the brows with the patch of shadow below tend to be read as the eyes. Particularly in the face of Jesus, we sense the wide-eyed yet unfocused gaze of one whose seeing is inward. Both through the choice of color and the manipulation of the values (dark and light equivalence of the col-

ors), the face and figure of Jesus seem transparent—a characteristic seen to varying degrees in other figures as well.

This effect of transparency is created in part by the kind of lighting Derain chose to use for this LAST SUPPER. The light is not the natural light of day coming through the archway in the back wall, nor does it come from an off-stage window, nor is it from a spotlight, to use the analogy to the theater again. Rather, the light seems to emanate from the tabletop and the figures and the vessels. This effect of emanation is most strongly felt in the face and figure of Christ.

Looking from Derain's LAST SUPPER to Duccio's painting, we are suddenly aware that Derain's style allows him to give the figure and face a kind of meaning which Duccio symbolizes and objectifies in the traditional manner with halos. Derain himself avowed that in his painting he was searching for "what is fixed, eternal, and complex." [5] It must not be overlooked, of course, that Duccio's halos are by no means only labels which suggest the divine aura, but part of his compositional structure as well. They are like musical notes—the three round, barely touching halos at the left, then a tenuous pause, then the dominant, emphatic, isolated central orb about the head of Jesus and its attendant descending eclipsed sphere about the head of St. John below, and finally the last three overlapping staccato notes. Duccio omitted the halos of the five foreground apostles, not in order to suggest any diminution of holiness in these disciples, for even Judas is haloed in some paintings of the Last Supper, but rather to allow us to see the table with its diamond-patterned, woven cover, and the variety of pottery, glasses, and knives which create a charming still-life pattern thereupon.

Duccio's upper room is crowded and busy. The apostles are eating bread and raising glasses of wine to their lips. One looks up as he is cutting bread. Peter, at Jesus' right, raises an incredulous hand at the words just spoken. Jesus holds the sop toward Judas. An air of interrupted and troubled activity is communicated to the beholder. We sense the momentary hush which follows a declaration having a different meaning to each of the individuals in the group, a hush which will be followed by queries and protestations.

In contrast, Derain's LAST SUPPER depicts a group enveloped by a languorous and continuing quietude. The gestures of the apostles are those of the awakening sleeper. Even the awkward movement of the apostle at the lower right with his uncommonly long upper arm seems to suggest torpor, and a reluctant return from sleep or meditation into consciousness. Derain's apostles appear more hieratic, more solemn, one might even say more liturgical, than do Duccio's.

In this contrast between the two paintings it becomes clear that Derain is not describing or telling a story. Rather than particularizing the setting and individualizing the faces, figures, and gestures as Duccio did, he has simplified and neutralized these until they become visual images of disciples, not portraits of a particular disciple or a particular type of disciple.

Thus, while the compositional structure is like that of paintings from the Renaissance tradition, the other characteristics of Derain's style—his emphasis upon simplified forms and triangular and diagonal thrusts, his sketchy brushwork and the strange transparency of many areas, the anonymity of the faces and the trancelike gestures—all communicate a feeling of ambiguity, as though these apostles were present not at a once-and-for-all-time event, but at an ongoing mystery, to which they bear witness but do not themselves comprehend.

[5] Gaston Diehl, *Derain* (New York: Crown Publishers, n.d.), p. 46.

3 calvary and the white crucifixion by Marc Chagall

Marc Chagall was once asked to explain his paintings and he replied, "I don't understand them at all. They are not literature. They are only pictorial arrangements of images that obsess me. . . . My paintings are my reason for existence, my life and that's all."[1] This is a more profound statement than it appears to be at first glance. The colorful, hybrid forms which keep recurring in the artist's work in ever new shapes and juxtapositions have attracted the psychoanalysts' attention. Indeed, Chagall's images have been catalogued and translated into psychoanalytic terms. But Jean Cassou reports that when he told Chagall of the clinical interpretation of one of his paintings while the two of them stood before it in the museum in Paris, the artist looked at him in bewilderment. For Chagall, his painting is a pictorial arrangement of images that obsess him, and he leaves the interpretation of these images to us—and to the psychoanalysts, if they so chose.[2] He lives in his own world, close to these obsessive images. "In my head I see many things, but I don't know whether I will be able to realize them," he remarked in an interview in 1963.[3] He was then seventy-six and had already created a prodigious number of paintings, etchings, ballet set designs, stained glass windows.

In these works of art we see recurrent types—figures and animals and objects, clothed in ever changing forms and colors, freely juxtaposed: an old Jew clasping the scrolls of the Torah, Christ on the cross, a pair of embracing lovers, the artist himself with his palette, a mother and child, an incandescent bouquet of flowers, a clock with its pendulum proclaiming the passage of time, a fantastic fish with wings, oxen patiently pulling a cart, a violinist strolling through time and space, a red cock with a startling human visage, or a man with a cock's head. What is the meaning of it all? The artist shakes his head when asked to exegete. He picks up his palette and turns again to his easel, for paintings are the reason for his existence, his life.

[1] James Johnson Sweeney, *Marc Chagall* (New York: Museum of Modern Art, 1946), p. 7.
[2] Daniel E. Schneider, "A Psychoanalytic Approach to Marc Chagall," *College Art Journal,* Winter, 1946.
[3] Carlton Lake, "Artist at Work: Marc Chagall," *Atlantic Monthly,* July, 1963, p. 111.

Another twentieth-century artist once observed, "It is the glory and misery of the artist's lot to transmit a message of which he does not possess the translation." [4] Any verbal explanation of the paintings is rejected by the artist, and quite rightly so. If what he wishes to express could be expressed in words, there would be no reason for painting the picture. The power of the work of art lies at this very point: that it speaks directly through color, lines, form, imagery, and we are confronted and in dialogue with the work of art before we know what it is that grasps us. But while we keep in mind the artist's admonition that his paintings are not literature, an attentive and verbalized exploration of the work of art can yet be wonderfully illuminating. By observing the images within each painting—that is, the iconography—and how the artist has structured these on his canvas—that is, the composition of the painting—we are able to get inside the work of art. The observer becomes the participant, seeing momentarily with the artist's eyes and feeling with his pulse beat.

Turning first to one of Chagall's early paintings, the CALVARY (Illustration 11) of 1912, now in the Museum of Modern Art in New York, we see a large canvas painted after the twenty-five-year-old artist had left his native town of Vitebsk in Russia and moved to Paris. In this early painting, as in all his art, there are recollections of his childhood in a humble Jewish home adjacent to the local Eastern Orthodox church. The symbols from the synagogue and the images from the Russian Christian Church mingle freely in his art.

As a youth in Russia, Chagall had made a pen drawing of the Crucifixion. This interesting drawing, which is closely related to the CALVARY, is reproduced in Franz Meyer's handsome monograph, *Marc Chagall*. The symbolic figure of Christ became one of the obsessive images seen in ever changing form in his paintings. He wrote of the CALVARY, "The symbolic figure of Christ was always near to me and I was determined to evoke it from my young heart. I wanted to show Christ as an innocent child. Now I see him otherwise. . . . When I painted Christ's parents I was thinking of my own parents. The bearded man is the child's father. He is my father and everybody's father." [5] (Illustration 9) In the CALVARY, Christ "as an innocent child" is elevated far above his parents, who stand at the foot of the cross. Their hands are extended as if that which they had so often held—the body of Jesus—had just been taken from them and they knew not what to do with their empty hands. Franz Meyer was apparently not aware of Chagall's statements which refer to the three figures as Christ's parents and Judas. Meyer identifies the two parents instead as John and Mary, the pair who stand at the foot of the cross in traditional depictions of the Crucifixion. He says, of the figure with the ladder, "He may be the one who has just helped nail Christ to the upright cross. But his first function is to embody an evil spirit as opposed to the good, the unholy custodian of the instrument of pain as opposed to the holy man, John." [6]

Chagall's freedom from the traditional iconography is evident in that he identifies the immense figure at the left as Christ's father, his own father, everybody's father. In traditional Christian art the place that this father figure occupies has always been given to John, the beloved disciple, who was asked to care for Mary the Mother of Jesus. Since John's Gospel records that Jesus from the cross commended the care of his mother to John the Evangelist, it was assumed that Joseph must have died before the time of the Crucifixion. Indeed, legend and art traditionally

[4] *Marc Chagall*, p. 7. The artist quoted is André Lhôte.

[5] *Museum of Modern Art Bulletin*, XVII (1950), 4.
[6] Franz Meyer, *Marc Chagall* (New York: Harry N. Abrams, 1963), p. 172.

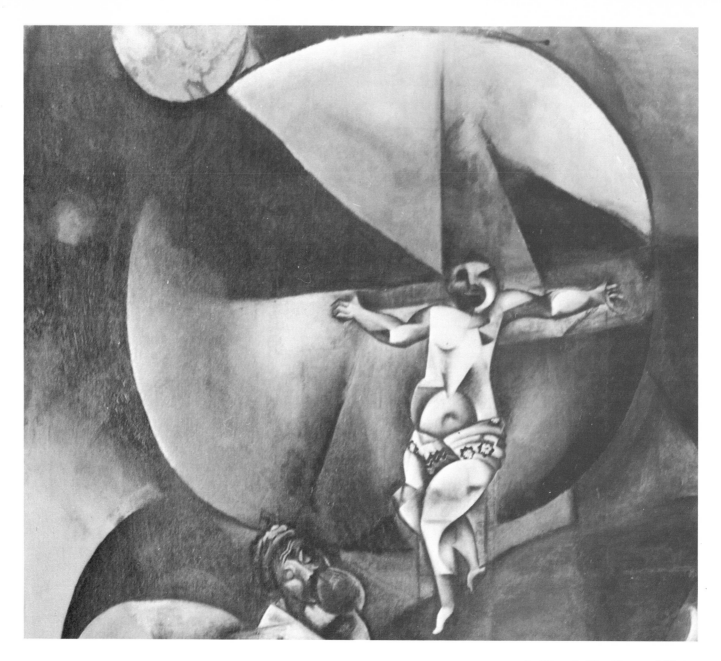

9. Chagall, The Figure of Christ:
detail from CALVARY, Illus. 11.

pictured him as an old man often quite helpless and senile, even at the time of the birth of Jesus. But here the young Jewish artist, recalling his own father, has made this patriarchal figure dominate the entire scene as, in his own recollections, his father had dominated all of his younger years.

Another iconographic peculiarity is the inclusion of the figure of Judas (Illustration 10). Except for an early Christian carved panel (Crucifixion relief from the fourth century, in the British Museum) which shows Judas hanging from a tree at the right of Christ on the cross, Judas has not been included in crucifixion depictions. Here he has a strangely large head and his features are rendered with greater detail and clarity than any of the others. He looks backward toward the group but seems to be walking diagonally out of the picture zone. Chagall said the Judas figure "was an apparition which frightened me a little so that I gave him a ladder to bring him down to an informal level." Something of the artist's own conflict about the Judas figure remains in this Judas; his face has a sly and evil watchfulness as he looks back at the Crucifixion and the mourning parents, yet his legs move nimbly away in the opposite direction as he balances his ladder lightly in his right hand.

The event takes place on a gently sloping hill at the edge of a river or lake. In the middle distance a small figure in a sailboat looks curiously toward Judas. The waters are indicated by waving lines. Here and there a decorative tree is seen in the distance, and a lone blossom grows in the foreground. Blossoms are scattered about the long gown of the mother, and the father's legs have decorative tendril-like patterns with a few silhouetted blossoms as well. The sky fills more than half of the background, and though sectioned into a succession of transparent and opaque planes, it has two large circular areas which could be read

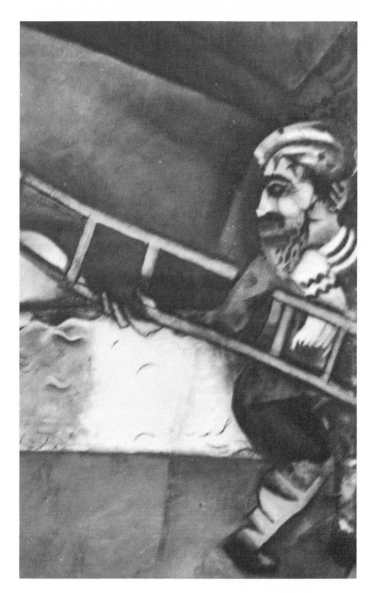

10. Chagall, Judas: detail from CALVARY, Illus. 11.

as the sun and the moon. Traditionally the sun and moon often are represented in crucifixion scenes, and they are located usually above the arms of the cross. The moon symbolizes the synagogue and the Old Covenant. At the time of the Crucifixion, the veil of the temple was rent, symbolizing that the New Covenant had come, and the sun was seen as symbolic of the church, which now shed a clear light over that which had been veiled before.

The great round disks in the sky are repeated in many partial round forms of various sizes throughout the canvas: the round head of the Christ "as an innocent child" and his circular abdomen, the two overlapping circles of the old father's face and beard, the large halo-like area about the flower in the foreground. A crescent shape is seen at the left, beginning in a sharp point against the sky and continuing through the body of the father.

But one of the most interesting of Chagall's compositional devices is the way in which the pie-shaped missing segment of the small circle in the upper right echoes the basic unifying form for the entire group of figures. This form, a pie-shaped wedge, or cone, has its apex at the top of the cross. Its right side is the line running from there to the head of Judas, and its left side is the line running from the right arm of Christ to the father's head; from there it is carried down in a succession of broken diagonals to the foreground. The lower perimeter of this cone curves from the father's foot along the lower edge of the painting and then along the upward arc at our right. Within this cone a succession of verticals descends from the top of the cross, as if created by successive swings of a great pendulum; indeed, that allusion seems appropriate, not only in describing the structure of the composition, but also in terms of content. The allusion to time, either overtly through the symbol of the clock, or by implication through unlikely juxtapositions, is a pervasive factor in Chagall's work.

The CALVARY of 1912 was first exhibited in Berlin and was then entitled DEDICATED TO CHRIST. Chagall had

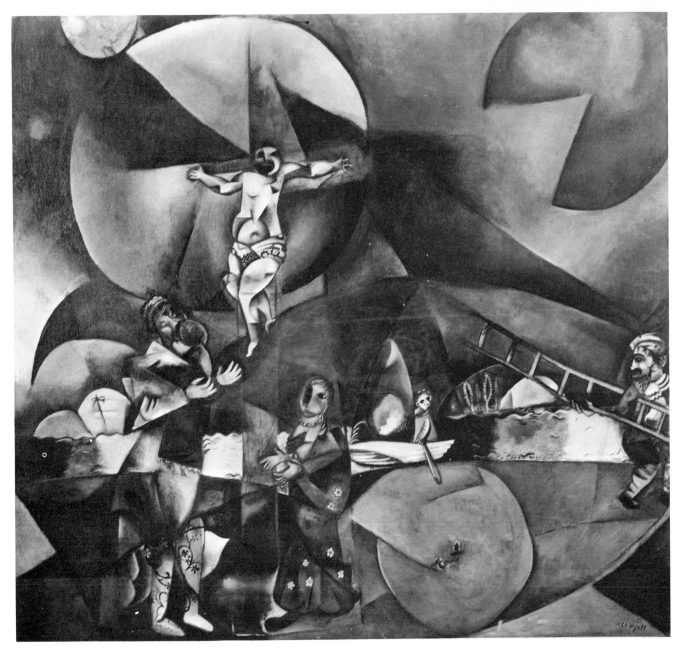

11. Marc Chagall, CALVARY, 1912.
Oil on canvas, 68″ x 75″.
Collection, the Museum of Modern Art, New York,
acquired through the Lillie P. Bliss Bequest.

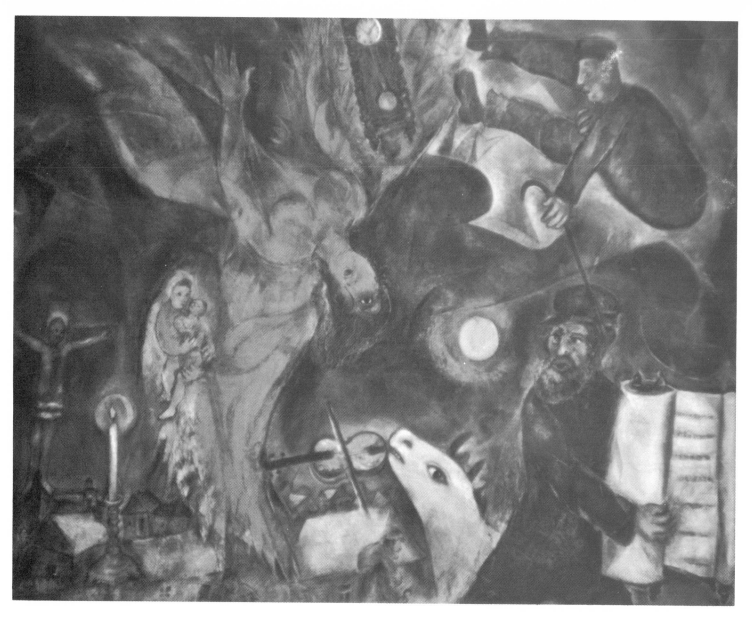

12. Marc Chagall, THE FALLING ANGEL, 1923-33-47.
Oil on canvas, 57" x 104".
Basel, Kunstmuseum.

said that the symbolic figure of Christ was always near, and the crucified Christ has indeed remained near to the artist during all of his long life. In ever changing form and ever changing juxtaposition this obsessive figure appears. In an apocalyptic FALLING ANGEL (Illustration 12), completed in 1947, a glowing Crucifixion and single candle are the only vertical and quiescent objects in a tumbling, chaotic world. In THE CRUCIFIED of 1944, it is not the Christ who is crucified but a succession of Jewish men hung from crosses in front of their homes in a war-torn, snow-covered village. In THE DESCENT FROM THE CROSS, 1941, the dead figure with a prayer shawl for a loincloth who is lowered from the cross by a strange cockheaded man has the facial features of the artist himself, and the titulus above has Chagall's name inscribed thereon. This painting was created in Connecticut after the artist came to this country for haven during the Second World War, and the imagery showing the artist himself as a victim of the Crucifixion is no doubt related to his experience at this time. The Nazi attacks had caught Chagall in Vichy, France, where he was busy with his painting. Soon after, he was in a police roundup of Jews in Marseilles. The emergency rescue committee packed him and his family and 3,500 pounds of his works of art on a ship for New York. The day before his ship arrived in New York in June of 1941, the Nazis attacked Russia.

The BLUE CRUCIFIXION, the YELLOW CRUCIFIXION, the MEXICAN CRUCIFIXION were all painted during this period of the 1940's, during the war and just after the end of the war. The death of his beloved wife, Bella, who often was represented in his work, may too be related to his preoccupation with the theme. But the image of the Crucified continues to appear in his work throughout his life, even in the recent designs for the stained glass windows of the Cathedral of Saint Étienne at Metz, France. He included the figure of Christ carrying the cross in the background, behind the figure of the patriarch Abraham who was about

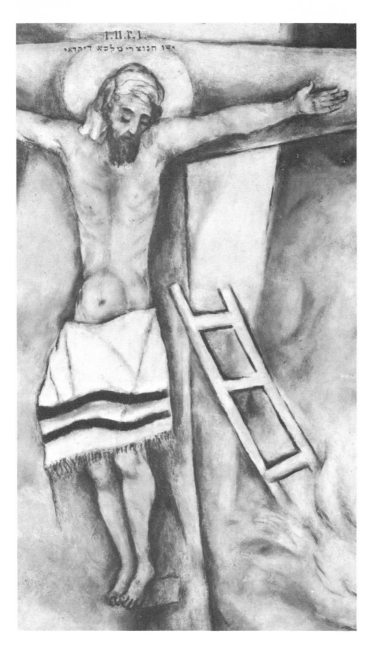

to slay his only son, Isaac. Carlton Lake, who in 1963 accompanied Chagall to the stained glass studios of Charles and Brigitte Marq where the artist's compositions were translated into stained glass, reports that when Chagall saw this window in the studio, he studied it carefully and said, "I can't see the Christ carrying his cross. It's not readable. I want to *see* him carrying his cross." [7] After Charles Marq had worked over this part, "That's much better," he said, "he's lightened this part. Now I can *see* the cross." And turning to his friends, the artist said, "We must all carry our cross with joy as long as we are here, trying to understand the world and God." [8]

Franz Meyer, in his handsome monograph on the artist, remarks that an interesting evolution has occurred in recent Jewish thinking in regard to the crucified Christ. He is seen "not so much as the founder of Christianity, as one within the perspective of Judaism. . . . Christ is not the Son of God: the Passion is not a chapter in religious history, but the incredibly lonely, unnatural, irrational act of one of the greatest of men." These words incorporate some of Chagall's own statement, "Christ is a poet . . . one of the

[7] "Artist at Work: Marc Chagall," p. 99.
[8] *Ibid.*, p. 108.

13. Chagall, Jesus of Nazareth:
detail from THE WHITE CRUCIFIXION, Illus. 15.

14. Thomas Eakins, THE CRUCIFIXION, 1880.
Oil on canvas, 96″ x 54″.
Courtesy of the Philadelphia Museum of Art.

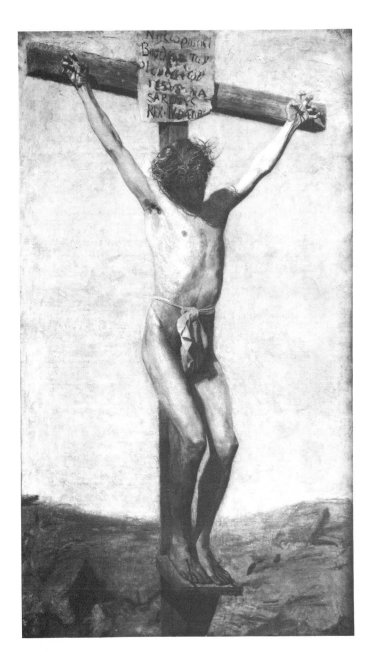

greatest—through the incredible, irrational manner of taking pain onto himself." [9]

Chagall's preoccupation with the "symbolic figure of Christ" is thus part of his art and his conscious thought. But of all Chagall's representations of the Christ figure, the one most clearly identified with the New Testament accounts of Jesus of Nazareth is the WHITE CRUCIFIXION (Illustration 15), painted in 1938 in a troubled and war-torn Europe. Chagall's Christ of the WHITE CRUCIFIXION (Illustration 13) serenely stretches forth his arms against a skewed, tau-shaped cross. His head is inclined downward and to his left, seemingly in relaxation and quietude, rather than with the sense of the abrupt cessation of muscular tension of Eakins' Christ. His hands, with open palms and fingers extended, make the nails visible but deny their function. When we look again at Eakins' CRUCIFIXION (Illustration 14), it is evident that in Eakins' painting the nails which pierce the palms of the Crucified do indeed support the sagging weight of the vanquished body and its burden of flesh, bone, and muscle. By contrast, Chagall's Christ seems to float weightlessly in front of the cross at the center of a world in chaos.

[9] *Marc Chagall*, p. 16.

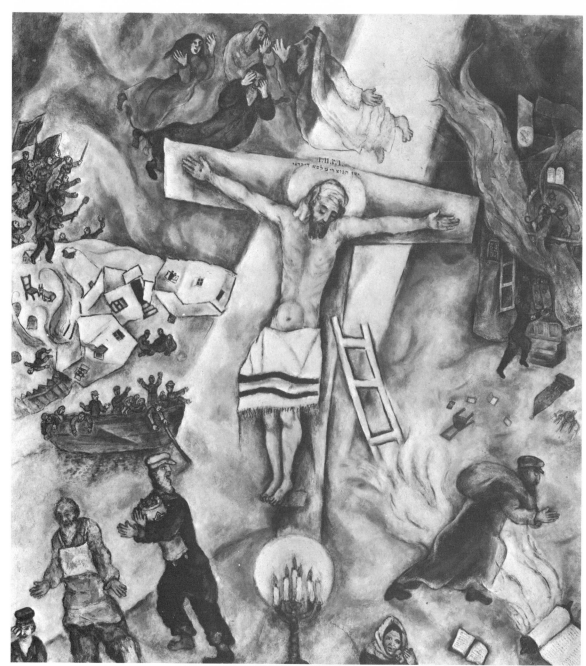

15. Marc Chagall,
THE WHITE CRUCIFIXION, 1938.
Oil on canvas, 61″ x 55″.
Courtesy of
the Art Institute of Chicago.

At the upper left, and reading counterclockwise, we see a threatening mob carrying flags and brandishing weapons, an overturned house and homes aflame, with walls which collapse and doors and windows which hang loosely on broken hinges. In a field nearby an upright chair and recumbent goat are incongruously juxtaposed, while an injured man lies helplessly behind the flaming, tumbling houses. Three persons huddle despondently together, for the boat in which the villagers flee has left without them. In the lower left foreground an old man weeps as he disappears from view. A second peasant stumbles sightlessly on, wearing a vest on which was formerly written in German, "I am a Jew";[10] a third holds the scrolls of the Torah protectively against his body as he turns with open mouth to glance backward toward the burning synagogue. At the foot of the cross a ceremonial branched candlestick burns serenely, giving forth a halo-like refulgence amid this scene of terror and destruction. An anguished mother hurries forward pressing her infant's head against her own cheek. An old peasant with a sack on his back flees amid the flames which seem to issue from

[10] *Marc Chagall,* p. 414. Chagall later painted over this, saying it was too "literal," p. 609.

the open scroll at the lower right. In the upper right, a synagogue is aflame. Books, a clock, a chair, a candelabra lie asunder as a man attempts to save some of the ceremonial objects.

The sinuous, lambent flames which issue from the burning synagogue move upward, meeting the shaft of white light which cuts diagonally down across the scene, surrounding the crucified Christ and focusing our attention on his figure. The structure of the painting is made up of many diagonal movements, the skewed tau-shaped cross proclaiming the central thrusts. The shaft of light and the pyramidal hill on which the cross is implanted form other vigorous diagonals which are opposed by the diagonals of the fleeing figures. The tumbling houses, the dark wedge made by the boat, and the collapsing walls of the synagogue present diagonal movements which play against the major thrusts, accentuating the dissonance and unresolved chaotic movement of the composition.

Within this central motif we perceive a narrow, ascending, cone-shaped area which is composed of the body and head of the Christ and is completed by the ladder at the right. The focal point of the whole composition is the round nimbus of light behind the head of Christ. This

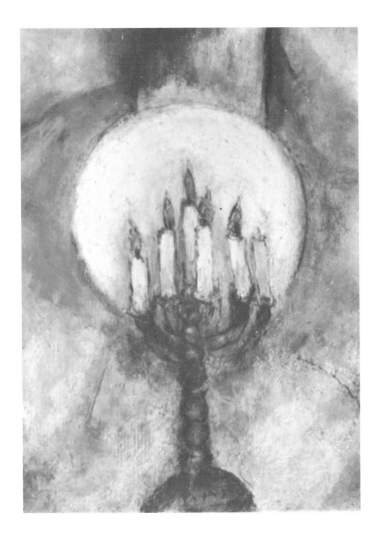

16. Chagall, The Menorah:
detail from THE WHITE CRUCIFIXION, Illus. 15.

17. opposite: Chagall, Peasants Above the Cross:
detail from THE WHITE CRUCIFIXION, Illus. 15.

disc of light is repeated in the glow about the candelabra in the lower foreground. As our eyes move to this area of the painting, the stability and quietude of this menorah become apparent (Illustration 16). It is the only object in the entire composition which is solidly vertical. It stands at the center of the lower margin, its shaft and candles erect, the candles burning steadily and surrounded by an opalescent, circular glow of light. The branched candlestick, or menorah, is used not only in the synagogue but in the home for ceremonial meals. The original Mosaic menorah had seven candlesticks, symbolic of the creation of the universe in seven days, but after the destruction of Jerusalem in A.D. 70, reproductions of the Temple menorah were prohibited, and thus later menorahs have five, six (as in Chagall's painting), or eight candlesticks.

A ladder is placed against the cross. In traditional Christian art, the ladder is for those who removed the body of Christ from the cross, but here, since there are no attendant figures, it recalls Jacob's dream:

There was a ladder set up on the earth, and the top of it reached to heaven; and behold, the angels of God were ascending and descending on it!

And behold the Lord stood above it and said, "I am the Lord, the God of Abraham your father and the God of Isaac."

(Genesis 28:12-13.)

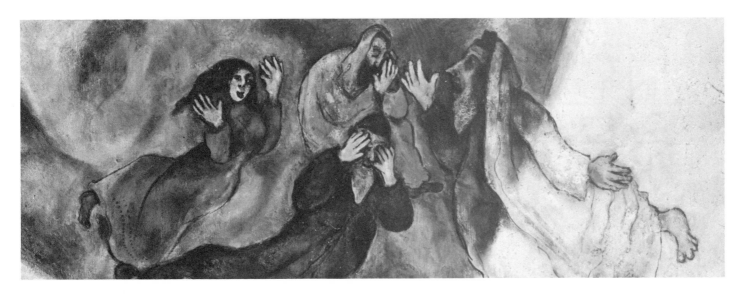

The ladder in Chagall's painting seems "set up on the earth" though its base is concealed by the whitish flames issuing from the scroll. The ladder reaches into the zone of heavenly light—"the top of it reached to heaven." The angels of God, in this case a peasant woman and three elderly Jews who gesture in sadness and dismay, are not seen ascending and descending the ladder, but instead gambol freely in a cluster above the cross (Illustration 17). Painters of the past, like Giotto, surrounded the cross of Christ with angelic mourners—cherubim and seraphim whose gestures of grief bespoke the mourning of all creation for this one death and sacrifice. Chagall, instead of representing the angelic hosts, has his plump Jewish peasants represent the heavenly hosts and express the lamentation over this death, and the many deaths, which they witness in this diaspora. These four figures, who are freed from the claims of gravity, gesture sorrowfully, three of them in the ancient pantomime: see no evil, hear no evil, speak no evil.[11]

[11] Allyn Weinstein, "The Iconography of Chagall," *Kenyon Review*, Winter, 1954, is the source of this interesting identification.

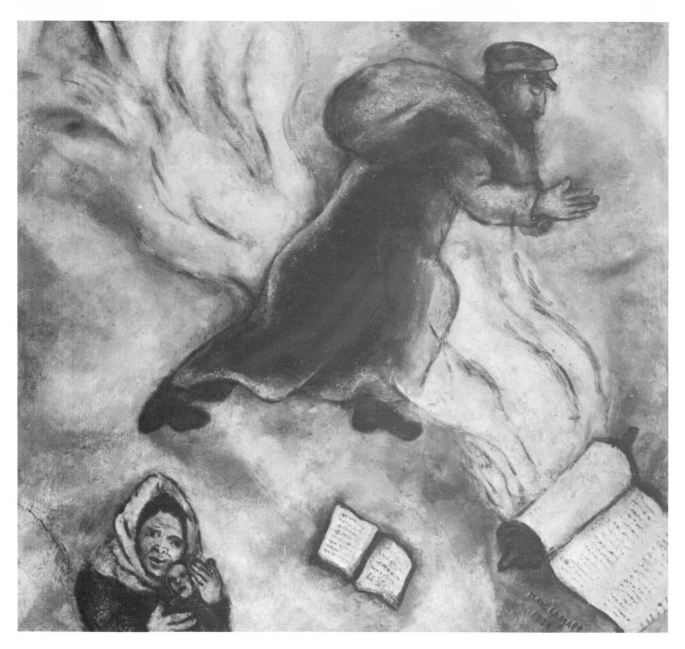

18. Chagall, Fleeing Man, Woman with Child:
detail from THE WHITE CRUCIFIXION, Illus. 15.

This vision in Jacob's dream is followed by a promise, and one which has a sharply poignant communication as it is read in the presence of Chagall's WHITE CRUCIFIXION:

*The land on which you lie I will give to you and to
 your descendants;
and your descendants shall be like the dust of the
 earth,
 and you shall spread abroad to the west and to the
 east and to the north and to the south;
and by you and your descendants shall all the families
 of the earth bless themselves.
Behold, I am with you and will keep you wherever
 you go,
 and will bring you back to this land; for I will not
 leave you until I have done that of which I have
 spoken to you.*

(Genesis 28:13-15.)

Chagall shows us Jacob's descendants, spreading abroad to all the corners of the earth—not as the blessed and rightful heirs of the Lord's creation, but as victims and fugitives of the ever recurring diaspora (Illustration 18). Christ on the cross hovers over the scene of terror and destruction with Pilate's inscription, "Jesus of Nazareth, King of the Jews," written in Hebrew characters above his head and a Jewish prayer shawl about his loins. The destruction and terror have a New Testament basis:

*And about the ninth hour Jesus cried with a loud
voice, "Eli, Eli, lama sabachthani?" that is, "My God,
my God, why hast thou forsaken me?" And some of
the bystanders hearing it said, "This man is calling*

*Elijah." And one of them at once ran and took a
sponge, filled it with vinegar, and put it on a reed,
and gave it to him to drink. But the others said, "Wait,
let us see whether Elijah will come to save him."
And Jesus cried again with a loud voice and yielded
up his spirit.*
*And behold, the curtain of the temple was torn in
two, from top to bottom; and the earth shook, and
the rocks were split.*

(Matthew 27:46-51.)

In the thought of the early church fathers, the tearing of the temple veil foretold the destruction of the Temple at Jerusalem and the ascendancy of the church of the New Covenant over the synagogue of the Old Covenant.

The armed mob at the upper left also has several possible contexts (Illustration 19). Chagall was still in Russia at the time of the October Revolution in 1917, when he witnessed the uprising at the age of eighteen. Thus the scene may reflect the memory of an actual occurrence in his boyhood. The ever recurrent pogroms of Jewish history are perhaps referred to as well. But a New Testament occurrence is also suggested—the invasion of the garden of Gethsemane by "a great crowd with swords and clubs, from the chief priests and the elders of the people." In late medieval and early Renaissance paintings of the Passion of Christ, the Crucifixion is often placed in a landscape in which the events leading up to the Crucifixion are pictured as if all these episodes occurred simultaneously in one continuous landscape setting. Thus Chagall's "crowd with swords and clubs" reiterates a subsidiary scene which has accompanied the Crucifixion in earlier paintings of the scene.

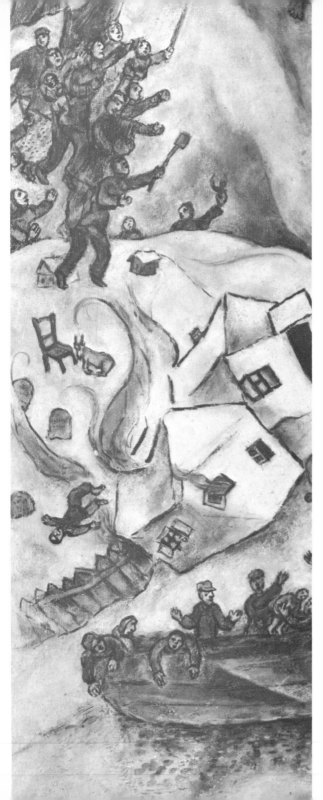

In suggesting these several interpretations for the armed crowd, it is not being argued that Chagall consciously intended these various interpretations. Rather he has drawn from the inner world of his own dreams and imagination a succession of images which are capable of suggesting to the beholder a variety of meanings. The images are related to the Old and New Testaments, to Jewish customs and lore, and to recollections of the artist's childhood in the village of Vitebsk in Russia. In particular, the burning synagogue (Illustration 20) is related to an experience of the artist, who as a young boy witnessed the burning of his hometown synagogue. In Chagall's poetic autobiography, *My Life,* he relates the episode:

19. Chagall, The Village Attacked and Abandoned: detail from THE WHITE CRUCIFIXION, Illus. 15.

*I'm alone on the river. I bathe. I scarcely disturb the
water.
Around me the peaceful town. The milky sky, dark
blue, is a little bluer to the left and from above
glows a divine happiness.
Suddenly, from the opposite bank, a puff of smoke
pours out from under the roof of the synagogue,
As though you could hear the cries of the burning
scrolls of the Torah and of the altar.
Flames are bursting out on every side.
The windows break.*[12]

[12] Marc Chagall, *My Life* (New York: Orion Press, 1960), p. 32.

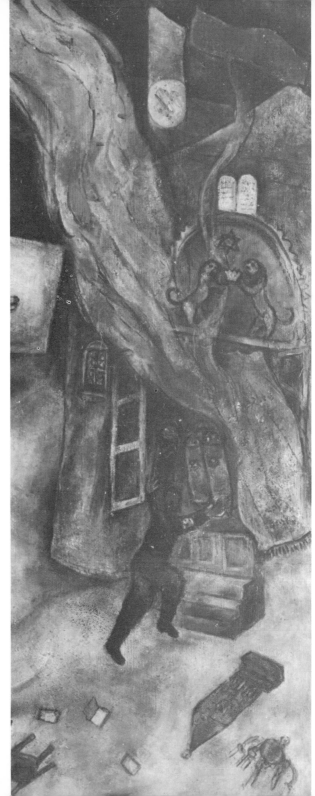

20. Chagall, The Burning Synagogue:
detail from THE WHITE CRUCIFIXION, Illus. 15.

The gold and red flames which leap up in sinuous curves intersecting the whitish shaft of heavenly light seem indeed to be the visible expression of the audible "cries of the burning scrolls of the Torah and of the altar." In Chagall's painting the synagogue and homes both burn with reddish, yellowish flames; whereas the scroll at the lower right gives forth a whitish flame, of the same opalescent tones as the shaft of light from above and the halo about the head of Jesus of Nazareth and about the menorah in the foreground. Thus the sun's colors are used for the devouring flames which issue from the burning structures built by man's hands. But the pale whitish moonlight is the analogy for the flames issuing from the scroll, the light of the ceremonial candelabra, the nimbus about the head of Jesus, and the supernatural shaft of light which surrounds his body.

The menorah with its centrality of location, its steadily burning candles, and its stable verticality in this chaotic turbulent scene, again claims our attention (Illustration 16). We note that it reiterates the size and shape of the nimbus about the head of Jesus, yet seems to be brighter in tone and more clearly delineated. We are reminded of the Psalmist's cry, "Thou also shalt light my candle; the Lord my God shall make my darkness light." Earlier in this same Psalm occur lines which describe this very scene:

> The sorrows of death compassed me, and the floods of ungodly men made me afraid.
> The sorrows of hell compassed me about; the snares of death prevented me. . . .
> Then the earth shook and trembled; the very foundations also of the hills moved and were shaken, because he was wroth.
>
> (Psalm 18:4, 5, 22, KJV)

It is clear from the variety of incidents and images that Chagall is not representing a particular event as it occurred at a particular time and place in history. And thus, appropriately, the representation of space for Chagall is not as it was for Eakins, that is, a mirroring of a specific segment of reality. For Chagall, space is kaleidoscope-like, its many pieces fit together into illogical and contradictory relationships; the mob at the upper left rushes forward to the right, making the tumbling houses seem to fall into an undefined abyss, but nearby figures are huddled on what appears to be flat ground. Beneath the falling houses is a river bearing a boat forward to the right.

All the logical spatial relationships are violated. For the figures which flee from the foreground into the undefined area outside the picture itself are large in size when compared to the mob, but small when compared with the figure of the Crucified. The size of the figures is determined by their expressive function instead of any natural visual relationship. The space relationships of these figures is also dictated more by the artist's wish to communicate a sense of terror and despair than by his intention to describe a particular scene.

As spectators of Chagall's painting, we are not witnessing an episode as much as we are experiencing a time-and-place-transcending vision. It is at once a dream and a nightmare. Chagall shows us a crucified Christ who serenely extends embracing arms on the cross; he is surrounded by unknowing humanity—by an angry, armed mob; by the eternal exiles who are forever fleeing across the waters from Egypt to Israel, from Spain to Holland, from England to the Continent, from America to Israel; the peasants, the prophets, the Wandering Jew, the mother and child, all of suffering humanity. (Illustration 21)

We have seen that Chagall's paintings draw together

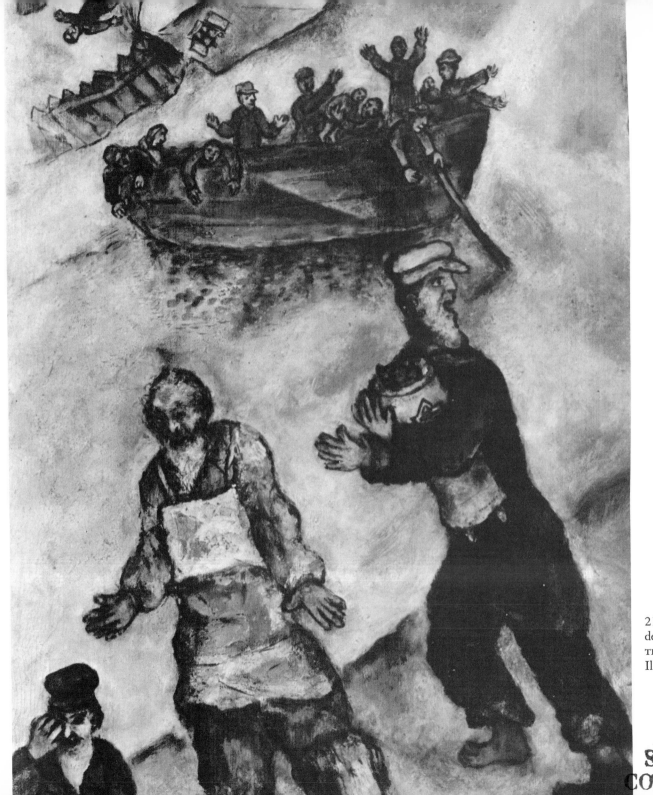

21. Chagall, Jews Fleeing:
detail from
THE WHITE CRUCIFIXION,
Illus. 15.

images and symbols and fragments of scenes from his own remembered life. He has juxtaposed these freely, not restricting his composition to a convincing mirroring of a specific segment of the visible world. The images are derived from various, and sometimes conflicting, sources. Time and space are represented as fluid and discontinuous, more akin to our dream-world experiences than to our day-to-day encounters.

We have noted possible interpretations for the imagery, but have affirmed that these suggestions are my no means exhaustive or definitive. Other interpretations are possible. Indeed, the artist has affirmed a kind of open-endedness in regard to the meanings; he spoke of something that "wells up spontaneously in the interplay of psychic and plastic contrasts, bringing to the picture and to the spectator realizations of unknown objects." [13]

All these characteristics are those of expressionist art and some are present in surrealist art. Chagall, though never a member of the group of artists who came to be known as Surrealists, was looked upon by them as something of a precursor. Surrealism was defined as "pure psychic automatism" which, its proponents believed, would express "the real process of thought." The Surrealists declared that the exercise of reason, aesthetic considerations, and moral preoccupations all caused distortions in the "real process of thought." The surrealist artists, like the writers James Joyce and Virginia Woolf, used the "stream of consciousness" as a source for their images and an influence on their style. They found the significant sources of art and life to be in our so-called irrational experiences—in dreams and nightmares, in momentary imaginative daydream excursions, and in more sustained but less frequent visions that carry us beyond the data of the senses.

[13] "Eleven Europeans in America," *Museum of Modern Art Bulletin,* XIII (1946), 34.

The connection between Surrealism as a style of artistic expression and the findings of Freud and other psychoanalysts about the structure of consciousness and the realm of the unconscious is surely apparent. Chagall refuses "to examine his own subconscious." [14] But as a child of his own time, he expresses himself through a style which is appropriate for his imagery. He spoke as a Surrealist when he once said, "All our interior world is reality—and that perhaps more so than our apparent world." [15]

Surrealist art has been discussed by the late Paul Tillich. Like some art historians of our day, he saw it as a recurrent style in the history of the Western art; a style in which

elements of the psychological as well as the natural reality are brought into the picture without a naturalistic connection. . . . Mankind does not feel at home in this world any more. The categories [of space, causality, substance] have lost their embracing and overwhelming and asserting power. There is no safety in the world.

We have Psalms in this spirit in the Old Testament, especially in the Book of Job, where it is said of man, "and his place does not know him anymore," and this is repeated in the 90th Psalm. Those are very profound words. The things in these pictures are displaced. Displaced persons are a symbol of our time, and displaced souls can be found in all countries. This large scale displacement of our existence is expressed in these pictures.[16]

[14] Jean Cassou, *Chagall* (New York: Frederick A. Praeger, 1965), p. 26.
[15] *Artists on Art,* p. 433.
[16] Tillich, "Existentialist Aspects of Modern Art," in *Christianity and the Existentialists,* p. 140.

Displaced persons, displaced souls, are the subject matter of the WHITE CRUCIFIXION, but hovering over the chaos of their lives and spirits is the figure on the cross and, in the foreground, the emblem of Jewish faith. We are reminded of the Suffering Servant:

> By oppression and judgment he was taken away;
> and as for his generation, who considered
> that he was cut off out of the land of the living,
> stricken for the transgression of my people?
> And they made his grave with the wicked, . . .
> although he had done no violence,
> and there was no deceit in his mouth.
> Yet it was the will of the Lord to bruise him;
> he has put him to grief; . . .
> he poured out his soul to death,
> and was numbered with the transgressors;
> yet he bore the sin of many,
> and made intercession for the transgressors.
> (Isaiah 53:8-12.)

the door of death

by Giacomo Manzù

There could hardly be a more awesome commission by a church to an artist of our day that that given by the Vatican to Giacomo Manzù when he was selected to design a pair of doors for St. Peter's in Rome. The present basilica was begun in 1506 under Pope Julius II and replaced the old St. Peter's built by the Emperor Constantine in A.D. 326 over the supposed tomb of the apostle Peter. The first plans for the present structure were drawn by the famous Renaissance architect, Bramante, and upon his death were redesigned by Michelangelo, who created the magnificent central dome, apse, and transept. The splendor of Michelangelo's conception is today diminished by the extended nave (built in the late sixteenth and early seventeenth centuries), which eclipses the view of the full and elastic curves of the great central dome. It is at the entrance to this extended nave that the large portals of St. Peter's are located. The central pair of doors was designed by a fifteenth-century Florentine sculptor, but the other doors were simple structures until our own century. A competition for the two doors was announced in 1947. Manzù submitted a plaster model and was one of twelve sculptors who were asked to make complete designs and studies of details. The jury who considered the work of the twelve sculptors selected Manzù's designs, and in 1952 Manzù was awarded the commission for the door at the extreme left.

The sixteen-hundred-year history of St. Peter's symbolizes a magnificent heritage, indeed, the treasures and traditions of Western Christianity. Thus the artist who is called upon to work in the ambience of this age-long theological tradition and history has a formidable task indeed. St. Peter's not only symbolizes theological traditions and structures, but it also contains notable art works of the past. The weight of this artistic tradition must have been a burden as well as a challenge to the artist. St. Peter's houses such early Christian reliefs as the sarcophagus of Junius Bassus (created in the fourth century for a prefect of Rome who died in A.D. 359) and masterpieces such as

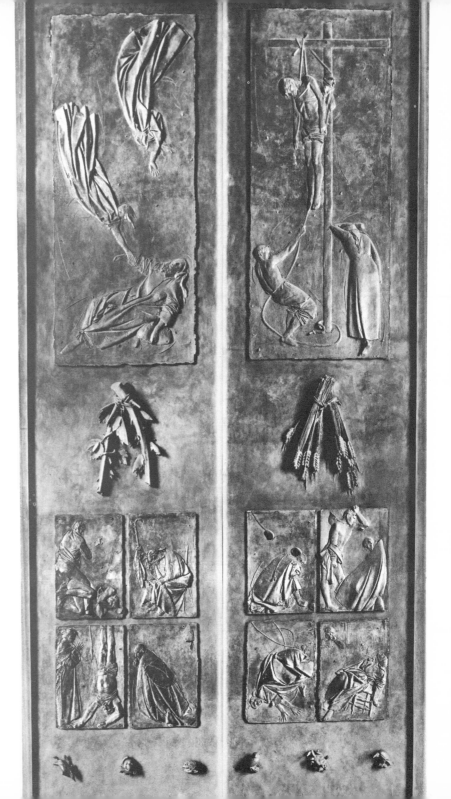

22. Giacomo Manzù,
THE DOOR OF DEATH, 1960-64.
Bronze, 25' x 12'.
Rome, St. Peter's Basilica.

the tender early PIETA by Michelangelo, completed in 1498 when the artist was only twenty-four, and sumptuous and grandiloquent baroque sculptures by Bernini.

At the time of the competition for the new doors, the theme was to be the glorification of the saints and martyrs of the church. Manzù's first design was on this subject. It had sixteen equal panels, crowded with many figures, surrounded by lengthy inscriptions. It was designed within an overall composition similar to the doors of the Florentine sculptor Filarete, who in the fifteenth century had created the central doors for St. Peter's. In Manzù's early studies the oppressive hand of the past is evident in both the iconography and the design.

Fortunately there was no deadline for Manzù's final design. In the years following the awarding of the commission in 1952, the artist apparently experienced indecision and uncertainty, inasmuch as many drawings were made, and the iconographic conception of the whole became fluid. During this same period Manzù received a commission for the doors of Salzburg Cathedral (1955-58). For that commission he used the ancient iconography more freely, and with a new accent. He also emancipated himself from the equal-paneled designs for bronze doors customary for Italian churches, the kind of designs used by his distinguished predecessors Donatello and Ghiberti. The Salzburg Cathe-

dral doors have two rectangular panels in relief above and two square panels near the base. Like the designs for St. Peter's, which the artist was working on at the time, these have high relief door handles composed of eucharistic symbols, grape vines and wheat sheaves.

Manzù's diffidence and indecision about the design for St. Peter's doors was overcome in 1961, when Pope John XXIII personally asked the artist to finish the doors and allowed him to change the theme. Manzù's son told Alexander Eliot, "My father would have gone through fire for that man." [1] Manzù memorialized John XXIII in two scenes on the door, one the beautiful relief of the Pope kneeling in prayer (Illustration 24) and the other, on the reverse side of the doors, a relief frieze stretching across both leaves of the door, showing the representatives at the Ecumenical Council being received by Pope John. (Pope John, who was Angelo Roncalli of Bergamo originally, met Manzù who was also from Bergamo, in 1956. In Rome, a century-old tradition dictated that a portrait bust be done of each pope on his entering the papacy. Pope John requested that Manzù create this portrait. Thus the artist had known and depicted the features of John XXIII before doing the doors.)

In the person of Pope John XXIII the artist found a sympathetic friend who understood his viewpoint, so he was freed to pursue a totally different iconographic program. Manzù, who had seen the atrocities and cruelties of the war years, felt that the real victims and even martyrs of our day were to be found in those common men and women who suffered and died anonymously. He wished to memorialize their agonies rather than those of the historic and legendary figures of the martyrs that populate the Acta

[1] Eliot, in *Art in America,* 53 (1965), 130-32.

Sanctorum and the lives of the saints. Pope John discerned a spirit of *aggiornamento* in Manzù's intention and encouraged him to proceed with the revised iconographic program.

Manzù's meetings with John XXIII were not his first contacts with the church hierarchy. In the period of the Fascist control of Italy and during Mussolini's drive for power, Manzù aroused the indignation of both the Fascist regime and that of the Vatican by exhibiting a series of reliefs of the Crucifixion in 1941. These sculptured reliefs showed corpulent cardinals and callous or cynical priests indifferently present at the Crucifixion. They were similar to the CRUCIFIXION WITH SOLDIER AND SORROWFUL FIGURES (Illustration 23), in which we see the tenderly wrought and youthful figure of the Crucified at the mercy of a fat, nude officer wearing the German steel helmet of the First World War.

Manzù was a professor at the Brera in Milan when Hitler broke through the Maginot line and drove into France; Mussolini joined in attacking the helpless country. As John Rewald notes, in his monograph on Manzù, in the past artists, like Dürer in his Apocalypse woodcuts, depicted the leaders of the church among the damned on Judgment Day. Manzù similarly depicted bloated generals and corrupt cardinals among those who afflict and destroy the youthful figure on the cross. Since Manzù was living in a Fascist country at the time of the exhibition of these works, it was to be expected that there would be a storm of protest. Rewald recounts that the "Fascist newspaper *Stampa* branded the artist as an enemy of the regime and an 'International Jew.' In addition to this, a friend of Manzù's, closely connected with the Vatican, told him that he was threatened with excommunication. This seems all the more strange as the Death of Christ is represented with

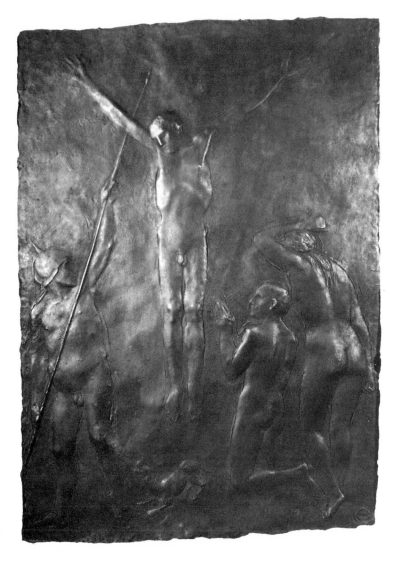

23. Giacomo Manzù,
CRUCIFIXION WITH SOLDIER AND
SORROWFUL FIGURES, 1942-57.
Bronze relief, 30½″ x 22″.
New York: Paul Rosenberg & Co.

such devout compassion that there can be no suggestion of rebellion against the Church. On the other hand, the political allusions leave no doubt that Christ appears as a victim of Fascism as well." [2]

In a feature article in *Life* magazine Manzù was recently referred to as a "professed Communist." [3] The issue carried color photographs of some of the portraits which Manzù did of John XXIII, and an article by Curtis B. Pepper entitled "An Artist and the Pope." But for a statement on Manzù's political convictions, a more reliable source is John Rewald, who has been his friend, critic, and patron for the past twelve years. Rewald writes of the 1941 exhibition, which included the series of Crucifixion panels, "Whereas the exhibition threatened to bring Manzù into conflict with the Church and the government, the Communist underground movement considered him one of their own. He protested against this, however, declaring that he was not so much pro-Communist as anti-Facist and anti-Nazi." [4]

[2] John Rewald, *Giacomo Manzù* (Greenwich, Conn.: New York Graphic Society, 1967), p. 43.
[3] *Life,* October 11, 1968, p. 52.
[4] *Giacomo Manzù,* p. 43.

24. Manzù, reliefs in the lower part of the left wing of THE DOOR OF DEATH: The Death of Abel, the Death of Joseph, Death by Violence, the Death of John XXIII. Detail from Illus. 22.

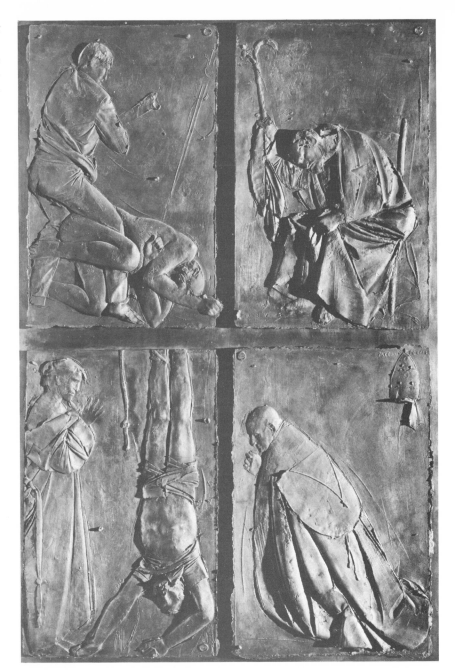

Once the subject matter was changed from the glorification of the saints and martyrs of the church to the contemplation of death, Manzù was able to move ahead with the composition. In the DOOR OF DEATH (Illustration 22), dedicated in 1964, we see that the death of Mary, the Mother of Jesus, and the Crucifixion of Jesus Christ occupy the large upper panels of the door. Below these large panels are eight smaller panels (Illustrations 24 and 25). From left to right, the subjects of the four top smaller panels are: the murder of Abel by his brother Cain; the death of the elderly Joseph; the stoning of Stephen, Christianity's first martyr; and the death of Pope Gregory VII.

The four lower panels are devoted to death in our time. One of these was made shortly after the death of Pope John. Manzù, who had agreed to make the death mask of the pontiff, was summoned when the Pope seemed on the point of death. But he knew the lively features of the Pope, for he had made many portraits of him between May, 1960, and his death in 1963. Soon after making the death mask and, as a personal tribute to the Pope,

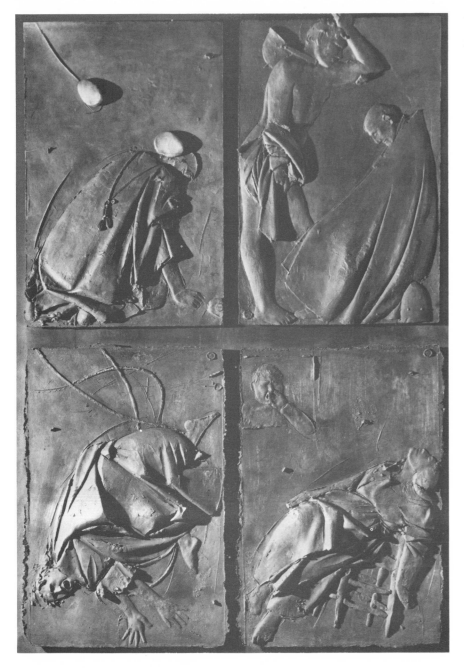

25. Manzù, reliefs in the lower
part of the right wing of THE DOOR OF DEATH:
The Death of Stephen, the Death of Gregory VII,
Death in the Air, Death on Earth.
Details from Illus. 22.

Manzù sculptured a panel in which the Pope is seen as alive, serenely kneeling in prayer, his tiara on a shelf at the upper right, and the words of his famous encyclical, *Pacem in Terris,* inscribed above. Manzù also cut the date of Pope John's death, 3.VI.63., into the panel of the elderly Joseph, which was to go above that of the Pope.

The three other lower panels, in addition to that of the kneeling Pope, show incidents symbolizing the many anonymous, tragic, and pathetic deaths that daily occur. In DEATH BY VIOLENCE a victim is hanging by his heels while a troubled woman witnesses his death. Perhaps this was inspired by an actual event in which the Fascists caught a Bergamo partisan and hung him upside down. For Italian citizens it has continued to be a reminder of Mussolini's fate. In DEATH IN THE AIR we see a figure helplessly catapulting through space, with the slack lines of a useless parachute dangling above. In DEATH ON THE EARTH a woman who will never be awakened by her own screaming child lifelessly tips backward on a falling chair. The theme of these panels, in the words of the

26. Giacomo Manzù, Wheat and Grapevine.
Bronze relief.
New York, Italian Building, Rockefeller Center.

27. opposite: Manzù, Christ:
detail from the Crucifixion panel, Illus. 32.

Order for the Burial of the Dead, is, "In the midst of life we are in death. . . . Man, that is born of a woman, hath but a short time to live, and is full of misery. He cometh up, and is cut down, like a flower; he fleeth as it were a shadow, and never continueth in one stay."

Since Manzù's doors are the only relief sculptures which are discussed in this book, a few words about the technique seem appropriate here. The panels which represent episodes and events are in low relief (bas-relief); whereas the bound wheat sheaves and vine branches are fully modeled and seem simply set against the background. (Another example of this technique is seen in Manzù's sculpture of wheat and grapevine on the Italian Building in New York City; Illustration 26.) The six birds and animals below the panels are also fully three dimensional, and also appear set against the bronze background, though they, like the eucharistic symbols, are cast as an integral part of the background panels.

Manzù made his studies, as well as his final designs, in clay, and the texture of the clay, including the way in which the sculptor manipulated this yielding substance, is plainly visible in the finished cast bronze doors. In the CRUCIFIXION panel the halo about the head of Christ and groovings on the rope show the clean, sharp curves of the shallow incised lines with raised edges, so characteristic of lines cut into soft clay (Illustration 27). The broad, shallow creases in the brief pants about the loins of the Christ are also typical of the conformations of clay in low relief.

Like the great Renaissance sculptors whose work he had seen, Manzù varies the depth of his relief—flattening certain forms against the background and, in other areas, giving greater roundness and fullness to the forms. Much of the torso of the Christ is in very low relief, but in the same panel the left leg of the grieving Eve has a swinging

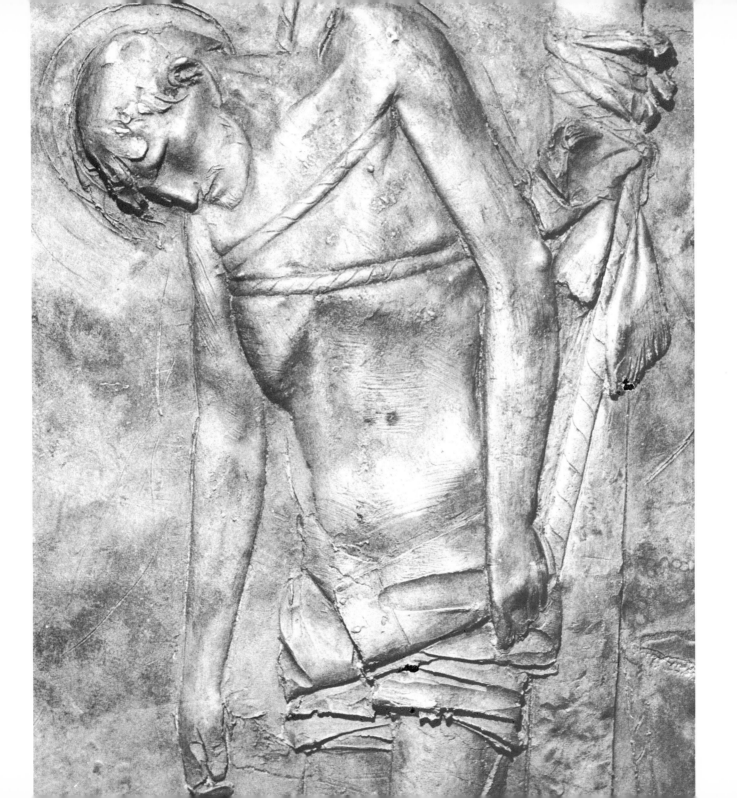

roundness of form and her visible naked foot is fully three dimensional (Illustration 32). The Renaissance sculptors used such variations between low and high relief in order to create an illusion of depth. Manzù instead uses such variations for expressive purposes. The exposed, tilted instep of Eve is a detail of such gratuitous beauty that it makes us catch our breath in delight, and renders more poignant her posture of grief and her buried head.

Manzù's superb craftsmanship has been admired by critics and collectors. Unlike most sculptors of our day, he uses the *cire perdue* (lost wax method), in which all casting is done directly on the modeled clay. No copies can be made, and therefore each piece is unique. Also each piece is so clear and accurate that the finest variations of texture are evident. Indeed, the artist's exact fingerprints remain forever on the doors, for on the inside of the door in the lower left corner the sculptor placed his own handprint upon which is set his sculptor's stamp as a kind of signature (Illustration 28). The exact convolutions of the fingerprints and the lines of the palm are clearly visible in an uncanny way. It is a broad-palmed hand with spatulate fingers which, because they are slender, appear longer than in fact they are.

The black-and-white photographs of the door cannot convey the subtleties of tone in the original bronze doors. We are reminded of Rodin's comment on his designs for his own bronze doors. (Rodin's portal THE GATES OF HELL was commissioned in 1880 for a secular building in Paris, and he chose Dante's epic as his subject matter; he worked on the designs over a long period of time, but the major conception dates from 1880-87.) He spoke of them as a "mélange of figures, some in bas-relief, others in the round, in order to obtain those beautiful blond shadows."

Manzù's way of working with parallel themes and similar figures and postures is demonstrated when we look from

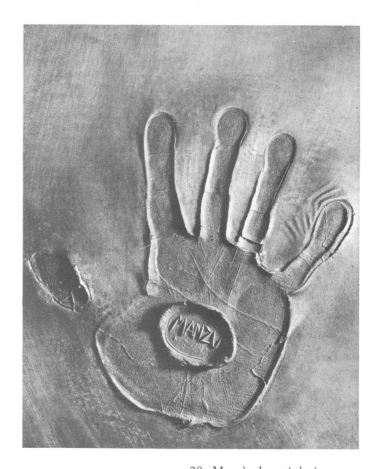

28. Manzù, the artist's signature, from the back of THE DOOR OF DEATH.

the Cain and Abel panel (Illustration 33) of 1964 to a drawing of 1965 entitled WAR (Illustration 29). We recognize the aggressor with the helmet and the fallen figure as a re-working of the Cain and Abel group, whereas the woman with her hands up to her mouth is the same figure who witnessed DEATH BY VIOLENCE in the earlier 1962 version of this theme (Illustration 30). In the WAR drawing, we see once again the shadowy presence of the man hung by his ankles and a figure sprawled face down upon the ground. Furthermore, the woman at the right in the drawing, WAR and at the left in DEATH BY VIOLENCE is a reincarnation of an earlier female mourner who witnessed the entombment of Christ (Illustration 31) in one of THE STATIONS OF THE CROSS made by Manzù for S. Eugenio, Rome, in 1951.

In the CRUCIFIXION panel (Illustration 32), to which we shall now give major attention, the cross has a very high, slender vertical post from which the Christ figure hangs lifelessly. The face of the Christ is not the traditional Christ type with long, dark hair and beard and large eyes and eye sockets that comes to us originally from the eastern Mediterranean area. Chagall's Christ of the WHITE CRUCI-FIXION (Illustration 15) and Velasquez' Christ (Illustration 2) are more representative of the traditional type. Manzù's Christ (Illustration 27) has a straight nose which continues the forehead contour in an unbroken line. His short hair clings closely about his head and falls across the forehead. A slight moustache and beard are suggested by a few incised lines at the corner of his mouth and about the chin.

Ropes encircle the rib cage of Manzù's Christ and his head sags abruptly forward. His arms and legs hang nervelessly pendant. His fingers are curled gently in about the palm, and his feet dangle in midair between the rope and cross. The rope is held by a male figure at our left who appears to be slowly releasing the length of rope which passes about the upright cross and over the arm of the cross and then about the lifeless body which is being lowered. The man is stripped to the waist, and his belted trousers are pulled up about his knees. We see his face in profile, but his sturdy torso in three-quarter view. The end of the rope goes behind his body and between his bare feet and terminates in a serpentine coil about the foot of the cross.

At our right a feminine figure with her back to us appears to have just stepped nearer the cross, for we see her left foot caught and held in what must be a momentary position in a larger movement of the whole body. She leans one elbow against the cross and buries her head against the raised arm.

*But here Grief turns her silence neither in this direction
 nor in that, nor for any reason.
And her coldness now is on the earth forever.*[5]

Her back is to us and her simple, long gown outlines and defines her spontaneous movement and her shapely body. We see the same figure in an earlier version of the Crucifixion done by the artist between 1947 and 1957 (Illustration 23). The posture of this nude female figure is the same, but the line which describes the contours of breast, rib cage, and pelvis, as well as the modeling of the lovely, rounded buttocks, arrests our attention, giving greater complexity to the figure and diminishing somewhat the diagonal thrust of the woman's body and its expression of intense grief. In both this early version and the final one used in the DOOR OF DEATH, the woman's sorrowful attitude and her long tresses suggest that she might be the Magdalene who has so often been represented in works of art depicting

[5] W. H. Auden, "For the Time Being," *The Collected Poetry of W. H. Auden* (New York: Random House, 1945), p. 408.

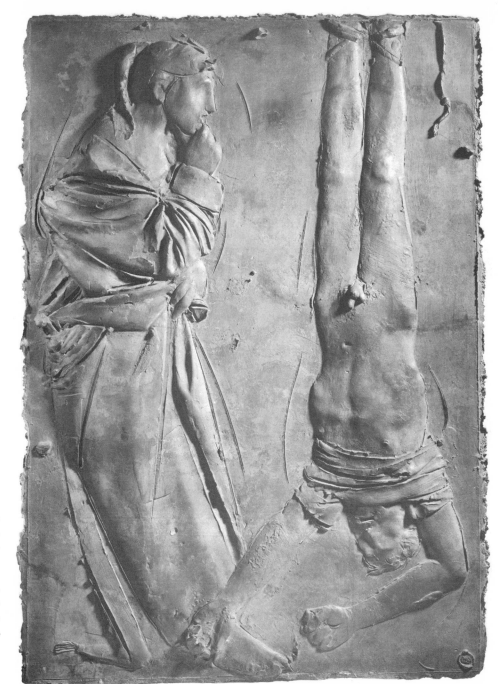

29. opposite: Giacomo Manzù, WAR, 1965.
Pastel and tempera on paper, 27″ x 30″.
Rome, collection of the artist.

30. Giacomo Manzù,
DEATH BY VIOLENCE, 1962.
Bronze relief, 39″ x 28″.
New York, Paul Rosenberg & Co.

the Crucifixion. But the artist identifies this figure as Eve instead—Eve, the mother of all living.

The book of Genesis records the story of the creation of man, and that when the Lord God had created woman and brought her to the first man, the man said,

> *This at last is bone of my bones*
> *and flesh of my flesh;*
> *she shall be called Woman,*
> *because she was taken out of Man*
> (*Genesis* 2:23.)

Here in Manzù's CRUCIFIXION, Eve the mother of all living, in a leap across the abyss of time, becomes the mourner over the death of Jesus Christ. She mourns "the bone of my bones, and flesh of my flesh," and as a prefiguration of Mary the Mother of Jesus Christ, she already mourns the end of the fruit of her own womb in that latter day. We are familiar with the parallelism between Christ and Adam from the passage in I Corinthians 15 which is read in the Order for the Burial of the Dead: "For since by man came death, by man came also the resurrection of the dead. For as in Adam all die, even so in Christ shall all be made alive." But the parallelism between Eve the first mother and Mary the Mother of Jesus of Nazareth is not as well known, though it too has a long tradition in art and in commentaries on biblical books. Like the Adam-Christ parallel, the first mother and the mother of Jesus Christ parallel sets forth the theological concept that all sin originated with one sinful act, and all atonement and redemption were made possible through one sacrificial death.

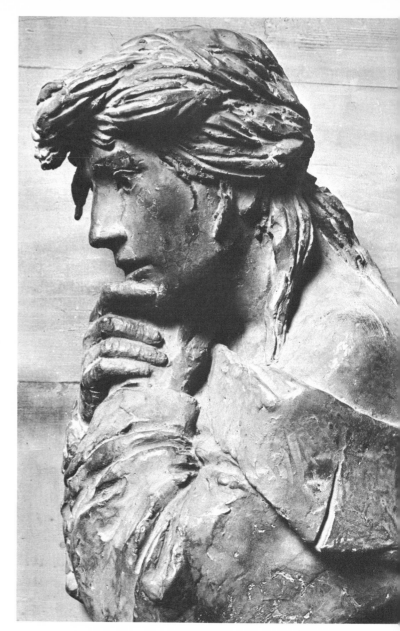

31. Giacomo Manzù, Mourning Woman:
detail from ENTOMBMENT OF CHRIST, 1951.
Bronze sculpture, 59″ x 50″.
Rome, Church of S. Eugenio.

Eve's presence in the Crucifixion scene has another iconographic significance too. We noted that one of the smaller scenes on the lower left door has as its subject the slaying of the righteous Abel by his brother Cain. Eve, the mother of Cain and Abel, mourns the death of the innocent Abel. The man who lowers the figure from the crossbeam dispassionately pursues his task, and we are reminded of Cain's reply to the Lord's query as to Abel's whereabouts after the murder, "I do not know; am I my brother's keeper?" Traditionally Abel is a type of Christ, one who had been righteous in the sight of God, one who was the first priest, and by his death the first martyr. Cain was taken to symbolize Christ's murderers and persecutors. Thus the Crucifixion can be understood here as a representation of the New Testament events prefigured through the Cain and Abel episode of the Old Testament.

We note that in depicting the scene the artist has given no indication of setting or background. The ground level is only implied by the placement of the base of the cross, by the curving lines of the rope which coils about it, and by the position of the feet of the two attendant figures.

It is noteworthy too that many of the usual iconographic details are not depicted. A halo is lightly incised about the bowed head of Christ, but his lifeless figure is without stigmata, that is, the nail holes on the hands and feet and the spear wound in the side. The crown of thorns and the identifying title are also not depicted. The dress of the two attendant figures is generalized and simplified, and all the contours and details which would betray a datable, transient fashion having been eliminated.

The design of the CRUCIFIXION panel has a simple, easily discernible structure. The slender, high cross is somewhat off center, and the segment of the crossbeam from which the corpus hangs is shorter than the other half of the beam. The body hangs from this shorter arm of the cross, and it forms the upper part of a teardrop shape which encloses the two figures below. The contours of this compositional shape are described by the descending line of the rope, the arm and right leg of Christ; then the arms and shoulders of the man who holds the rope, along the rope and about the woman's body, and up to the torso of the Christ figure, terminating in the rope again. Thus we have an off-center, slender, asymmetrical cross which has set against it a group of figures which form a teardrop-shaped area. This compositional shape with its slender upper apex and its full, bulblike lower contours has been used by earlier masters in works of art when grief or tragedy was being expressed. This abstract shape, in itself resembling the contours of a tear, seems abstractly to be expressive of sorrow.

This panel of the CRUCIFIXION, as all the others on the door, has a much greater degree of naturalism and realism than any of the other twentieth-century works of art discussed in this volume. When studying the figures we know that Manzù, like the nineteenth-century painter Eakins, must have used a model for the figures. He must have made many studies of actual postures and attitudes before finally achieving the breathtaking simplicity of the final conception. But Manzù's truthfulness to nature is more selective than Eakin's. Manzù delineates the arms of the Christ with simplified continuous contours, yet the rope about the rib cage is shown as pressing into the flesh, causing it to bulge realistically against the confining pressure of the ropes. The folds of the brief pants about the loins of the Christ figure are summarily given, but three buttons and buttonholes are clearly indicated. The cross is simple in shape and without texture, but the rope which coils about its base terminates in an ugly convoluted knot which is described in detail. Thus Manzù allows our eyes to pass over certain areas and forms, and then suddenly and forc-

ibly commands our attention. As in the selective realism of some twentieth-century poetry, this device tends to draw us up short, evoking a sense of surprise or even shock. He engages our attention and focuses it on a detail, but carries us further to seek for the *meaning* of the detail. The rope which is so explicitly described encircles the body of Christ, is drawn across the void, and then encircles the body of the man who lowers the Crucified, and finally terminates in a coil about the foot of the cross. A rope is part of the composition in most of the panels of the DOOR OF DEATH: it functions to bind the prisoner, to lower the body of the victim, or when broken or entangled, to plunge the mortal woman to her death in DEATH IN THE AIR. Thus the re-iterated representation of the rope which, in formal terms, functions as a moving line across a void and is opposed to the larger volumes of the figures, in symbolic terms bespeaks the fettered and bound condition of mankind in this world.

From the point where the ropeman holds it, the rope becomes serpentine in movement. Both its serpentine contours and the ugly character of the convoluted knot bring to mind the words of the Lord God when he rebuked the serpent in the Garden of Eden, saying,

> *Because you have done this,*
> *cursed are you above all cattle,*
> *and above all wild animals;*
> *upon your belly you shall go,*
> *and dust you shall eat*
> *all the days of your life.*
> *I will put enmity between you and the woman,*
> *and between your seed and her seed;*
> *he shall bruise your head,*
> *and you shall bruise his heel.*
>
> (*Genesis* 3:14-15.)

The serpent of the Garden of Eden was later identified with "the dragon, that ancient serpent, who is the Devil and Satan," and thus an image of evil. In the Bible the word "serpent" is used both for ordinary snakes and for mythic "dragons." Cope says that the "Genesis narrative does not itself identify the Serpent with Satan—the identification is apparently first made by inference in the first century B.C. in the Alexandrian Greek Wisdom: 'By the envy of the Devil death entered into the world.' . . . The first actual death recorded in Genesis is the murder of Abel by Cain, and it is this that seems to be referred to in John: 'He (the Devil) was a murderer from the beginning (8:44): St. Paul's words, 'The God of peace shall bruise Satan under your feet shortly' (Rom. 16:20) seems to echo the obscure verse in Genesis which refers to the relationship between human beings and snakes (3:15) quoted above." [6] In Manzù's CRUCIFIXION, the serpent-like rope connects the Crucified and the implicated ropeman, the innocent Abel and the murderer Cain.

Certain features of this Crucifixion become increasingly puzzling as one continues to contemplate it. There is a contradiction between the lack of any suggestion of time or space, on the one hand, and the sense of immediacy of action and emotion of the three figures, on the other hand (an utter lack of action and emotion, of course, in the case of the Christ, but the animation seems to have *just* ceased). The intense experience of physical effort (the ropeman) or grief (the Eve), as well as the cessation of life in the Christ figure, appear to take place in a void. Further, we discern a subtle yet insistent sense of guilt, of being implicated in the death of the Crucified on the part of Eve and the ropeman. They remind us of the lines from one of Eliot's plays:

[6] Gilbert Cope *Symbolism in the Bible and the Church* (New York: Philosophical Library, 1959), p. 182.

32. Manzù, The Crucifixion of Christ, 1964.
Relief in the upper right wing of
THE DOOR OF DEATH, Illus. 22.

*The circle of our understanding
Is a very restricted area. . . .
What is happening outside of the circle?
And what is the meaning of happening? . . .
And what is being done to us?
And what are we, and what are we doing?
To each and all of these questions
There is no conceivable answer.
We have suffered far more than a personal loss—
We have lost our way in the dark.*[7]

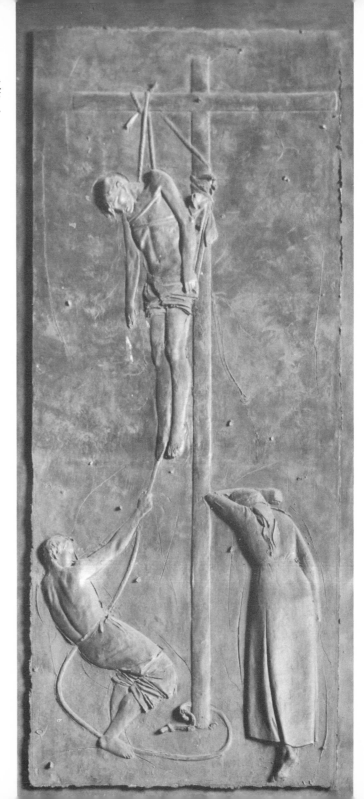

[7] T. S. Eliot, *The Complete Poems and Plays* (New York:
Harcourt, Brace & World, 1962), *The Family Reunion*, p. 291.

This contradictory combination of intense emotion experienced by persons who seem to exist in a void or a vacuum is characteristic of the smaller panels as well. THE KILLING OF ABEL (Illustration 33) is another example. Manzù represents Cain standing over the figure of Abel, one of his legs caught between the legs of his slain brother. Abel has just fallen forward to the ground, and his crumpled figure assumes a womblike position. Above him stands Cain with tense buttocks, in a position of primeval aggression and power. We are reminded of the Lord's words to Cain: "Sin is couching at the door; its desire is for you, but you must master it." Cain did not master sin. Instead sin mastered Cain, and now he stands over the body of Abel, enmeshed and entangled in sin just as he is with Abel's slain body which, scissors-like, encloses one of his legs and presses against the other.

Cain's face is seen in profile, whereas Abel's is hidden from view. One of Abel's hands, contracted into a fist, projects outside the defined limits of the panel itself. But this contraction of the fingers does not have any aggressive connotations; rather, it seems like the relaxation that comes with sleep or loss of consciousness. We see a similar relaxed incurving of the fingers in the case of the Christ figure of the CRUCIFIXION panel.

The two figures almost completely fill the triangle of the left lower half of the composition. If an imaginary line is drawn from the upper left-hand corner to the lower right-hand corner of the panel, only the head and shoulder of Cain and a portion of Abel cut into the surrounding void which is the locus of the crime.

Outside the civil garden
Of every day of love there
Crouches a wild passion
 To destroy and be destroyed.
 . . . Like
Wheat our souls are sifted
And cast into the void.[8]

[8] *The Collected Poetry of W. H. Auden*, p. 408.

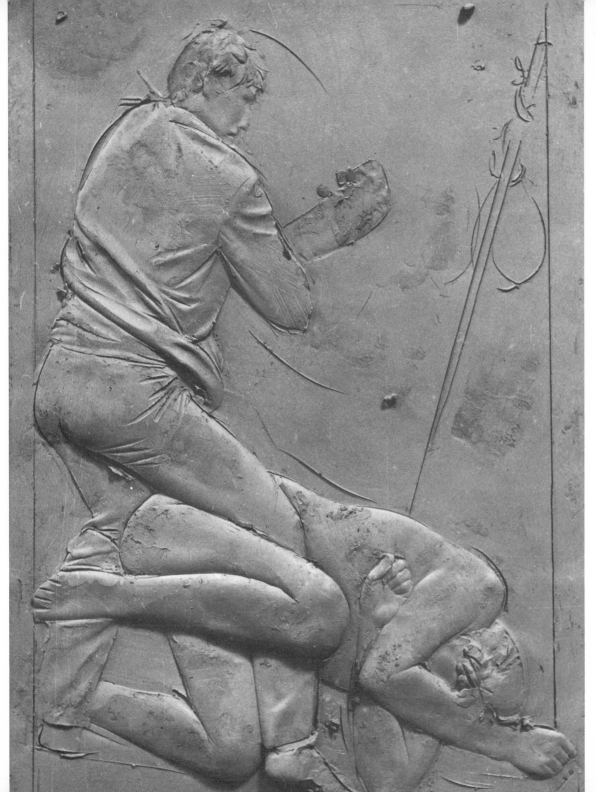

33. Manzù, Cain and Abel: panel from the lower left wing of THE DOOR OF DEATH, Illus. 22.

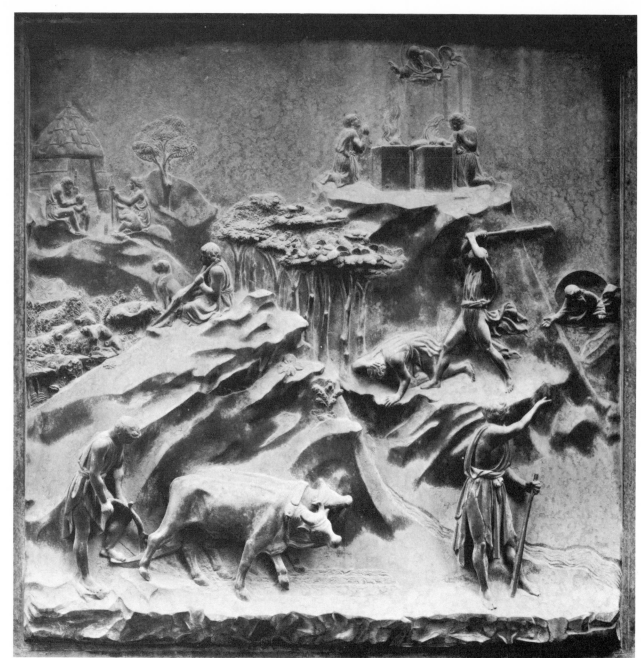

34. Lorenzo Ghiberti,
The Story of Cain and Abel:
detail from
THE GATES OF PARADISE, 1425-52.
Bronze, 31″ x 31″.
Florence, the Baptistry.
Courtesy of
Alinari-Art Reference Bureau.

These words are spoken by one of the choruses in W. H. Auden's Christmas Oratorio, "For the Time Being." In antiphonal form the choruses set the mood and describe the situation of waiting with which the Christmas Oratorio begins. The reference to the void has parallels, both in its style and content, to Manzù's sculptured panels. Violent emotions and wild passions imaged against a void, or vacuum, are characteristic of some twentieth-century poetry as well as certain of the visual arts.

This particular feature of Manzù's reliefs is underlined if we contrast his Cain and Abel with the same subject matter as represented by his predecessor, the Italian Renaissance sculptor Ghiberti, who created the famed "Gates of Paradise," the bronze doors for the Baptistry of Florence (1425-52). Ghiberti's doors have ten equal-size panels representing episodes from the Old Testament. The Cain and Abel panel (Illustration 34) represents not only the slaying of Abel but the whole story as set forth in Genesis. Also it contains the gratuitous additions which most of the biblical episodes acquired both as they were represented again and again in the visual arts, and as they were told and retold in legends and commentaries through the centuries.

In the background in the Ghiberti panel we see Adam and Eve seated outside a thatched hut, the elderly first parent leaning on the instrument which he used to "till the ground from which he was taken." The child Cain leans upon his knee, and across from them Eve with her distaff has the infant Abel at her side. This cozy, domestic tableau has a charming pastoral scene in its foreground. Here the adolescent and pensive Abel is seated on a rocky terrain with his dog, erect and vigilant, at his feet, as both of them watch over the flock. We note with delight the sculptor's skillful delineation of the low shrubs, ferns, and a star-shaped ground plant, and the sheep with their volute-like horns. Several sheep are recumbent and sleeping, and another busily scratches himself. Moving to the foreground we see Cain guiding the plow along neatly parallel furrows behind two oxen. On a plateau in the background Cain and Abel each kneel before an altar whereon their offerings to the Lord are aflame, and the Lord is seen speaking out of the heavens to them: "In the course of time Cain brought to the Lord an offering of the fruit of the ground, and Abel brought of the firstlings of his flock and of their fat portions. And the Lord had regard for Abel and his offering, but for Cain and his offering he had no regard." (Genesis 4:3-5.) The scene of the offering of the sacrifices by Cain and Abel has in front of it the slaying of Abel and, in the foreground at the right, Cain's reply to the Lord's indictment. Cain has a staff in hand and stands beside a rushing stream, as he is about to depart as "a fugitive and a wanderer on the earth" for "the land of Nod, east of Eden."

All these events, occurring at different times, are yet seen in one continuous landscape. And it is a landscape of captivating charm—its rocky eminences and glades, its trees and shrubs and low plants, poetically depicted. The elderly Adam has all the dignity and gravity of a classical sage, and Eve, with her graceful garment which bares a shapely shoulder to our gaze, is reminiscent of the figures on Greek reliefs. Cain and Abel too are comely in proportions and graceful in all their attitudes and actions. Looking now at the detail of the killing of Abel (Illustration 35) we note the grace and ease, even in this violent act. Abel has fallen forward on one knee, and with one hand he protects the back of his head. Yet his position is a balanced one. Ghiberti has depicted with care such details as the locks of hair, caplike about the small head, and the classically proportioned foot with its articulated ankle and patrician toes. The gesture of Cain with his upraised

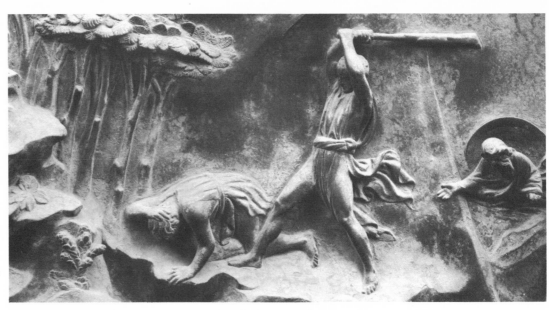

35. Ghiberti, Cain Slays Abel: detail from Illus. 34.

club is one of great beauty, which, like the movements of a skilled ballet dancer, is able to suggest all the prior motions as well as the "follow through." Ghiberti has delineated the anatomy of the figure in a way which shows a delight in the structure of bone and muscle. Like the great classical artists of the past and Renaissance artists of his own period, he has given special emphasis to all the joints, the locus of the possibility of movement. Thus the ankle, the knee, and the juncture of the thighs with the torso are all bared to our eyes, and the graceful garment flows about the body, emphasizing and underlining, but not concealing, the body beneath. The two billowing ends of Cain's brief garment serve as a foil for the dominant movement which sweeps from his upraised arms in an arc along his torso and down his left leg. The undulant contours of this garment are also set in contrast against the rigidity of his club, which is seen at a point in midair.

Whereas Manzù shows the crime committed, Ghiberti presents it in the moment before it is accomplished.

In the Manzù panel (Illustration 33) it is evident that even though the sculptor has generalized the apparel of the two figures and given no indication of setting, the figures and the action are distinctly of the twentieth century. All storytelling elements, gratuitous details of setting —indeed all the classical reminiscences in types and postures—have been eschewed by the twentieth-century sculptor. Whereas Ghiberti's human beings are noble and act out the biblical drama with ballet-like grace, Manzù presents naked passion and bestial violence. The killer and the victim seem inextricably bound together in this terrible murder which occurs nowhere and everywhere. Brutality and mindless violence are the subject of Manzù's panel. They take place in a void—nowhere and everywhere, at no special time, but at all times.

the man with a lamb and the corrida crucifixion by Pablo Picasso

In his long and productive lifetime, the prodigious artist Pablo Picasso has had two known overtures from religious bodies who were interested in commissioning him to create works of art for specific places of worship. Immediately after World War II, he was visited in his Paris studio by Canon Devémy of the Church of Notre-Dame-de-Toute-Grâce at Assy, France. Canon Devémy had been familiar with Picasso's early paintings from the Blue and Rose periods, with their lonely laborers and laundresses, their dreaming adolescents and poetic circus performers—figures portrayed with a sense of sympathetic identification which, at its best, was nostalgic, but which, in some works, became sentimental. On this visit the Canon found Picasso surrounded by his creations of the terrible war years when his painting showed the human figure with distortions of the most violent kind—the face and body torn asunder and rejoined together with radical dislocations and disjunctions.

Canon Devémy had come to the studio to propose that Picasso create a work of art for one of the side altars of the church at Assy, representing St. Dominic. Since St. Dominic was Spanish born, the Canon felt that the Spanish artist Picasso might respond to this particular subject. William Rubin, who talked with Canon Devémy when working on his book on the church at Assy, said of the encounter, "Picasso was surprised but most cordial, and showed Devémy some canvases of male figures he had just completed, suggesting, probably with a touch of facetiousness, that they might serve as representations of the saint. These pictures, executed in the extremely expressionistic style of Picasso's war-time work, shocked the Canon, just as they were to shock less naïve sensibilities in the Salon d'Automne immediately after the cessation of hostilities in 1945. Concluding that Picasso was unsuited for the task, Devémy thanked the artist for his time and took his leave." And so ended this episode.[1]

[1] William S. Rubin, *Modern Sacred Art and the Church at Assy* (New York: Columbia University Press, 1961), p. 34.

Picasso was also asked if he would design a group of stained glass windows for the Cathedral at Metz, France. Two French artists of Picasso's generation had already designed stained glass windows for places of worship. His friend Matisse had designed windows for a convent chapel in southern France, at Vence (Matisse was architect as well as designer for the entire structure and all its fittings), and the elderly French artist Georges Rouault, who had created works of art with religious subject matter all of his long life, had finally been commissioned by the church at Assy to design four stained glass windows for the façade wall of the church. Picasso accepted the proposal made by Robert Renard (chief architectural advisor for the Cathedral of Metz). But subsequently the Archbishop of Metz and the papal nunzio opposed it.

Picasso had been condemned by conservative Catholics in a much circulated document now referred to as "The Tract of Angers," which came out in 1951, at the time of the vivid reaction of some of the Catholic clergy and hierarchy to one of the works of art created for the church at Assy. A sculptured crucifix, designed by Germaine Richier, touched off the growing opposition by the conservative Catholic clergy to commissions then being given to distinguished artists. The document, signed "A Group of Catholics," indicted painters belonging to a school led by "Picasso—Communist Artist and Enemy of God."

Picasso had indeed become a member of the Communist party during the occupation of France by the Germans. Many French Communists were heroic workers in the Resistance, a fact that commanded the respect and gratitude of many Frenchmen. Some of the intellectuals, too, were Communists, among them, Picasso's friends, the poets Paul Eluard and Louis Aragon. It was through the influence of Laurent Cassanova, a Resistance figure who had made three escapes from German prison camps, that Picasso became a member of the Communist party during the war.[2]

The relationship of the artist Picasso to that enemy of the church, the Communist party, is an interesting one. The Communists did not favor his art but understood well the importance of his name. Picasso's friend, the poet Louis Aragon, who was an intellectual leader among the French Communists, came to the artist's studio to request a poster advertising the Communist World Peace Congress. Looking about Picasso's studio, he saw a handsome lithograph of a pigeon, which gave him the idea of using it as a dove, the symbol of peace, for the congress. Picasso consented to the suggestion and the poster, made from the litograph of the pigeon, was widely reproduced, so the dove of peace flew about the whole Western world advertising the World Peace Congress.

After the death of Stalin, Aragon pressed Picasso again, this time for a portrait of Stalin to be published in his weekly paper, *Les Lettres Françaises*. Haste was necessary, for the paper was to go to press. Picasso was irritated by the pressures, protesting that he had never seen Stalin and didn't recall what he looked like, "except that he wears a uniform with big buttons down the front, has a military cap, and a large mustache." But he grudgingly complied, using an old newspaper photo of Stalin for his interpretation.[3] Several days after the drawing was published, he was visited by journalists who asked if it were true that he

[2] A lively account of Picasso's relationship with the Communist party is to be found in Françoise Gilot, *Life with Picasso* (New York: McGraw-Hill, 1946). His political and artistic activities in Paris during the war are documented in the article by Alfred H. Barr, Jr., "Picasso: A Digest with Notes," *Museum of Modern Art Bulletin*, XII January, 1945).

[3] *Life with Picasso*, p. 260.

was making fun of Stalin in this portrait. The Communist party condemned Picasso, but as the news of the episode got about, the amusement in the worldwide press reaction embarrassed the Communists, and they apologized to Picasso.

Picasso's relationship with the other political ideology of the twentieth century has been of a totally different nature. He has been uncompromising and unflinching in his hostility to nazism. GUERNICA was painted in 1937 and commemorated the bombing, by the German Luftwaffe, of a town in his Spanish homeland. He lampooned Hitler's ally, Franco, in his DREAMS AND LIES OF FRANCO. He had been denounced by Hitler, but he remained in Paris during the four years of Nazi occupation, though many French artists had left for sanctuary elsewhere and some few had become collaborationists. Reports from Paris during and immediately after the period of the occupation indicate that his presence in the city was of great importance to the French Resistance movement. Recalling this time, Picasso told an American interviewer six days after the liberation, "Do you know Hitler himself once did me the honor of naming me in one of his speeches as the wicked corrupter of youth. So for four years I've been personally forbidden to show or to sell my works. . . . I have not painted the war," said Picasso quietly, "because I am not the kind of painter who goes out like a photographer for something to depict. But I have no doubt that the war is in these paintings I have done. Later on perhaps the historians will find them and show that my style has changed under the war's influence. Myself, I do not know." [4]

Picasso's style did indeed change during the war, and it was the paintings of this period that Canon Devémy saw when he had visited the artist's studio with the intention

of commissioning Picasso to create an image of the Iberian St. Dominic for the church at Assy. The very features which caused Hitler to condemn Picasso's art as degenerate and the Communists officials to condemn his portrait of Stalin caused the clergyman to withdraw. Canon Devémy visited Picasso before the program for the commissioning of fine contemporary French artists for the church at Assy had been fully developed and articulated.

Soon after the Canon's withdrawal from Picasso's studio, two other Dominican priests, Father Couturier and Father Régamey, vigorously began to pursue a program to get the greatest living artists to work for the church. They courageously sought out and commissioned Leger, Chagall, Lipchitz, Lurcat, Rouault, Matisse, Bonnard, and Braque to create works of art for the little Alpine church at Assy. A crucifix executed by the French sculptor Germaine Richier set off the debate between the conservative clergy (the Integrists) and the Modernist group in the French Dominican order. In the exchange of verbal hostilities which followed, an unnamed Dominican father was quoted by Jean Cassou as saying, "Modern art will have had three enemies, Hitler, Stalin, and the Pope." Another critic, Bernard Dorival, revised this triumvirate, saying that the conservative bishops were "in accord with the Kremlin, the White House, and the late Mr. Hitler." [5]

It was during the years of the German occupation that Picasso created the masterpiece of sculpture THE MAN WITH A LAMB (Illustration 40). Though the title does not suggest religious subject matter, the conception and content

[4] Barr, "Picasso: A Digest with Notes," p. 2.

[5] Modern Sacred Art and the Church at Assy, p. 51 n. 19. The reference to the White House is probably an allusion to the personal taste of President Truman. Jean Cassou, quoted in a previous chapter as the author of a recent book on Chagall, is chief curator of the Musée d'Art Moderne in Paris and professor at the École du Louvre. It was he who arranged the first large Picasso retrospective—seventy-four paintings and five sculptures—after the liberation of Paris in October, 1944.

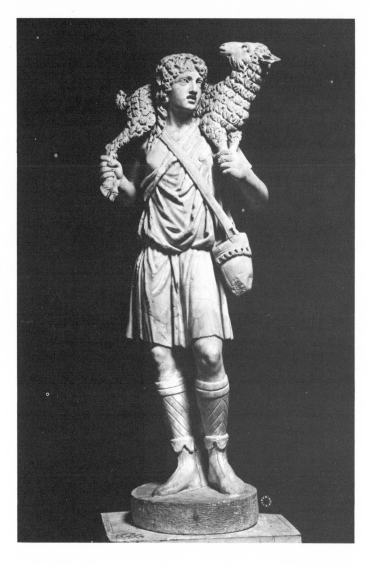

36. THE GOOD SHEPHERD, third or fourth century A.D.
Marble, about 48″ high.
Rome, Lateran Museum.
Courtesy of Anderson-Art Reference Bureau.

of this somber sculpture are rooted in the religious consciousness of Western man. The prototype in the early Christian era is the Good Shepherd image, seen in an extant free-standing figure, the famous third/fourth century statue in the Lateran Museum, Rome (Illustration 36) and in early sarcophagi. The early Christians were loath to represent Jesus Christ pictorially and depicted him allegorically on the basis of the parable of the lost sheep, wherein the Shepherd, on finding the lost sheep, "lays it on his shoulder, rejoicing" (Luke: 15:4-6). Thus the New Testament image adds another dimension of meaning to the significances which the Old Testament image had already received from its poets and prophets. The Twenty-third Psalm, with its familiar pastoral image, is well known to Christians. The archetypal image of the Lord as shepherd was projected, as Gilbert Cope notes, "upon the image of Israel's ideal king, David, who is called from his sheep to be the anointed shepherd-king; it is then further developed in connection with the figure of the Messiah." [6] In Ezekiel 34, we read,

For thus says the Lord God: Behold, I, I myself will search for my sheep, and will seek them out. As a shepherd seeks out his flock when some of his sheep have been scattered abroad, so will I seek out my sheep; and I will rescue them from all places where they have been scattered on a day of clouds and thick darkness.

The artists of the early Christian era had a model within the classical repertoire, the statue of Hermes Criophoros. The God Hermes was not only the giver of fertility to field, flock, and herd, but also conducted the souls of the

[6] *Symbolism in the Bible and the Church,* p. 205.

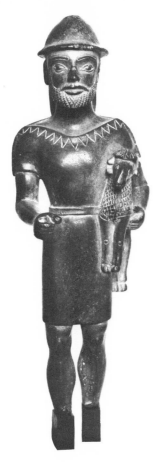

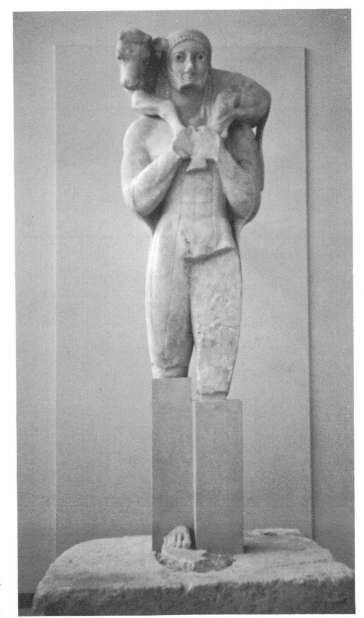

37. HERMES CARRYING A RAM, C. 530 B.C.
Bronze, about 6″ high.
Athens, National Museum.
Courtesy of T.A.P. Service.

38. THE CALF BEARER, Greek Archaic Period.
Marble about 5′ high.
Athens, Acropolis Museum.

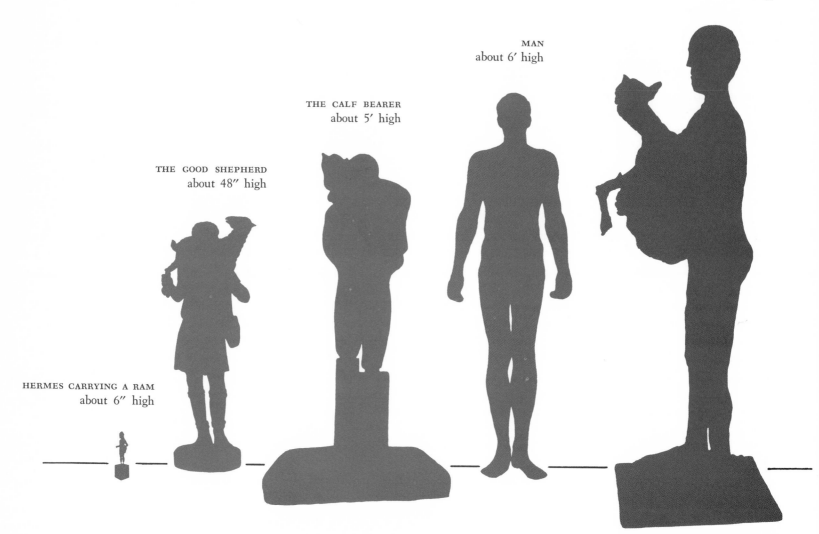

THE MAN WITH A LAMB
88″ high

MAN
about 6′ high

THE CALF BEARER
about 5′ high

THE GOOD SHEPHERD
about 48″ high

HERMES CARRYING A RAM
about 6″ high

39. Proportionate sizes of the sculptures.

dead to Hades. In these representations, the pagan messenger god is shown carrying a kid or goat. The most common form for the representations is an upright male figure with the animal held over the shoulders and the front legs grasped by one hand, the back legs by the other, like the famous archaic CALF BEARER in the Acropolis Museum (Illustration 38). But at least one early Greek sculpture shows the figure holding the animal in front of the chest as Picasso has done with his MAN WITH A LAMB.[7] And a small bronze sculpture from about 530 B.C. shows Hermes carrying a ram under one arm (Illustration 37). Egyptian and Mesopotamian art also had images of the shepherd carrying a lamb or calf. So this image, rich with many accretions of significance, lies deep within the multilayered strata of Mediterranean consciousness which Picasso is heir to as one born in Malaga, Spain, and resident for much of his mature life in southern France near the borders of the blue Mediterranean.

THE MAN WITH A LAMB was born out of the troubled war years. Picasso had made an etching of a freize depicting a family group with a man carrying a sheep in the center. Telling Françoise Gilot how the sculpture was created, he referred to this etching and a series of preliminary drawings. "When I begin a series of drawings like that," Pablo explained, "I don't know whether they're going to remain just drawings, or become an etching or a lithograph, or even a sculpture. But when I had finally isolated that figure of a man carrying the sheep at the center of the frieze, I saw it in relief and then in space, in the round. Then I knew it couldn't be a painting; it had to be sculpture. At that moment I had such a clear picture of it, it came forth just like Athena, fully armed from the brow of Zeus. The conception was a year or two in taking shape but when I went to work the sculpture was done almost immediately. I had a man come to make the iron armature. I showed him what proportions to give it, then I let it sit around for about two months without doing anything to it. I kept thinking about it, though . . . and when I finally started to work, I did it all in two afternoons. There was such a heavy mass of clay on the armature, I knew it wouldn't hold together long in that form, so I had it cast in plaster as soon as I could, even before it was completely dry."[8]

The plaster of the original MAN WITH A LAMB remained in that form for six years, for during the war it was impossible to have sculpture cast in bronze. The Germans used all available bronze, even some of the statues in Parisian public parks. Some time later, Picasso went to an Italian bronze caster by the name of Valsuani and persuaded the reluctant craftsman to try casting THE MAN WITH A LAMB. Three copies were made. One Picasso has in his own keeping, in his garden; one he gave to the town of Vallauris as a war memorial dedicated to those killed during the hostilities; and one was sold and now is in America, jointly owned by the Sturgis Ingersolls and by the Philadelphia Museum of Art.

THE MAN WITH A LAMB is larger than life size. The total height, including the small patch of terrain upon which he stands, is seven feet, four inches. When we view the group from the front, we see the man standing, his right foot advanced, the struggling animal held in front of him. With his right hand under the buttocks of the animal, he supports the lamb's full weight. With his left hand he clasps three of the animal's legs, while the fourth hangs loosely, protruding at a sharp angle. The square-set lines of the man's shoulder are surmounted by a massive head with heavy brows and deep eye sockets in which are set pro-

[7] For this information and further details see the very interesting article by Paul Laporte, "The Man with a Lamb," *Art Journal* (Spring, 1962).

[8] *Life with Picasso*, pp. 288-89.

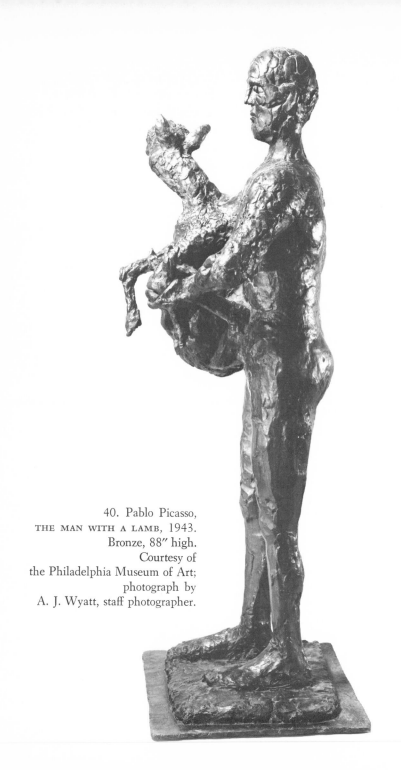
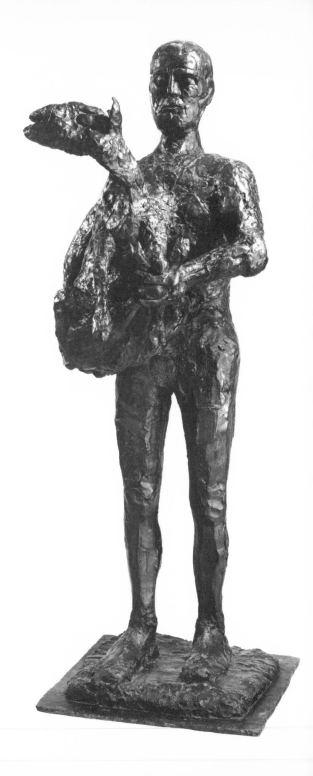

40. Pablo Picasso,
THE MAN WITH A LAMB, 1943.
Bronze, 88″ high.
Courtesy of
the Philadelphia Museum of Art;
photograph by
A. J. Wyatt, staff photographer.

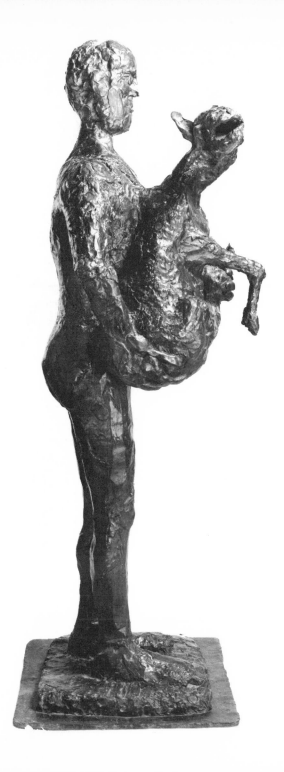

jecting eyeballs (Illustration 41). The pupil itself also projects sculpturally from the surface of the eyeball, giving the eyes both a farseeing and an inwardseeing look. What is *not* in focus for this man is the visible world. He clasps the large, struggling lamb against his body, in an endeavor to support the off-center weight of the lamb. Yet he retains his own somewhat precarious footing upon a minimal suggestion of earth.

From the side, this impression of an uneasy balance, precariously obtained and held, more through an effort of will than through purely physical means, is strengthened. The animal's neck seems unnaturally long as it cranes forward and away from the man's body, but this movement is sharply terminated by the head, which bends back toward the man's shoulder and head. The massive weight of the lamb's body, together with its angular, struggling extremities, is just barely held by the man. His legs press the minimal earth. His buttocks are tense, his shoulders rigid. The man, though virile and sturdy of build, has been modeled wholly nude, but without genitals. This is unusual in Picasso's art, which characteristically shows a natural acceptance of male and female sexuality, and candor in representing the sex organs.

The bronze retains all the record of the spontaneous, creative gestures of the artist as he worked the clay over his armature. The exact size and shape of some of the bits of clay are visible, particularly in the upper part of the sculpture. We are reminded that Picasso said, "The conception was a year or two in taking shape, but when I went to work, the sculpture was done almost immediately." [9]

[9] *Life with Picasso,* p. 289. In her account of the creation of this sculpture, Françoise Gilot says it was made of clay. Wilhelm Boeck in Sabartes' book on Picasso, and Alfred H. Barr, in his *Picasso: Fifty Years of His Art* (New York: Museum of Modern Art), describe THE MAN WITH A LAMB as being built up in wet plaster rather than in clay, like Picasso's other sculptures of that time.

THE MAN WITH A LAMB AND THE CORRIDA CRUCIFIXION 85

The legs show the broad strokes of the instrument which cut away the excess clay and shaped that which remained. The entire surface of the statue has the alive and vivid movement which bespeaks the spontaneous gesture of the artist's hands as he formed this man out of clay, out of "the dust from the ground."

But this MAN WITH A LAMB does not walk into our world born out of a paradisal or idyllic pastoral realm. He seems, instead, like a survivor of Hiroshima or Auschwitz, one who has seen and known only suffering, one who was "cut off out of the land of the living, his soul poured out to death. He returns as one from whom men hide their faces." (Isaiah 53:8.)

The image of the shepherd is woven throughout the Bible. His role is that of one who is self-sacrificing, and his care for his sheep is emphasized. But the shepherd who rescues the sheep and cares for them is also the one who, in a priestly role, sacrifices the animal in a ritual offering to the Lord. Picasso's somber figure holds the lamb in front of him, at once steadying and staying the struggling weight and seeming to offer it; but the offering—if, indeed, it can be so interpreted—is made with the grim finality of an Abraham who journeyed three days with Isaac, knowing that his beloved son was to be the sacrificial offering. THE MAN WITH A LAMB is at once the shepherd and the priest. In an ancient mass for the dead, the good shepherd is the one who carries the dead, "through the darkness, over the abyss, past the jaws of the Lion, to the fields of light." [10] The "fields of light" do not exist for Picasso's MAN WITH A LAMB either as a hope or as a recollection. He inhabits the darkness, the abyss, the jaws of the Lion.

He seems a figure involved in "the journey to Hades, the descent into the unconscious, and the leave-taking from the upper world," as Jung describes some of Picasso's art. This statement is in an interesting, sharply criticized essay on Picasso, written at the time of a large exhibit of Picasso's work held in Zurich in 1932.[11] The criticism was provoked primarily by a paragraph describing characteristics of images produced by neurotics as over against schizophrenics. Jung said that Picasso belonged to the latter group, intending that it be understood that the imagery in his art belonged to this latter group. He described schizophrenic art as being fragmented, and having " 'lines of fracture'—that is, a series of psychic 'faults' which run right through the picture. The picture leaves one cold, or disturbs one by its paradoxical, unfeeling, and grotesque unconcern for the beholder." [12] The journey to Hades, or "the Nekyia is no aimless and purely destructive fall into the abyss. . . . The journey through the psychic history of mankind has as its object the restoration of the whole man, by awakening the memories in the blood. . . . It is he who at all times of upheaval has caused the tremor of the upper world, and always will. This man stands opposed to the man of the present, because he is the one who ever is as he was, whereas the other is what he is only for the moment." [13] Picasso's MAN WITH A LAMB was created long after Jung wrote these words about Picasso's art. But when we look again at the intense, yet unfocused gaze of this man with his burden of struggling animal flesh and bone, "the tremor of the upper world" is experienced in the presence of one so naked in flesh and spirit. We recognize the presence of "one who ever is as he was."

[10] Eduard Syndicus, *Early Christian Art* (New York: Hawthorn Books, 1960), p. 22.

[11] C. G. Jung, *The Spirit in Man, Art, and Literature* (New York: Pantheon Books, 1966), p. 138.
[12] *Ibid.*, p. 137.
[13] *Ibid.*, pp. 139-40.

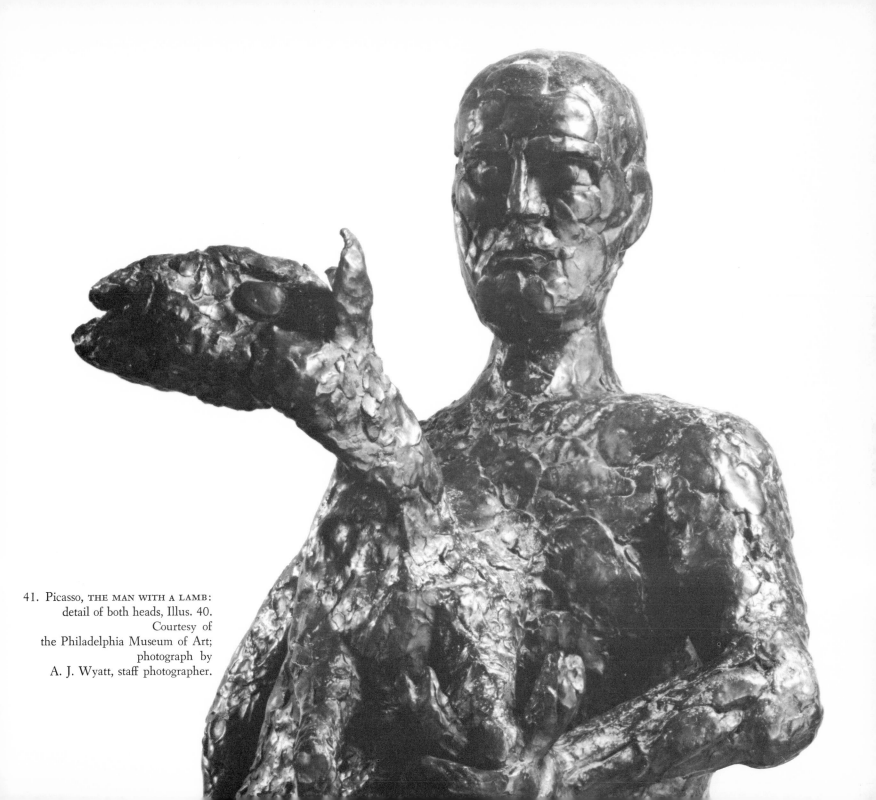

41. Picasso, THE MAN WITH A LAMB:
detail of both heads, Illus. 40.
Courtesy of
the Philadelphia Museum of Art;
photograph by
A. J. Wyatt, staff photographer.

It has been seen previously that Manzù gave immediacy and poignancy to his sculptured Crucifixion (Illustration 32) by his allusions to the Old Testament stories of Eve and Cain and Abel. Picasso, on the other hand, alludes, in a group of drawings which he did in 1959, to another ancient Mediterranean myth of a differing origin. He chose to set his Christ on the cross at the heart of the drama of the *corrida*, known in English as the bullfight. The two themes of the Crucifixion and the *corrida*, united uniquely by Picasso in this group of drawings, had both been treated previously but separately by the artist.

A succession of drawings made in 1927 and 1929 depicts the Crucifixion. These drawings have the undulant lines and bulbous forms characteristic of this period of the artist's work, and they culminate in the strange, small, vividly colored painting of the CRUCIFIXION dated February 7, 1930. Two years later Picasso made another group of drawings on this theme, this time using Grünewald's famous Isenheim CRUCIFIXION as the acknowledged basis for a freely linear composition and another group in which the figures are made up of bonelike segments. These sketches date from the time when the influence of Surrealism was at full tide among the artists and poets of the intellectual centers of Paris, Brussels, and New York.

As for the bullfight theme, it has been treated again and again by Picasso throughout his long and productive career. The principal antagonist of the fête, the bull, has been represented in ever changing artistic and symbolic form by Picasso; so much so, indeed, that in the vast literature on the artist we have many interpretive writings and one entire book on the subject.[14] The artist has lived in south-ern France for many years, refusing to return to his natal land, Spain, until its Fascist regime is defeated. But the festival of the *corrida* is still enacted at the ancient towns of Nîmes and Arles, and there Picasso and his family and friends go to participate in this ancient ritual.

The renowned bullfighter Luis Miguel Dominguin has long been a close friend of Picasso's, and when the group of drawings in which the Crucifixion series appears was published, it was accompanied by a thoroughly engaging little essay by Dominguin. The bullfighter's introductory essay does more to make vivid the significance of the *corrida* than do many learned studies on the subject. He remarks: "If we fail to invest the bullfight with transcendental and necessary meaning it ceases to seem at all serious." It is indeed a life-and-death struggle of a bull and a man:

> When the bull plays himself into our hands . . . when we ourselves appear to be most spontaneous, we are actually applying the results of many years of experience, of struggles, of acquired knowledge of the ways of bulls; and all of this is part and parcel of the history of humanity since its mythical origins—I mean those bulls that escaped from Crete and Rome, wandered over the most scattered regions of Europe and finally wound up by becoming acclimatized to the salt marshes of Andalusia.[15]

For Dominguin the historical and the mythical significance of the bull gives to the beast a certain grandeur and dignity which is woven into the fabric of the *corrida*. Spain, as well as Rome, has ancient statues of Mithra killing the mythic bull. Among the classical Greeks the bull was a cult beast of Poseidon, whose kingdom was the

[14] Vincente Marrero, *Picasso and the Bull* (Chicago: Henry Regnery, 1956).

[15] Luis Miguel Dominguin, *Pablo Picasso, Toros y Toreros* (New York: Harry N. Abrams, 1961), p. 11.

surface fabric of the earth, both the land and the sea. One of the labors of Heracles was the taming of the Cretan bull who was a dread killer. The bull was a sacrificial animal among the Indo-Aryans, as among the Jews. In more benign form the bull is the animal associated with St. Luke and is used symbolically to represent the Evangelist. Thus the bullfighter in vanquishing the bull reenacts the myth, "charged with the past and heavy with the future." [16]

What has Picasso made of this peculiarly Spanish compounding of ancient classic Mediterranean myth and Christian event? He began a succession of studies of the CORRIDA CRUCIFIXION theme on March 2, 1959, and on that day completed nineteen sketches, some in charcoal, some in ink, and some using both mediums. The following day an additional eight drawings were made in ink, also on this theme. The two series have been handsomely reproduced in the fine volume *Pablo Picasso, Toros y Toreros,* and it is from this group that the three drawings reproduced were chosen. Before discussing these in detail, some information on the preceding sketches in the series will be helpful in providing a context for the three drawings.

The first sketch of the series presents the conception which we see elaborated later, where a figure with arms outstretched, as if on a cross, clasps in his right hand a length of fabric which is at once a bullfighter's cape and a loincloth. With it he draws the charging bull away from a figure fallen beneath a horse. The original sketch shows this group as if in the distance, small in size at the upper left. The foreground at the right is occupied by two studies of the upper torso of the figure brandishing the cape-loincloth. The next sketch again deals with the torso and outstretched arms, and Picasso added a large stigmata at the

[16] *Picasso and the Bull,* p. 12.

center of the open palm of the left hand of the Christ. This stigmata is ovoid in form with a dark, pupil-like area which converts it into a wide-awake, staring eye within the wide, sturdy palm. The next studies are of the animals —the bull with arched neck, charging away from us, the horse crumpled upon the ground, its legs a tangle of abrupt and broken forms, its neck craning backward and upward in anguish.

The fourth drawing suddenly takes up another subject and we see a handsome, dark, fully realized drawing, the features of Picasso's beloved wife, Jacqueline, represented as the Mater Dolorosa. She is represented as the Mother of Christ, who weeps for him and all mankind; she wears a crown, an elaborately patterned mantilla or veil, and a bejeweled neckpiece, beneath which we see her heart pierced by seven swords. The meaning of the pierced heart originates in the scriptural passage in Luke's Gospel where it is told that the old Simeon, a man "righteous and devout," took the child Jesus in his arms when his parents brought him to the temple to present him to the Lord, and spoke the words which went into the liturgy as the *Nunc Dimittis,* lines which conclude with the prophecy:

Behold, this child is set for the fall and
 rising of many in Israel,
And for a sign that is spoken against
(and a sword will pierce through your own
 soul also)
That thoughts out of many hearts may be revealed.
 (Luke 2:34-35.)

Picasso was certainly familiar with the traditional form of the Mater Dolorosa, as these devotional images are to be seen in many Catholic churches and homes, as well as in art museums, and the painting collections in Spain. (Picas-

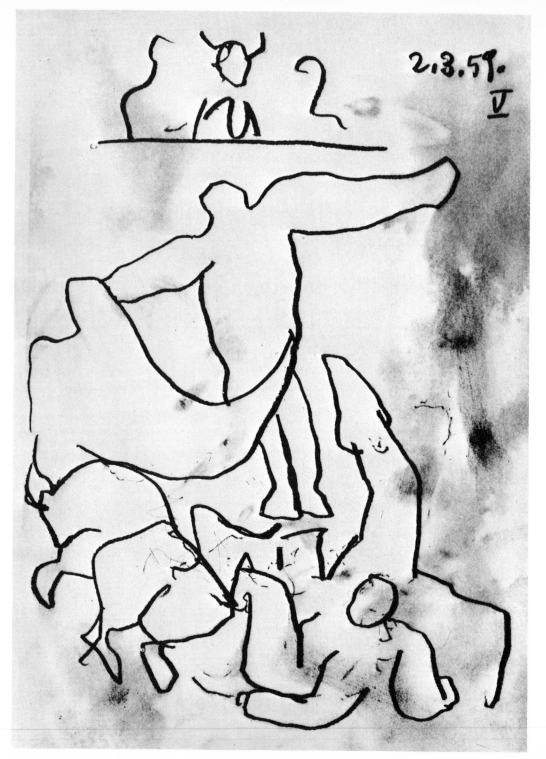

42. Pablo Picasso,
THE CORRIDA CRUCIFIXION,
No. V,
March 2, 1959.
Drawing from Pablo Picasso,
Toros y Toreros,
about 14″ x 12″.
Collection of the artist.
By arrangement
SPADEM 1966
by French Reproduction
Rights, Inc.

so, in absentia, had been appointed director of the Prado Gallery in Madrid by the republican government of Spain.) Some of these images show Mary the Mother of Jesus either with one sword piercing her heart in reference to Simeon's prophecy, or seven swords in reference to the Seven Sorrows of Mary (the Seven Sorrows are the alleged episodes of her life in which the passion of Christ is foretold). Picasso, numerically faithful to the traditional iconography, has represented the Mater Dolorosa with seven swords piercing her heart. But the presence of this powerful drawing in the CORRIDA CRUCIFIXION series suggests another interpretation for these piercing instruments. They might also be the *pic,* the lance used by the picadors who open the bullfight, irritating and enraging the bull but not disabling him. This double allusion to the bullfight and the Seven Sorrows is consistent with the entire series of drawings and is related to it in another way: the fifth drawing (Illustration 42) has several very cursory scrawls above the lines which we tend to interpret as the crossbeam of the cross. In traditional representations of the crucifixion we find in this area the titulus (as in the Eakins and Velásquez paintings) and mourning angels (Chagall's sorrowful peasants serve in this role in his WHITE CRUCIFIXION), or, in earlier art, the moon and sun, symbolic of the half-veiled light of the synagogue and the full light of the church. But from a study of the other drawings of the series, it is clear that Picasso has indicated here the *setting* for the event of the CORRIDA CRUCIFIXION: the line above the arm and head of Christ is the edge of the stadium and above are the spectators, the women with their high combs and mantillas, for whom the bullfighter chooses to fight, as Dominguin says, like the medieval knight, "not simply in carnal terms, rather as a symbolic image of the aspiration toward happiness that every man has within him." Thus,

the cursory lines may refer to the spectators and, in particular, to the woman for whom the bullfighter chooses to fight, the Mater Dolorosa, who as witness of the CORRIDA CRUCIFIXION weeps for the loss of her child and for the sins of the whole world. (Drawings 9, 12, and 17 of the March 2 series shows the spectators, as do drawings 5 and 6 of the March 3 series.)

Looking now at the illustrations which reproduce the drawings that have been selected for detailed study in this book, we note in the first (Illustration 42) the outline of the Christ figure is one continuous line which describes the arms, neck, and head, moving down along one side, abruptly delineating the legs and blocky feet. The line itself has a spontaneous, freely moving quality. We sense the varying pressure of the artist's hand which holds the charcoal; our eyes follow the naked immediacy of the act of creation as his hand hesitates, moves quickly on, leaps across the white nothingness of the paper, describing the forms, smudging the whiteness, converting it into a setting, a place.

It is difficult to describe the peculiar quality of the linear pattern and the line itself in this drawing, and in others of the series. What makes these sketchy studies—records of the metamorphosis of an idea—into works of art? The lines seem blunt and rough, sometimes attenuated, sometimes turgid and swollen. If we recall the undulating grace of Botticelli's line, or the incisive power of Michelangelo's lines, we notice Picasso's line seems more random, more varied, more spontaneous. And it is ugly also—"supremely and magnificently ugly," to use Roger Fry's words.

Roger Fry, English critic and one time curator at the Metropolitan Museum of Art in New York, aptly put the difference between our two uses of the word *beauty*: one to indicate sensual charm and the other to mean the appro-

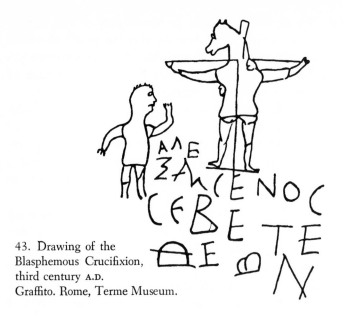

43. Drawing of the Blasphemous Crucifixion, third century A.D. Graffito. Rome, Terme Museum.

whitewashed or plaster-covered wall, cutting through the outer layer and exposing the darker material beneath. The technique was used decoratively on sixteenth-century Italian architecture, but it has been used by all manner of men throughout the ages on public walls, city edifices, and latrines for the random inscriptions and pungent caricatures created by the populace. This graffito was scratched upon the walls of the Domus Gelotiana on the Palatine Hill at Rome, presumably by a pagan deriding a Christian friend. It shows a figure with the head of an ass, with arms extended, attached to a tau-shaped cross. His feet are placed on the suppedaneum, and the ass's head is turned toward a figure standing at the left who has his hand raised in the antique gesture of adoration. Under the group is an inscription written in Greek: "Alexaminos Adores (his) God." [18]

This drawing communicates to us through its literary content. Its strongly derisive impact is felt only by those whose associations are already well established. For those who deem the ass to be the most stupid and lowly of beasts, and the crucified to be the divine Son of God, the amalgamation of the two is offensive and it is, indeed, a blasphemous drawing. For those who are not predisposed in regard to either of these images, the compounding of them is meaningless. Judged simply as a drawing, the formal characteristics of this third-century graffito are negligible; the line and space relationships have little communicative power. The lines are the mere tracing of contours which identify the subject matter. Picasso's lines, for all their freely composed character and simplified, distorted forms, still communicate a vitality and a pathos.

The cape-loincloth which Christ as matador flourishes before the charging bull is described by a line which is

priateness and the intenseness of the emotions aroused, though what is depicted may be extremely ugly.[17] The sharp junctures, sudden changes of direction, and the lumpishness of the shapes bounded by these rough lines give a raw crudity to the design, but in this crudity we still sense Picasso's purposeful hand. The random and spontaneous movements are the product of the artist's hand, exhibiting a lifetime of experience behind each movement. We have only to compare Picasso's sketch with an artistically illiterate work to be conscious of the difference. Perhaps the earliest extant representation of the Crucifixion is a kind of caricature executed in the early third century and known as the BLASPHEMOUS CRUCIFIXION (Illustration 43). It is a graffito. Graffito, or sgraffito, is the technique of scratching or incising a design or motif on a

[17] Roger Fry, "An Essay in Aesthetics," *Vision and Design* (Gloucester, Mass.: Peter Smith, 1947), p. 20.

[18] For additional information see Cabrol and Leclercq, *Dictionnaire d'archéologie chrétienne et de liturgie* (1941), III, 3051.

continuous with the torso of the Christ figure, almost as if it were a part of the body. One of his hands remains affixed to the cross, which is not indicated in this drawing but remains invisibly present in the posture of the figure as it stands upon the suppedaneum, just as did the Christ of Velásquez and of Chagall in the WHITE CRUCIFIXION. At the lower left we see the bull charging into the cape. His buttocks and waving tail are seen from behind, the arching line of his back, shoulders, and lower neck are one continuous line with a springlike tension in its curvature. The bull's plunging movement with lowered head exposes the animal's withers and the tiny vital spot, aimed at in the matador's final death-dealing blow, which is known as the "cross." [19] Two frame-shaped horns spring from this "white bullock of the crescent shaped brow." [20] His forelegs are drawn under him as he makes this last desperate charge.

The Christ-matador figure has drawn the bull away from the picador, who lies half beneath his fallen horse, supporting himself upon his elbows and looking up toward the Christ. The picador is the man who from horseback places the pic (a pole with a shaft and a triangular steel point) in the bull's upper back under the direction of the matador, the objective being to cause the bull to lose some of his force. Hemingway said of the picador, "Of all the ill-paid professions of civil life I believe it is the roughest and most constantly exposed to danger of death, which, fortunately, is nearly always removed by the matador's cape." [21] The horse cranes his neck upward in anguish and, with one leg at right angles to his body and the earth, he helplessly paws the ground. The recumbent figure of

[19] Jacques Boudet, *Man and Beast* (New York: Golden Press, 1964), p. 231.
[20] Unamuno, *The Christ of Velásquez*, p. 36. This line is from the poem entitled "Bullock."
[21] *Death in the Afternoon* (New York: Charles Scribner's Sons, 1932), p. 466.

the picador with his horse is reminiscent of the iconography for another New Testament event—the conversion of Saul. Though the account in Acts 9:3 makes no mention of a horse, it was assumed that Saul, the persecutor of Christians, would have journeyed to Damascus by horseback, and that he had fallen to the ground from the horse when a light flashed from heaven and a voice was heard saying, "Saul, Saul, why do you persecute me?" In paintings of the subject, the horse is sometimes seen standing near the fallen figure, and sometimes it too sprawls next to the recumbent Saul.

The fallen picador in Picasso's drawing looks upward toward the Christ figure. He, too, has outspread arms, but they have a supportive role. The lines of this figure are so entangled with the lines of the two animals' bodies that it is difficult to read the positions of the three. They form a mass of conflicting movements, a chaotic coalescence of living, struggling bodies. The arching line of the bull's purposeful plunge is balanced by the attenuated, broken curve of the horse's neck and jaw. Between these two beasts, one the aggressor and the other the victim, lies the crumpled form of the fallen man.

The next drawings reiterate the central theme as seen from near and far. Two pages are devoted to studies of the horse—one, his fallen position with upthrust head; another, studies of the head alone. One page brings us close in upon the fallen picador with his broken pic still in his hand. These pages show a more descriptive line and more anatomical detail than Picasso used in the previous sketch. Drawings IX through number XVI are in ink and show dramatic blacks contrasted with the gleaming white paper.

In the CORRIDA CRUCIFIXION series, No. XVI (Illustration 44), we are brought in close to the figure on the cross, with only the head of the bull and the head of the horse visible. The Christ figure and face are represented in greater de-

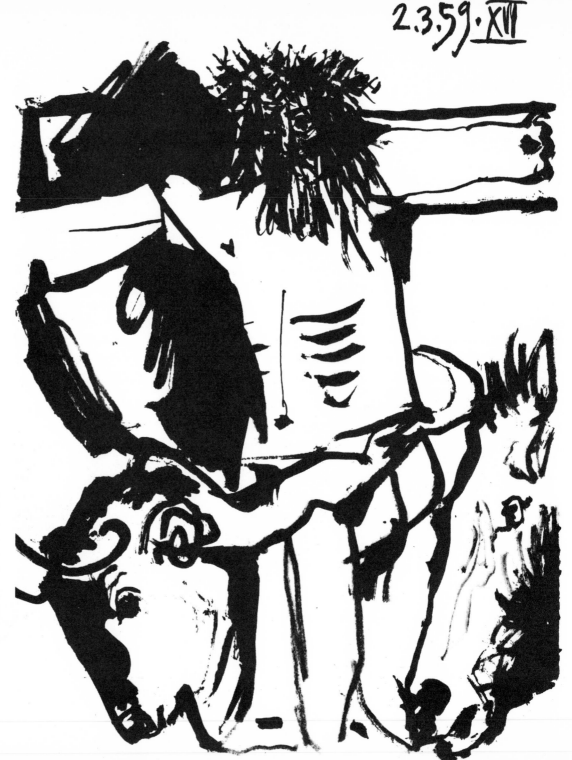

2.3.59 · XVI

44. Pablo Picasso,
THE CORRIDA CRUCIFIXION
No. XVI,
March 2, 1959.
Drawing from Pablo Picasso,
Toros y Toreros,
about 14″ x 12″.
Collection of the artist.
By arrangement
SPADEM 1966
by French Reproduction
Rights, Inc.

tail. A great, spiny crown of thorns encompasses Christ's head, becoming intermeshed with his dark hair and his thick black beard, and finally lost in the inky shadows along the right side of his head. His eyes are wide open and attentively fixed upon the lowered head of the bull. The cross, a thick tau-shaped structure, is clearly defined. Christ's left arm stretches forth, and the blunt, truncated end of the arm is held fast to the crossbar by a large, dark nailhead. The other hand is out of the picture area, but the gesture is clear, for again the right hand holds the cape-loincloth which is flourished before the charging bull. The head of the bull is delineated by bold lines, the powerful movement of the massive head being contrasted with the delicate curvature of the death-dealing horns. The lines which describe the horse are more broken and erratic, giving an ill-kempt look to the animal. He stares at his adversary, his nostrils wide and his mouth open. As Marrero remarks, "The horse is the most innocent, defenseless participant in the *corrida,* ancient and hopeless and impotent jades," the polar opposite of the bull with its brute force.[22]

This drawing has a sparkling richness in its dark and light pattern. The basic structure for the composition, the cross with its burden, forms a tilted, slightly off-center horizontal. The crossbar tilts slightly downward to the spectators' left, and against this the gesturing right arm of Christ makes another diagonal. The heads of the two animals create wedge-shaped diagonals in the lower corners, and these forms contain the movement and thus claim our attention. But one of the strongest movements of the drawing is the spiral which makes a strongly three-dimensional curve about the body of Christ. It is formed by the cape which comes from behind the torso of the Christ and moves across his loins; at one juncture it seems to merge with the head of the bull and yet to flow on behind it;

[22]*Picasso and the Bull,* p. 74.

then it continues, changing from a white form bounded by heavy black contours to a dark swirl, terminating within the palm of the Christ. A dark shadow above the right arm of the Christ continues the movement until it is halted at the edge of the crossbeam.

The composition of this drawing, its movement and disposition of form, is powerful. Two areas in particular have a breathtaking beauty of design. The torso of the Christ with its incisive yet delicate *lina alba,* which moves from breastbone to navel, has the rib cage indicated with a succession of dark strokes which must have been sketched in an instant but which have a relationship analogous to a line of musical notes which we hear as melody. The head of the bull, too, is drawn with great skill; the curves of the horns, coiling inward then upward, contrast with the powerful, sharp definition of the head along the left contour; the eye with its black ovoid form becomes part of the dark profile. Thus we get the kind of asymmetrical, yet perfectly balanced interlocking of lights and darks that is found in the Oriental oviform called the yin-yang symbol. (This figure [Illustration 45] is made by first drawing a circle, bisecting it with a diameter, then creating a semicircle on either side of the diameter. If the diameter is then erased, the figure remaining is divided into two interlocking halves which are complementary and congruent. This Oriental symbol shows one of these halves as dark, the other light, and they refer to polar opposites— light and dark, good and evil, male and female.)

45. The yin-yang symbol.

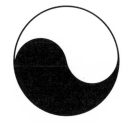

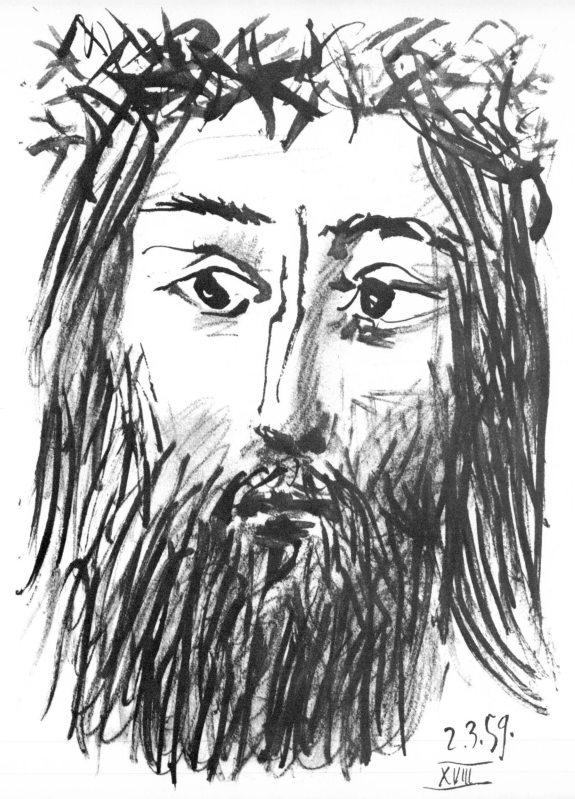

46. Pablo Picasso,
THE CORRIDA CRUCIFIXION
No. XVIII
March 2, 1959.
Drawing from Pablo Picasso,
Toros y Toreros,
about 14″ x 12″.
Collection of the artist.
By arrangement
SPADEM 1966
by French Reproduction
Rights, Inc.

Diego Velásquez, Christ:
detail from CHRIST ON THE CROSS,
1631-32, Illus. 2.
Courtesy of
Anderson-Art Reference Bureau.

2.3.59.
XVIII

The oviform, with its interlocking opposites of dark and light, is a symbol peculiarly appropriate for Picasso's bulls. As in this drawing, they are most often represented as aggressive and brutal, but also possessed of a kind of grandeur and dignity. Their power is the raw strength of brute nature. Picasso never sees these bulls as Ahab saw the white whale in Melville's *Moby Dick,* as a malevolent enemy in whom all the forces of evil and destruction were incarnate.

Drawing XVIII (Illustration 46) isolates the head and centers our attention on the facial features and expression of the Christ of the CORRIDA CRUCIFIXION series. It is a fascinating drawing, for though the type of Christ is remarkably similar to traditional Spanish representations, the iconography is new. If we study it vis-à-vis the Velàsquez Christ, we find the physiognomy to be remarkably akin to that of the seventeenth-century Spanish artist's representation. The brow, the slender nose, the deep-set eyes, the moustache and beard which cling about the lips but do not wholly conceal them are characteristic of both. But Velásquez' Christ has his head bowed and eyes closed. Despite the crown of thorns, the somber face communicates the sense of serene acceptance and quietude. Quite the opposite is true of Picasso's Christ, whose eyes are brilliant and alert with a terrible urgency, whose brow is furrowed and jaws tense. Part of the extreme animation of this face is achieved through the jagged, clashing, staccato lines of the crown of thorns, the reiterated, slashing lines of the beard and hair. But the real focus is in the eyes. They seem dilated to the point where we see only enormous pupils, coal black with glistening highlights.

These eyes also show another expressive artistic device, an exaggerated asymmetry of the placement of the two eyes. If the left half of the face is covered, the eye at the right appears to be glancing upward and has a somewhat

unfocused, inward-looking expression. If then the right half of the face is covered and the left side alone is studied, the left eye appears to be intensely focused, looking sharply downward to our left. This side of the face also appears flatter, wider, and more frontal. Now as we look at the entire drawing, it is apparent that these disjunctions communicate a sense of vivid immediacy; it is the moment written on this face—the moment of confrontation with the death-dealing adversary, the bull.

What is the meaning of the bull for Picasso? This is a question which has been the subject of much speculation.[23] Picasso's famous painting GUERNICA has the bull as its dominant and most imposing form. This bull stands impassively astride the wreckage and suffering about him— the shrieking mother with her dead child in her arms, the dead warrior with a wounded horse, an anguished, weeping woman, another who leaps from the window, her body aflame. In GUERNICA, the horse is also shown as pitiful, wounded, and suffering. In conversations with friends and critics, Picasso was asked about the meaning of the bull. But conflicting statements by the artist were reported. On one occasion he said, "The bull there [in GUERNICA] represents brutality, the horse, the people."[24] His interlocutor, Jerome Seckler, pursued the interpretation, referred to Fascism as causing darkness, brutality, death, and destruction, inferring then that the bull symbolized Fascism. Picasso shook his head as Mr. Seckler talked. "Yes," he said, "you are right. But I did not try consciously to show that in my painting. If you interpret it that way, then you are

correct, but still it wasn't my idea to present it that way. . . . I don't know why I used those particular objects. They don't represent anything in particular. The bull is a bull, . . . the lamp is a lamp, . . . that's all. But there is definitely no political connection there for me. Darkness and brutality, yes, but not Fascism."[25]

If Picasso were questioned about the series of drawings we have been discussing and were asked about the meaning of the Christ on the cross who draws the malevolent bull away from the helpless horse, he would no doubt give the same kind of answer. For Picasso, "a picture is not thought out and settled beforehand. While it is being done it changes as one's thoughts change and when it is finished, it still goes on changing, according to the state of mind of whoever is looking at it. A picture lives a life like a living creature, undergoing the changes imposed on us by our life from day to day. This is natural enough, as the picture lives only through the man who is looking at it."[26]

We are invited by the artist to see the work of art as a living, changing thing. Picasso rejects an interpretation of symbols which demands a verbal counterpart for each visual symbol. To interpret the bull as symbolizing evil and the horse as pitiful mankind, and the gesture of the Christ as an act of salvation which is to be equated with the sacrificial death upon the cross, is to verbalize and decode that which has its expressive power in the integrity of the visual image. There are analogies between the two, but the work of art, the visual image, stands by itself. Even the artist cannot limit its meanings or translate them into words, or into another universe of discourse.

[23] Vincente Marrero's book *Picasso and the Bull* gives the Spanish national setting and backgrounds in myth, literature, and poetry for the bullfight. Juan Larrea, in his book on Picasso's GUERNICA, provides an elaborate psychological and political interpretation for all the component parts.
[24] Typescript of "Symposium on Guernica," New York, Museum of Modern Art, November 25, 1947, p. 16.

[25] *Ibid.*, p. 18. The reference is to a painting made one year after GUERNICA and having some of the same symbols, the STILL LIFE WITH BULL'S HEAD, now owned by the Museum of Modern Art, New York.
[26] *The Spanish Masters of Twentieth-Century Painting,* Catalog of Exhibit, San Francisco Museum of Art and Portland Museum of Art, 1948, from "Conversation avec Picasso, 1935," p. 52.

the stations of the cross by Barnett Newman

Barnett Newman's subject matter for the fourteen paintings entitled STATIONS OF THE CROSS is death. But rather than depicting the event of death as it claims its own in the midst of life, as Manzù did, Newman's series depicts the experience of death as it occurs within the field of consciousness, as expressed in the agonized cry, "My God, My God, why hast thou forsaken me?"

Newman has stated that he regards the Stations as phases of a continuous agony, and not as a series of separate episodes. Thus, the title of the series of paintings creates a problem, for traditionally the Stations of the Cross consisted of fourteen works of art whose subject is the separate episodes which occurred from the time of Christ's condemnation until his entombment. This iconography of the *Via Crucis* is familiar to Roman Catholics, but less so to Protestants. The custom of placing sculptured or painted representations of various incidents related to the Passion of Christ within the church or adjacent to the church arose at a relatively late period—the seventeenth century. The worshiper who prays before the fourteen different Stations of the Cross is reliving the acts of devotion made by the pilgrim who visits the Holy Land and prays at each of the actual places where Jesus is believed to have suffered on the way to Calvary. Though the number of places and incidents varied in the early Stations of the Cross, fourteen stations became customary. The subjects are: (1) Jesus is condemned. (2) Jesus takes the cross. (3) Jesus falls for the first time. (4) Jesus meets Mary, his mother. (5) Simon the Cyrenian helps bear the cross. (6) Jesus meets Veronica. (7) Jesus falls for the second time. (8) Jesus meets the daughters of Jerusalem. (9) Jesus falls for the third time. (10) Jesus is stripped of his garments. (11) Jesus is nailed on the cross. (12) Jesus dies on the cross. (13) Jesus is taken from the cross. (14) The entombment.

The precise way in which Newman created the STATIONS OF THE CROSS denies any assignment of specific subject matter to the fourteen Stations. He started painting them in 1958, and for a time he contemplated calling the first two, which he felt to be a pair, Adam and Eve. "I knew I would do more," he said, and subsequently he painted

MAN
about 6′ high

Barnett Newman
Twelfth Station
from THE STATIONS
OF THE CROSS
78″ x 60″

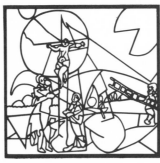

Marc Chagall
CALVARY
68″ x 75″

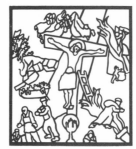

Marc Chagall
THE WHITE CRUCIFIXION
61″ x 55″

47. Proportionate sizes of paintings
by Newman, Chagall, and Derain.

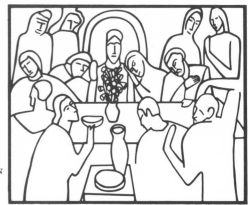

André Derain
THE LAST SUPPER
89″ x 113″

two more in the same size, and again used pure black vertical stripes on the raw canvas. It was at this stage, when four had been completed, that he experienced "a sense of the cry," and, as he said, the paintings began to speak to him. He knew he had embarked on a series of paintings which could, if the intention and invention were sustained, eventuate in the fourteen STATIONS OF THE CROSS.[1]

In 1961 he exhibited the first painting of the group, giving it the title STATION (Illustration 48). With the theme for the group established, he painted the FIFTH (Illustration 51) and SIXTH STATIONS in 1962, and in 1964 and 1965 he completed three paintings each. The two final paintings were begun in 1965 and finished in 1966. So, this cycle of paintings covers an eight-year period.

[1] Telephone conversation with the artist, December 25, 1967.

Once the title was known to him, the number of paintings in the series was dictated by the subject matter. But their order was determined by the order in which the artist painted them, rather than by the chronological movement of a set of historical events or incidents he was following. Once the scheme of the total cycle of painting had become part of his conscious intention, Newman associated a specific biblical passage with the entire cycle—the words of Jesus at the ninth hour when he cried "with a loud voice, 'Eloi, Eloi, lema sabachthani?' which means My God, my God, why hast thou forsaken me?"

For the catalog of the original exhibition of the STATIONS OF THE CROSS, held at the Solomon R. Guggenheim Museum in New York City in 1966, Newman wrote a statement of his own reflections on this cry of Jesus:

Lema Sabachthani—why? Why did you forsake me? Why forsake me? To what purpose? Why?

This is the passion. This outcry of Jesus. Not the terrible walk up the Via Dolorosa, but the question that has no answer.

This overwhelming question that does not complain, makes today's talk of alienation, as if alienation were a modern invention, an embarrassment. This question that has no answer has been with us so long—since Jesus—since Abraham—since Adam—the original question.

Lema? To what purpose—is the unanswerable question of human suffering.

Can the Passion be expressed by a series of anecdotes, by fourteen sentimental illustrations? Do not the Stations tell of one event?

The first pilgrims walked the Via Dolorosa to identify themselves with the original moment, not to reduce it to a pious legend; nor even to worship the story of one man and his agony, but to stand witness to the story of each man's agony; the agony that is single, constant, unrelenting, willed—world without end.

> *The ones who are born are to die*
> *Against thy will art thou formed*
> *Against thy will art thou born*
> *Against thy will dost thou live*
> *Against thy will die.*

Jesus surely heard these words from the "Pirke Abot," "The Wisdom of the Fathers."

No one gets anybody's permission to be born. No one asks to live. Who can say he has more *permission than anybody else?*[2]

[2] *Barnett Newman, The Stations of the Cross* (New York: The Solomon R. Guggenheim Museum, 1966), p. 9. The artist prefers the Moffat version *lema* to the more common *lama* used in the King James translation and the RSV.

As a group, the Stations create their own ambience. The illustrations of these paintings in this book are so small in contrast to the originals, and are so distorting of the dark and light pattern, that those who have not seen the actual paintings must exercise a kind of imaginative re-creation of the originals, using what clues the present text and the illustrations may provide.

The STATIONS OF THE CROSS are large in size, each being six feet and six inches high and five feet wide. Thus each panel is taller than most beholders and about the width of their extended reach. Their size is of central importance in their communicative power. While large, they represent a human scale, one which requires us neither to move in closely to study detail and "read" the painting as we would a book, nor to retreat to a distance to comprehend it. Rather, the paintings invite our attention, accepting and playing upon our psyches and our senses. Yet they keep their own integrity as independent creations. They do not woo our interest with blandishments, nor compel our emotions by visual tricks which shock or irritate or confuse. They are, and they invite us to be.

They should be hung in chronological order and placed about ten or twelve inches above the floor, as they were at the original exhibition at the Guggenheim Museum. Then we confront them as we would another person. But unlike the encounter with another individual, they reveal all of their power and the totality of their formal attributes in this first moment: we are able to *see* the entire field of each painting in one glimpse. This is not to say that we are not invited to linger and to look and that we do not find it hard to move on to the next of the series. The actual physical act of seeing these paintings must be distinguished from the kind of seeing we do in regard to a painting like Chagall's WHITE CRUCIFIXION, in which so many images claim our attention and in which the eyes tend to move hither and yon about the canvas, now concentrating on this detail, now on that.

It is important that the STATIONS OF THE CROSS be seen as a single group in the order of their creation. They form an organic whole, a symphonic mass to be seen as serial parts of a single unity. One can say of them, as Newman himself said in speaking of a series of lithographs which he had made, "since they grew one out of the other, they also form an organic whole so that as they separate and as they join in their interplay, their symphonic mass lends additional clarity to each, . . . and at the same time, each adds its song to the full chorus." [3]

The paintings are conceived to be complete without any kind of frame. Hence, the wooden stretcher, which is made the size the artist requires for the completed painting and has the canvas stretched across it, is used for the hanging of the canvas itself. Traditional easel paintings on canvas are similarly supported by a stretcher, but they are then set into a frame and the painting is hung from this frame. The frame serves the function of defining the limits of the painting, either setting it off from, or relating it to, its environment. In the case of traditional easel paintings, the frame surrounds the painting, isolating it and emphasizing it as a unit separate from its environment. Although the illustrations in this book reproduce the Eakins' CRUCIFIXION, Chagall's CALVARY and WHITE CRUCIFIXION, and Derain's LAST SUPPER without their frames, visitors to the museums see them hung within the usual decorative, heavily projecting frame. In the case of traditional mural paintings, the surrounding moldings both set off the work of art and relate it to its physical setting and to its total environment. The elaborate, beautifully proportioned moldings of the doorway into which Manzù's bronze doors are set also serve

[3] Newman, preface to *Eighteen Cantos,* a Volume of Lithographs (New York: Universals Limited Editions, 1964).

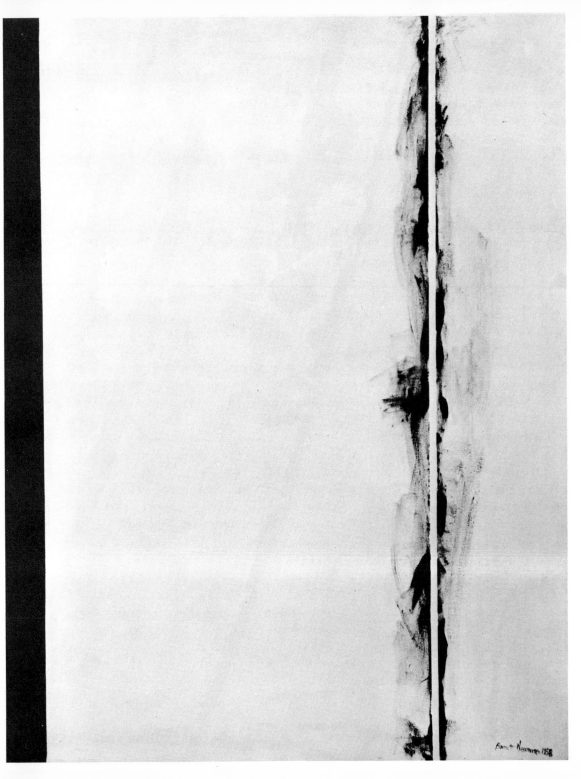

48. Barnett Newman, First Station
from THE STATIONS OF THE CROSS, 1958.
Magna on canvas, 78″ x 60″.
Collection of the artist.
Courtesy of
the Solomon R. Guggenheim Museum.

this kind of function. Further, the carefully wrought, engaged classical columns and the inscription above both set apart Manzù's composition and relate it to the larger composition of the architectural design for the entrance portals of the great basilica.

It is this *setting off* of the work of art that Newman wishes to avoid. Newman said that he did not use frames for the STATIONS OF THE CROSS, for the frame turned the painting into an object or a window. If the painting becomes an "object," a thing alongside other things, it is delimited not only in its physical properties, but also in its communicative properties. Newman rejected the frame, he said, because it "constricted content"[4] The thrust of this statement is felt if in imagination we visualize the fourteen paintings of the STATIONS OF THE CROSS hung side by side, each enframed with heavy moldings. This isolation of the single paintings from each other and from the walls, ceiling, and floor of their imagined environment would transmute and distort the meaning of the paintings. They would then be separate slices of a graph, isolated pulsebeats, segments of variations on a theme, suspended and projected over against their environment. Seen as the artist intended them to be seen, they form a visual group locked into a relationship—rhythmic pulsations across a continuous and open-ended field, creating their own interrelationships with each other, with the surrounding space, and with us.

Newman's frameless paintings simply define their own limits. And it is a magnificent and mysterious achievement that the paintings are indeed enclosed within their declared space and have no tendency to spill out or extend upward or downward beyond their assigned limits. We note this particularly in regard to the top and bottom of the paintings, for the vertical format might make them

[4] Conversation with Barnett Newman, March 27, 1967.

seem arbitrarily limited, a segment of a striped fabric or film sequence, which might be clipped off at almost any point, shorter or taller. Indeed, many of Newman's paintings are much taller. One of them, painted in 1961 while the STATIONS OF THE CROSS were in progress, is proportionately twice the width of the Stations. It, too, is composed of simple vertical stripes of black paint on the raw canvas. Painted as a memorial to the artist's brother, who died in February, 1961, it is called SHINING FORTH (TO GEORGE). Like the STATIONS OF THE CROSS, this painting breathes praise as well as lamentation. And like the STATIONS OF THE CROSS, it, too, mysteriously seems entirely and justly contained within its self-defined limits.

The artist has limited his palette to black and white as seen against the raw canvas. But even with this severe limitation, he achieves a variety of textures which gives a subtle richness to the surface of the paintings. The range of tones from the gleaming incandescent whites to the deepest, most velvety blacks is also varied almost beyond all comprehension. We experience the same kind of expansion of sensory capacity in the presence of the greatest pianists, who draw forth from their instruments an incredible range of volume, from the deep and somber low notes to the high soft notes, as if they were breathed upon the air, hardly audible, more an aura than a sound.

The variety, subtlety, and complexity of tonality in the STATIONS OF THE CROSS are in part the result of the kinds of paint used—acrylic, duco, and oil. The FIRST, SECOND, and TENTH STATIONS are magna paint; the THIRD through the EIGHTH STATIONS are oil paint; the NINTH, ELEVENTH, TWELFTH, THIRTEENTH STATIONS are acrylic polymer; the FOURTEENTH STATION is acrylic polymer and duco. These paints were applied directly to the raw canvas, and in the case of the oil paint, a softly yellowish zone sometimes runs along the paint stripe. This is caused by the vehicle,

the agent carrying the pigment, which "bleeds" into the adjacent canvas when the paint ·is thin. This is not a technical "goof" but a purposeful use of the natural properties of the paints and canvas. Newman's paintings, like Mark Rothko's glorious murals for Harvard, have been criticized by some intellectuals who certainly must be more sensitive and less judgmental in their perceptions in their own disciplines. Philistines assail abstract expressionist art as being sloppy or unfinished, because the completed painting has drips of paint, freely brushed areas, or reworkings of contours which record changes made during the evolving composition. These are left as they are because the artist has incorporated them into the total composition. Whether or not they "work" in the completed painting must be judged in regard to the totality of the composition, not by the older canons of tidiness.

Newman chose to limit his vocabulary to black, white, and the tones of the canvas itself. Given this self-imposed limitation, he has achieved a tremendous variety of textures and tones; the bleeding of the vehicle into the canvas expands his vocabulary, adding another intermediate shade between the extremes of the velvety black and the glowing white.

The first six STATIONS OF THE CROSS have a solid vertical black stripe at the edge of the canvas and a more varied slender stripe about three quarters of the way across the canvas, again running the full height of the painting. Like the FIRST STATION (Illustration 48), all the paintings mysteriously create space. Despite the large proportion of what we can technically describe as empty space, these areas do not seem amorphous or undefined. They are not voids; they are not nothingness. Rather, they are subtly alive and vibrant. The space between the dark stripes relates to the stripes and vibrates between them just as the silence be-

tween chords in music is pregnant with the relationship between the chords and is filled wtih recollections and expectations.

In an interview with Dorothy Seckler Newman remarked that he hoped he had contributed a new way of seeing. "Instead of using outlines, instead of making shapes or setting off spaces, my drawing *declares the space.*" He has also *declared* space and the size and shape of the paintings. Their dimensions and limits are autonomous space *created* by the artist. Newman referred to the mysterious physical and associative properties of space when he asked his interviewer, "Is space where the orifices are in the faces of people talking to each other, or is it not between the glance of their eyes as they respond to each other?" [5]

The NINTH, TENTH, (Illustration 53), and ELEVENTH STATIONS, as well as the concluding FOURTEENTH STATION, have no black stripes at all. Instead they have gleaming, glistening white stripes set against the raw canvas. In this juxtaposition they appear warmly golden in tone. After the somber paintings which precede them, these panels are a visual shock. We tend to return to the earlier panels to convince our doubting eyes that this canvas is indeed the same color and texture as the canvases with the stark and pulsating vertical chords of black. It is indeed the same canvas, but the opaque and shimmering white paint tends to take on a spatial character, and the wheatlike golden canvas tends to become the stripes. This is the kind of optical reversal which we sometimes experience in moments of excruciating physical pain or ecstasy when suddenly an all-enveloping, almost blinding clarity is given tones and colors. Whereas the black-striped paintings seem expres-

[5] Dorothy G. Seckler, "Frontiers of Space," in *Art in America,* 50 (1962), 86.

49. Barnett Newman, Third Station,
from THE STATIONS OF THE CROSS, 1960.
Oil on canvas, 78″ x 60″.
Collection of the artist.
Courtesy of
the Solomon R. Guggenheim Museum.

sions of particular moments of agony, chained in time, the white-striped canvases seem expressions of the piercing, light-filled experience of pain, when time and space cease to have any meaning to consciousness.

Both the FIRST STATION and the TWELFTH STATION (Illustration 54) have incisive black stripes along the left margin of the canvas. The FIRST STATION has then a broad area of raw canvas which is animated by the tension between the erect and precise dark stripe at the left and its opposite, the delicate vertical white stripe which is feathered about by brushy plumes of blackness. Though the gestures by which these black strokes were laid upon the canvas must have been quick, free, spontaneous movements, not "thought out" or planned, it is evident that they are not random patterns or bravura flourishes. They pulsate before our eyes, flowing and fluctuating vertically up and down before us, yet seeming, almost yearningly, to reach into the gleaming areas of golden canvas at either side.

Newman was once asked how long it took him to paint one of his large compositions. He replied, "It took a second, but the second took a lifetime." He went on to explain, "The concept and execution have to work together at the exact, same moment. Impulse and control have to join. This is obviously unscientific and illogical since theoretically one follows the other. But physically this is what *has* to happen. This is the paradox of the miraculous event. Somehow the two things get joined." [6]

The artist's reticent signature and the date the painting was completed appear along the lower left margin of the canvas of the FIRST STATION, sloping gently toward the corner. The size and angle of the characters are just as surely a part of the total composition as are, for instance, Dürer's more self-consciously integrated monograms in his

[6] *Ibid.*, p. 86.

50. Newman, Third Station: detail from Illus. 49.

graphic works. In Dürer's engraving KNIGHT, DEATH, AND THE DEVIL, for instance, the date and his monogram are carefully inscribed on a slate which is propped up against a stone in the foreground at the lower left, at an angle which invites our easy scrutiny.[7]

The TWELFTH STATION reverses the dark and light pattern. It is predominantly black. A slender straight stripe of canvas visible between the black margin and the major central black expanse of the painting seems an aperture, a door ajar allowing a crack of light into the blackness of the wavering, failing consciousness. A second, narrower such stripe stretches upward again, bisecting the encompassing blackness. And then the blackness softly feathers off into the remaining zone of the canvas. This zone, a little less than a third of the total canvas, has within it two small, splinter-like dashes of black paint and also the artist's signature and date, gray in tone and slightly aslant. Though the two black dashes certainly have a vivid function in regard to the white zone they inhabit, they are not purely formalistic or decorative. Although they do animate the zone in purely formal terms, more important is their function in transmuting what would have been a zone of quietude and terminus into a living ambience. For these tiny dark shapes, with their suggestion of movement, tend to be associated in the beholder's mind with primitive forms of life itself (sperm or marine life such as pollywogs, etc.). We may also see in them the emblem of consciousness now freed from pain and suffering and resident within a new medium.

Again it must be reiterated that in all probability the artist himself had no such associative meanings in mind while painting the TWELFTH STATION. He works, he has said, "only out of high passion" [8] and, like the playwright Harold Pinter, only knows what he has done when he has done it.[9] But his intention, we know, was to create a series of paintings on the theme of "the unanswerable question of human suffering." And this he has done.

But he has gone further too, for despite his despairing and reiterated questions about human suffering in his statement about the meaning of the STATIONS OF THE CROSS, when the paintings are studied as a group, increasingly we feel that they present a kind of answer to the artist's own questions. They affirm the wavering, fluctuating minimal experience of being—"I am," as set against nothingness. They tell us of human suffering and of time as an experienced perception:

> Then came, at a predetermined moment, a moment in
> time and of time,
> A moment not out of time, but in time, in what we call
> history: transecting, bisecting the world
> of time, a moment in time but not like a
> moment of time,
> A moment in time but time was made through that mo-
> ment: for without the meaning there is no time,
> and that moment of time gave the meaning.[10]

[7] For discussion of this etching and monogram, see *Style and Content in Christian Art*, plate 54, p. 153.

[8] Seckler, p. 82.

[9] In a recent interview the dramatist Harold Pinter spoke of his method of writing a play. "I don't know what kind of characters my plays will have until they . . . well, until they are. Until they indicate to me what they are. I don't conceptualize in any way. Once I've got the clues I follow them—that's my job, really to follow the clues. . . . I can't remember exactly how a given play developed in my mind. . . . I follow what I see on the paper in front of me—one sentence after another. That doesn't mean I don't have a dim, possible over-all idea." An interview with Harold Pinter by Lawrence M. Bensky, in the *New York Times*, January 1, 1967. Harold Pinter is the author of *The Caretaker, The Collection, The Homecoming*, and other plays.

[10] T. S. Eliot, *Choruses from "The Rock,"* VII.

Barnett Newman's fourteen STATIONS OF THE CROSS are abstract expressionist paintings.[11] What we now designate as abstract expressionism is an artistic style or visual language which a group of artists of the New York area developed during and immediately following World War II. These exceedingly gifted artists, most of whom had passed through their own individual phase of Surrealism, were mature of age and congenial of viewpoint. World War II came as a cataclysmic shock to them. Newman, reflecting on this period of his own life, says that he was wrenched out of all occupations and preoccupations and that for him, like the other artists of his generation, the question became not how to paint or what to paint, but why paint? The threatened dissolution of the objective, visible world—that which Cézanne had berated and adored as "Nature"—threw into radical and inescapable relief the ultimate questions of human existence. For the artist it was not so much a question of physical survival, but survival *as an artist*. The objective-subjective dilemma took on new and frightening dimensions.

Jackson Pollock, Newman's longtime friend and colleague, was creating large paintings having no reference to visible reality in 1945. Pollock's first painting in the drip technique was done in 1947. (When the paint is thinned until it has the consistency of cream, it can be applied to the canvas or panel by dipping a brush or stick into the paint and allowing it to drip, or splatter, from this instrument onto the surface of the canvas; the latter is usually placed on the floor or other horizontal surface when the artist is using the drip or splatter technique.) In 1948 Newman joined Robert Motherwell, Mark Rothko, and several other artists who together had started a cooperative art school called "Subjects of the Artist."

The title of their school seems paradoxical if we accept the term "abstract expressionist" as a description of their style. What is the *"subject* of the artist," if he uses forms which, instead of describing or transmuting the visible world, present a new thing? "Subject is crucial and only that subject matter is crucial which is tragic and timeless," Mark Rothko remarked. With variations of emphasis, the abstract expressionists affirmed the importance of subject matter. Newman, too, has said that the "central issue of painting is the subject-matter." But he went on to remark that "most people think of subject-matter as what Meyer Schapiro has called "object-matter."

Translated into terms which relate to the STATIONS OF THE CROSS, if the historic episodes commemorated by the usual fourteen Stations of the Cross were represented by fourteen separate pictorial representations of these episodes —Jesus condemned, Jesus takes the cross, and thus through the series—these episodes are, to use Schapiro's term, the object matter. The true and "crucial" subject matter of the STATIONS OF THE CROSS is the meaning of suffering—"My God, my God, why hast thou forsaken me?" And Newman, rather than mirroring the suffering of Jesus, moves from the description and interpretation of visible suffering into the psyche of the suffering individual. He projects pulsations within the field of consciousness, the minimal and final experience of being. Stark stripes are set against a resonant expanse suggesting the immense reaches of the cosmos, celebrating the preciousness of the minutely finite in the vast theater of the cosmos and the immeasurable, unending reaches of infinity.

[11] "Abstract expressionism" is a term which came into common acceptance after World War II. Alfred H. Barr of the Museum of Modern Art, New York, used it referring to the work of a group of artists who were painting in New York at this time. Though their styles varied, their work has certain characteristics in common: largeness of size, a kind of flatness, and a lack of illusionism with regard to space. The subject matter is never descriptively rendered. Recognizable forms are seldom used, and when they do emerge, they often are loaded with intense, if ambiguous, emotions.

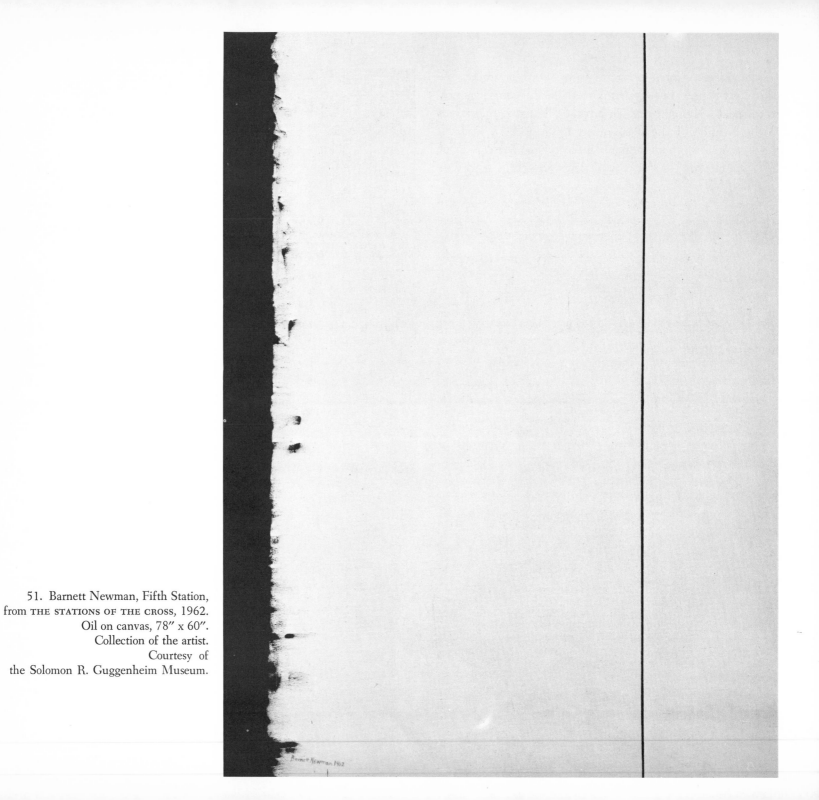

51. Barnett Newman, Fifth Station,
from THE STATIONS OF THE CROSS, 1962.
Oil on canvas, 78" x 60".
Collection of the artist.
Courtesy of
the Solomon R. Guggenheim Museum.

The abstract expressionist artists insist on the importance of subject matter, but for many of them the subject is not, so to speak, "thought out" in advance, but rather emerges in the creation of the work of art itself. Jackson Pollock, the first of the group to attain international fame, said of his own method, "I don't work from drawings or colour sketches. My painting is direct. I want to express my feelings rather than illustrate them." [12] "When I am *in* my painting, I'm not aware of what I'm doing. It is only after a sort of 'get acquainted' period that I see what I have been about. I have no fears about making changes, destroying the image, etc., because the painting has a life of its own. I try to let it come through." [13] Newman reports, as we noted before, that he painted four of the STATIONS OF THE CROSS before the theme which defined both the subject for the paintings and their number had emerged. He said, speaking more generally, that the artists "start from a subjective attitude, which, in the process of our endeavor, becomes related to the world." [14] The whole question of titles and subject matter was discussed by a group of abstract expressionists, Newman among them, April, 1950. Alfred Barr, a friend of the artists and then Director of Collections at the Museum of Modern Art, asked how many of the artists named their paintings *after* completion. Thirteen raised their hands; six said they named their works *before* starting the painting.

The name or title for a painting and its subject matter are not necessarily similar. Titles are often given simply

[12] Narration by the artist from the film *Jackson Pollock* by Hans Namuth and Paul Falkenberg in 1951; quoted in Bryan Robertson, *Jackson Pollock* (New York: Harry Abrams, 1960), p. 194.
[13] From a statement by the artist in *Possibilities,* I (Winter, 1947-48), 79.
[14] Robert Motherwell and Ad Reinhardt, *Modern Artists in America* (New York: Wittenborn Schultz, 1951), p. 16.

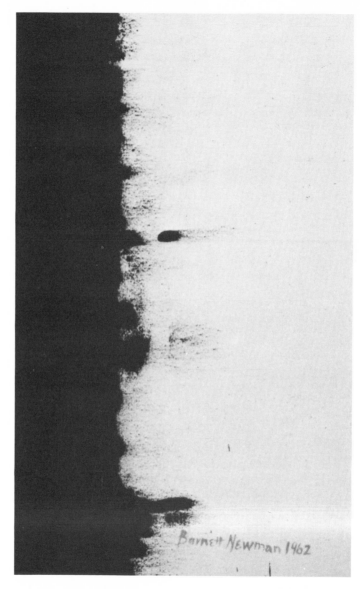

52. Newman, Fifth Station: detail from Illus. 51.

for identification. During the 1950's many abstract expressionist painters avoided titles which in any way referred to subject manner. Jackson Pollock simply numbered his canvases—Number 10, or Number 12. Mark Rothko distinguished his canvases by color, TAN AND BLACK AND RED, or LIGHT EARTH AND BLUE. The painter Pousette-Dart defended this kind of titling, saying it forced people to look at the work of art and to try to identify their own experience.

But Barnett Newman gave titles to his paintings even at the height of the abstract expressionist enthusiasm for nonverbal communication. Indeed, his titles have a peculiar relevance for this study, for his source is so often scriptural. His titles range across the grand subjects of the Hebrew Bible—Genesis, the Beginning, Covenant, Abraham, Adam, Day One—and they also include a group of subjects from classical mythology. In the meeting of the artists referred to above, he argued for titles which identify the subject matter, so that the audience could be helped.[15]

As for the form or composition of abstract expressionist art, the large size of the paintings and their nonobjective content are their most apparent and determinative characteristics. Large individual compositions have been created since the time of the Renaissance. Tintoretto's resplendent vision into Paradise painted for the Ducal Palace in Venice is enormous, as is such a secular document as Jacques Louis David's CORONATION OF NAPOLEON. But these paintings mirror the visible world or image a supernatural world. The abstract expressionist artist uses a similarly large area of canvas, but across its surface he creates patterns and forms which originate not in a vision of this world or a supernatural world, but in the individual artist's spontaneous gesture.

[15] *Ibid.*, p. 15.

The abstract expressionist artist works with broad brushes, paint rollers, sticks dipped in liquid paint. Ignoring the appearances of things, the artist is yet sensitive to the patterns and rhythms of the natural world. Through his first spontaneous lines and forms brushed upon the canvas, he initiates a constellation which suggests, even propels, the lines and forms which will follow. The composition of the whole is developed in this fashion—spontaneous and random patterns which call for additional elaborating or balancing patterns, a kind of open and free dialogue between the first lines and forms and those which issue from them. Meyer Schapiro refers to these compositions as having "a kind of order that in the end retains the aspect of the original disorder as a manifestation of freedom." He likens the artists' method to what we all use in the forming of human speech.

When we speak, we produce automatically a series of words which have an order and a meaning for us, and yet are not fully designed. The first word could not be uttered unless certain words were to follow, but we cannot discover, through introspection, that we had already thought of the words that were to follow.

This "improvised serial production of parts and relationship in an order, with a latent unity and purposefulness" is characteristic of poetry and music of our day, as well as of painting.[16]

The kind of fluid and spontaneous image-making which we all do, when doodling for instance, issues from a similar creative process. But unlike the untrained doodler, the mature artist has the immense experience, discipline, and knowledge of his craft at his command, making even his

[16] Meyer Shapiro, "The Liberating Quality of Avant-Garde Art," *Art News,* Summer, 1957, pp. 39-40.

53. Barnett Newman, Tenth Station,
from THE STATIONS OF THE CROSS, 1965.
Magna on canvas, 78″ x 60″.
Collection of the artist.
Courtesy of
the Solomon R. Guggenheim Museum.

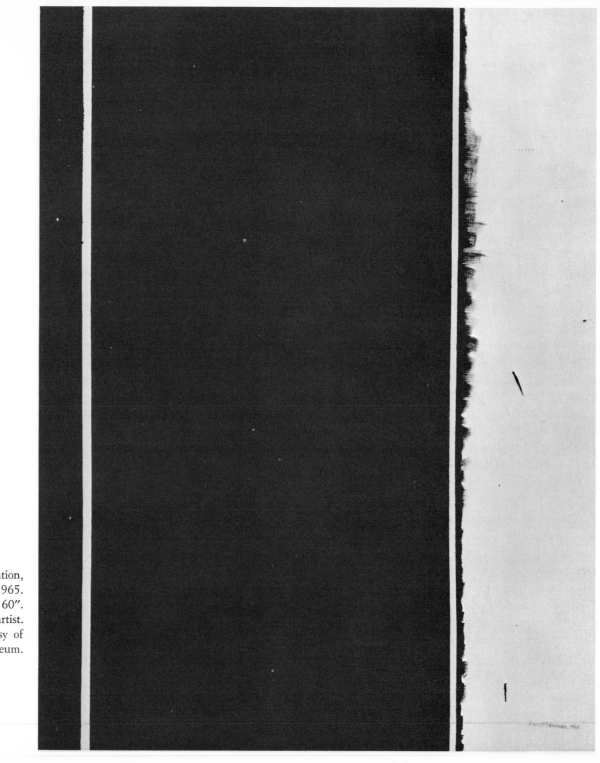

54. Barnett Newman, Twelfth Station,
from THE STATIONS OF THE CROSS, 1965.
Acrylic polymer on canvas, 78″ x 60″.
Collection of the artist.
Courtesy of
the Solomon R. Guggenheim Museum.

spontaneous sketch a serious expression of meaning, at one level or another.

When abstract art is completely nonrepresentational and has no connection with "object matter," the question of space becomes a central problem. In traditional painting since the time of the Renaissance, the artist has made his canvas into a transparent window through which the event or action is seen. Eakins' and Velásquez' CRUCIFIXIONS, Derain's LAST SUPPER, and Chagall's CALVARY are all pictured in this way. Chagall's WHITE CRUCIFIXION is also based on this kind of spatial conception, but in this composition Chagall shows the chaos of a world torn asunder, and he does this by fracturing the space and presenting it with nightmare-like discontinuities. But it is still a *distortion* of the naturalistic space of traditional painting, not a totally new conception of space.

Manzù's sculptured reliefs present a different representation of space than Ghiberti's, whose reliefs are a skillful and exquisite example of what has been referred to here as the traditional way of indicating depth in works of art. Manzù's figures are modeled in front of the picture plane rather than behind it (see Illustration 22). They project into *our* space, the viewer's space, rather than being seen through the window-like aperture which defines their space and sets it off from *our* space. Since Manzù makes no attempt to describe the space against which the figures move, it becomes a void, the kind of echoing, undefined space which is the setting for some works of contemporary dance and drama. Though undefined and unconfined, its psychic communication is powerful—suggesting no place or any place, no time or any time.

But the abstract expressionist space is of another kind. The size of these canvases in the two-dimensional plane alone means that we experience them as expansive paintings rather than as circumscribed easel pictures. Often the size of these paintings belittles us, and when the surface palpitates with glorious color, as in Mark Rothko's large canvases and the other large works of Newman, the paintings communicate a feeling of opulence and plentitude that makes our spirits soar. The first brushstroke across the canvas begins the transformation of the spatial character of the whole. Colors and lines and forms, as they are added to the composition, may be read as behind or in front of each other, moving forward or pushing back into depth. But these relationships are dictated by line, form, and color, not by any reference to the reading of depth which we do in traditional paintings, where mechanical or aerial perspective and the diminution of objects as they recede away in the distance are the basis for our interpretation.

The space "declared" by the artist in his work of art is often very complex, and capable of a variety of interpretations. Therein lies one of the fascinations of these paintings. Pollock's paintings with their intricate webbing of color can be seen as shallow spatially, with interlacing, swirling, indecipherable inscriptions across their surfaces. But no sooner do we so interpret them than we see lines and patterns projecting into a depth without end. And the whole of the cosmos seems figured within Pollock's larger paintings of the early 1950's.

We have seen that in Newman's STATIONS OF THE CROSS the painted zones and the background reverse each other when the series is seen in its correct order. In the first canvases, the black stripes are seen as the expressive zone, the canvas as background; but when we encounter the white-striped canvases, the NINTH, TENTH, ELEVENTH STATIONS it is the canvas which becomes the expressive zone and the white stripes the background. If several of the fourteen paintings were to be seen separately, our experience of space in each would be different from what it is when they are hung as a group, serially.

From the discusssion of abstract expresssionism as an artistic style, we can derive certain conclusions about the characteristic content of abstract expressionism. First it expresses and evokes an interior experience rather than an external event. The size of the canvases and their majestic simplicity provoke an immediate response rather than the gradually built-up response elicited by works of art which are read more slowly. Often the emotional response of those who confront these works of art is an immediate and powerful one, touched with awe. There are rich overtones to the response as the emotional content is discerned. The ancient categories of pathos and ecstasy, tragedy and exaltation, are expressed by these large and vibrant canvases.

In the case of Barnett Newman's STATIONS OF THE CROSS, the power of their communication lies not only in their expression of agony and in the terrible and searching question of the meaning of human suffering; but mysteriously, and perhaps not at all intended by the artist, the series of paintings also expresses an affirmation. The affirmation points beyond the affirmation of the artist as artist, and his profound gift of creating a work of art out of negativity, pain, suffering, and loss. This he has done. But more than this he has created a series of paintings which breathe praise as well as lamentation, which seem to cry, out of the depths: "Naked I came from my mother's womb, and naked shall I return; the Lord gave, and the Lord has taken away; blessed be the name of the Lord." (Job 1:21.)

secular art with Sacred Themes

"We pose the religious problems of a new content." Franz Marc, the German Expressionist painter, wrote these words at Verdun in 1915, a few years after Derain's LAST SUPPER and Chagall's CALVARY had been completed. Marc had been reflecting on the art of the past and that of his own day. The early heroic phase of Cubism had by then spent itself. He felt that a new art would be born.

[People] *will not seek the new form in the past, in the outward world, or in the stylized appearances of nature, but they will build up their form from within themselves, in the light of their new knowledge that turned the old world fable into a world form, and the old world view into a world insight. The art of the future will give form to our scientific convictions; this is our religion and our truth, and it is profound and weighty enough to produce the greatest style and the greatest revolution of form that the world has ever seen.*[1]

[1] *Artists on Art,* p. 446.

To varying degrees, the artists represented in this book have indeed built up their forms from within themselves. And these works of art do indeed pose the religious problems of a new content. Before drawing together the data about these paintings and sculptures at the level of content, it will be well to look at them again, reviewing and summarizing the iconographic data and the style of each.

ICONOGRAPHY

It is not by chance that such a large proportion of a very small selection have the Crucifixion as their theme. The painting by Thomas Eakins, the CRUCIFIXION, which dates from the late nineteenth century but exhibits some characteristics which anticipate twentieth-century attitudes, was the first example we discussed. The Chagall paintings, the CALVARY of 1912 and the WHITE CRUCIFIXION of 1938, follow, and it was noted that these are but two of many paintings by this artist showing variations on the Crucifixion theme.

Manzù's DOOR OF DEATH for St. Peter's, Rome, has a major large panel devoted to the Crucifixion. But the subject matter has been treated by this artist in other commissioned works as well. (Manzù designed several reliefs for a STATIONS OF THE CROSS for S. Eugenio, Rome, in 1951; the Crucifixion and Deposition were among the subjects for these Stations.) It occurs in a succession of bas-relief panels, many done in the period from 1939 to 1942, which he executed without a commission, and not for a particular place. After completing the doors for St. Peter's, Manzù returned to the Crucifixion theme again, working between 1955 and 1965 on a series of reliefs which he has called VARIATIONS ON A THEME. In these the familiar figures from the 1939-42 group are seen again—the mourning woman, the fettered prisoners, the figure with arms spread upon a cross, one hung by a rope encircling his waistline, indifferent cardinals with their tall conical hats, and the anonymous aggressive figures who lower the victim from a cross. The themes of human brutality and human suffering are created and re-created in varying form by Manzù, each with allusions to the Crucifixion and the Passion theme.

Picasso's CORRIDA CRUCIFIXION drawings date from March, 1959, but he too had treated the theme on other occasions, none of which was done for a commission.

Barnett Newman's STATIONS OF THE CROSS, painted between 1958 and 1966, also are concerned with the Crucifixion, but in these fourteen paintings it is depicted as an interior experience rather than an external event. This list could be greatly expanded—Georges Rouault, Max Beckmann, Graham Sutherland, Gerhard Marcks, Ernst Barlach, Germaine Richier, Henri Matisse, to name but those who come most immediately to mind.

The twentieth-century artist sees an analogy and paradigm in the death of Christ upon the cross to his own confrontation with suffering, anxiety, pain, and death. Earlier ages gave visual form to the question of death by depicting the Last Judgment. Van Eyck and Fra Angelico, Michelangelo and Hieronymus Bosch in their dramatic paintings of the Last Judgment pictured the end of all earthly events as a scene in which the last trump sounds and the elect are raised into eternal bliss and the damned cast into everlasting torment. The biblical passage upon which the pictured event is based is in Matthew's Gospel, and these scriptural passages paint a picture for all men everywhere—the tribes of the earth, the nations, the flocks. Jesus, talking with his disciples on the Mount of Olives, speaks of the end which will come, and

then all the tribes of the earth will mourn, and they will see the Son of man coming on the clouds of heaven with power and great glory; and he will send out his angels with a loud trumpet call, and they will gather his elect from the four winds, from one end of heaven to the other. . . . Before him will be gathered all the nations, and he will separate them one from another as a shepherd separates the sheep from the goats, and he will place the sheep at his right hand, but the goats at the left. . . . And they [at his left hand] will go away into eternal punishment, but the righteous into eternal life.

(Matthew 24:30-31; 25:32-33, 46.)

But this vision of the corporate end of all time is not what moves the twentieth-century artist. It is rather the terrible, desolating cry, "My God, my God, why hast thou forsaken me?" that grips him. Some of these artists have survived two World Wars, and the moral and theological dimensions of the Last Judgment are less a part of their consciousness than the existential moment of the threat of death. The suffering and death of the individual hu-

man being is experienced by analogy in the example of the death and passion of Jesus of Nazareth.

Each of the artists has interpreted the subject matter in a highly individual way. When traditional symbols do occur, they are transmuted and evoke differing and contrary associations. Chagall depicts his Christ on the cross with a halo about his head (Illustration 13), the traditional symbol for the effulgence of the divine. But Chagall also halos the menorah, which is linked with the biblical Temple and the ceremonial meals in the Jewish homes. The menorah burns with a steady radiance, its great orb of light providing the one stable element in a chaotic, torn world. Jesus Christ on the cross is indeed at the center of this vision, but his cross tilts and floats within the holocaust. It is the menorah which burns with serene radiance at the foot of the cross.

Examples of new symbols within the traditional iconography have also been noted. In his LAST SUPPER (Illustration 3) Derain introduced a vase of lilies where the chalice might have been placed by earlier artists. Since the vase of lilies has had specific references in the past to the purity of the Virgin Mary, its presence in this scene is perplexing. Is it a variation upon the ancient theme or a private symbolism with referents within the artist's own psyche? Or is it an object which functions primarily at the level of design, at which level it does, indeed, serve an important function as part of the major vertical axis of the composition? Such departures from the iconography of the past occur frequently in the work of twentieth-century artists as they depict the ancient themes.

It was noted in the case of Picasso's MAN WITH A LAMB (Illustration 40) and his CORRIDA CRUCIFIXION drawings (Illustrations 42, 44, 46) how ancient Mediterranean mythology was welded to Christian subject matter, yielding compelling and powerful images. This amalgamation of pagan and Christian imagery has occurred before, notably in the early Christian era when the classical vocabulary of ancient forms was taken over to represent Christian subject matter and to express the theological concepts of the church. But Picasso's use of the two iconographies is more akin to Michelangelo's appropriation of both, particularly at the deeper level of content. Michelangelo, in the sculptures for the Medici sepulchral chapel, represents time in the classical manner through allegorical figures representing day and night, dawn and dusk. But their classical allegorical significance is transmuted by their powerful, restive bodies with their elongated limbs and massive torsos, the fleshly burden of their fettered spirits. We shall return to a consideration of this issue when reviewing the content of the works of art in this study.

Even in the case of Manzù's commissioned DOOR OF DEATH for St. Peter's in Rome, the iconographic program has peculiarly twentieth-century characteristics. The original commission described the subject matter as the glorification of the past martyrs. But Manzù, with the consent and encouragement of Pope John, changed the theme to a memorial to the present-day unnamed martyrs—not the martyrs of the present-day church, but rather political martyrs and the anonymous human beings who die daily. Manzù's iconography here is not related as much to the episodes of a martyrology as to a twentieth-century Dance of Death. The Dance of Death is an iconographic cycle frequently depicted in the late Middle Ages in which the skeletal figure of Death grabs by the hand all manner of men and women—the king and the pauper, the cleric and the stonemason, the nun and the housewife, in the midst of their daily concerns with their worldly goods about them; it is a didactic *memento mori,* reminding all who see it that this is indeed a transitory life and that, in more current phraseology, "you can't take it with you."

Manzù's figure helplessly falling through the air amid a tangle of useless parachute cords, the mother fallen back in her chair as her terrified child cries at the window, are the Everyman of a twentieth-century Dance of Death, not the archetypal figures of a martyrology.

Manzù's CRUCIFIXION panel (Illustration 32) has a double reference to Old and New Testament iconography with its compounding of the Christ on the cross with Cain's murder of the righteous Abel, while Eve weeps at the foot of the cross. Christian iconography of the past, particularly in the early Christian and medieval periods, often juxtaposed the Old and New Testament themes. The Old Testament events were seen as prefigurations of events which are recorded in the New Testament. The righteous Abel, "the keeper of the sheep" and thus the first Good Shepherd, was a type of Christ. This juxtaposition of Old and New Testament figures proclaimed the unity of all events within the divine plan and yielded an antiphonal pairing of images and events of great poetic beauty and power. But in Manzù's CRUCIFIXION the reference to prefiguration does not function as an affirmation of a unity within the divine scheme or as a fulfillment. Instead the event seems set against a void. The implied historical and theological significances are reduced and minimized, and this Christ, though hallowed, seems to bear no more burden of meaning and significance than those in the panels below who die anonymously and alone. The theme for the DOOR OF DEATH is death as it occurs in the midst of life.

Death is also the subject matter of Barnett Newman's STATIONS OF THE CROSS (Illustrations 49-54), but rather than representing the event or moment of death, Newman depicts the psychic and physical experience as it fluctuates within the field of individual consciousness. It has already been noted that the title for these fourteen paintings is misleading, particularly to Roman Catholics who know the fourteen events and the liturgy associated with each event of the traditional Stations. Newman's intention accords more closely with the content of another liturgy, the Seven Last Words of Christ. This liturgical service, originating in the eighteenth century, was held on Good Friday, and recollected the three hours, from noon till three o'clock, when Christ hung upon the cross. The Seven Last Words are the last sentences recorded in the different Gospels spoken by Jesus from the cross. The commonly accepted "words" in order are: (1) "Father, forgive them; for they know not what they do" (Luke 23:34). (2) "To-day shalt thou be with me in Paradise" (Luke 23:43). (3) "Woman, behold thy son! . . . Behold thy mother" (John 19:26). (4) *Eloi, Eloi, lama sabachthani?* which is . . . My God, my God, why hast thou forsaken me?" (Mark 15:34). (5) "I thirst" (John 19:28). (6) "It is finished" (John 19:30). (7) "Father, into thy hands I commend my spirit!" (Luke 23:46.) It is interesting to note that though the seven "words" have had innumerable sermonic interpretations, they have not elicited a visual imagery or accepted iconography as have the Stations of the Cross. Instead, the art form associated with the *Tre Ora* liturgy is music.

The service and the setting for the music is described in an interesting document by the composer Josef Haydn, who was commissioned in 1785 by a "Clergyman of Cadiz," Spain, to write instrumental music for the Seven Last Words of Jesus on the Cross.

It was then customary every year during Lent, to perform an Oratorio in the Cathedral at Cadiz, the effect of which the following arrangements contributed to heighten. The wall, windows, and columns of the Church were hung with black cloth, and only one large lamp, hanging in the center, lighted the solemn and religious gloom. At noon the doors were closed,

and the music began. After a prelude, suited to the occasion, the Bishop ascended the Pulpit, and pronounced one of the Seven Words, which was succeeded by reflections upon it. As soon as these were ended, he descended from the Pulpit and knelt before the Altar. The pause was filled by music. The Bishop ascended and descended again a second, a third time, and so on; and each time the Orchestra filled up the intervals in the discourse.[2]

Haydn's music was written originally without a text, and it evokes the mood of the whole Passion. When we listen to this quartet, the paintings, of Barnett Newman's cycle come spontaneously to mind. Newman's paintings, too, are a series of adagios, with changing minor and major tonalities and lyric expansion and dramatic contraction of the melodic line.

One of the Seven Last Words, is, of course, the explicit theme of Newman's paintings, the cry of desolation, "Eloi, Eloi, lama sabachthani," and it is interesting to note that Haydn, like Newman, expresses the cry of despair, yet transmutes it finally into an expression of trust as well. Haydn, when he enlarged the original instrumental score into a choral oratorio in 1801, explicitly verbalizes this note of trust by the words of the cadenza, "Go not from me," then the solo, "My hope hath been in thee, O Lord," and finally, "Thou art my God"—all phrases drawn from his text for the adagio for "My God, my God why hast thou forsaken me?" As we have seen, Newman, too, in spite of and perhaps unknown to himself, implicitly makes an affirmation through the STATIONS OF THE CROSS. Like Job,

he seems to say, "The Lord gave, and the Lord has taken away; blessed be the name of the Lord."

STYLE

In style, the works of art range from the detailed realism of Eakins' CRUCIFIXION to the black and white abstract expressionist canvases of Newman's STATIONS OF THE CROSS. Eakins' CRUCIFIXION is bleakly descriptive, the body of his Christ figure being set against a rocky terrain in the brilliant light of midday. As Clement Greenberg has observed, Eakins had a natural, neutral, transparent style, used with an honesty and appropriateness, without flourishes, without either elegance or inelegance—a plain style but not a pedestrian one, a style with visionary overtones which move us all the more because they echo facts.[3]

Then in our own century, during the pre–World War I period, the style of Cubism was created by Picasso and Braque, and the data of the visible world were taken apart, then reassembled into new relationships in the work of art. The cubical, ovoid, and conical forms were disposed in shallow or ambiguous space relationships. Derain's LAST SUPPER and Chagall's CALVARY both show the influence of Cubism. Derain's style in the LAST SUPPER, with its clearly defined but insubstantial figures, communicates a sense of timelessness and transcendent meanings, peculiarly appropriate to the subject matter. The transparent adjacent planes give a kind of timeless aura to Derain's LAST SUPPER which Byzantine art achieves through its flattened forms and spaceless-timeless gold backgrounds. Similar cubist-influenced techniques when used by Chagall for the highly

[2] From Irving Kolodin's essay accompanying the Westminster album of Josef Haydn's *Seven Last Words of Christ,* opus 51, recorded by the Amadeus Quartet.

[3] Clement Greenberg, "Thomas Eakins," in *Art and Culture* (Boston: Beacon Press, 1967), p. 178.

individual imagery of his CALVARY (Illustration 11) draw us into the storybook world of the oft-repeated and embroidered-upon narrative or folk tale.

Though the symbols and persons of Chagall's later WHITE CRUCIFIXION are rendered in a more descriptive way than those of CALVARY, they are scattered about a nightmare world with disjunctions of time and space. Visible reality is replaced by dream and vision. Substantial objects functioning symbolically levitate and float in an eerie and nebulous space. This is the Surrealist world where verity to the psychic processes and to the subconscious and irrational sources of expression is more important than verity to the visible world.

Manzù's style is closer to the art of the past than that of any of the twentieth-century artists in this study. Manzù's eye responds to the beauty of the visible world, and he grasps and re-creates this beauty in the objects and persons represented on the DOOR OF DEATH—the lyrical, unfolding, ascending lines of the angels' robes and their outstretched hands which reach toward the dying Mary, the graceful arclike movement of the grieving Eve, the nobility of posture and sparse linear description for the kneeling Pope, the richly three-dimensional rendering of the eucharistic symbols, the grapevines and the wheat sheaves. These and many more forms delight the eye and reward the spirit. They capture a selected segment of the vast panorama of the visible world, and present it in its quintessence. But these breathtakingly compelling images, which represent the persons and objects of a worldly reality, are set against a spaceless nothingness. And this locus, together with the highly individual and highly secularized iconography, are twentieth-century characteristics.

The style of Picasso's MAN WITH A LAMB is expressionistic. Expressionist art, though representing the persons, places, and objects of the visible world, shows its subject matter as refracted through the emotions and reactions of the artist. Franz Marc[4] remarked that he does not want to paint the roe, but a picture of what "the roe feels." Thus Picasso's MAN WITH A LAMB is represented with purposive simplification and distortions of the anatomic form of man and animal. Unlike a Renaissance sculptor such as Ghiberti (Illustration 35), or the twentieth-century Italian Giacomo Manzù (Illustration 27), Picasso is not interested in describing the body as an organic unity with its structure of bone and muscle, sheathed with fine flesh. Instead, he built up his figure by pressing the plaster[5] to his armature with spontaneous gestures, creating massive areas, rough surfaces, craggy forms. "In sculpture, I cut through appearances to the marrow, and rebuild the essentials from there," Picasso said in a recent interview.[6] It is the "marrow" and the "essentials" which give the expressive power to this MAN WITH A LAMB.

Picasso's CORRIDA CRUCIFIXION drawings are also expressionist in style. Again, the simplifications of the forms reduce the Christ and the animals to irregular contours and scrawled areas of black set against the whiteness of the paper. The drawings are what Dominguin, Picasso's bullfighter friend, called "plastic writings," since paintings and drawings remain "the supreme calligraphy of the artist's emotions." [7] The dark and light areas interpenetrate in freely moving patterns, providing clues for our identification of figures, faces, actions. Figures, faces, and actions indeed are there to be read, but only through the intuitive

[4] Franz Marc (1880-1916) was a German expressionist artist killed during the First World War, who is known particularly for his paintings of animals.
[5] See Note 9, p. 85.
[6] Simonne Gauthier, "Picasso, the Ninth Decade," *Look,* November 28, 1967, p. 88.
[7] *Pablo Picasso, Toros y Toreros,* p. 16.

leap which the understanding of the artist's intention allows.

Readers of this book will be interested to know that the two sculptors whose work has been discussed in this book have met. In 1965, accompanied by a friend, Manzù went to see Picasso at Mougins, France. John Rewald tells of the visit in his monograph on Manzù:

This short visit, which gave Manzù the greatest pleasure, confirmed his opinion that Picasso is the only true master among living sculptors. Despite the unbridgeable differences in their nature, or perhaps because of them, this meeting was a profound experience for Manzù. It brought him into contact with a temperament that is like an erupting volcano, ceaselessly spouting smoke and lava. The vigour of the old man who tirelessly produced works from all corners of his large house to show to his guests, who stood around for hours in a huge vestibule while they walked from one haphazardly placed sculpture to another, whose magnetic personality seemed to give a special dimension to the paintings, drawings and collages lying everywhere in heaps, all this seemed strange and yet attractive to Manzù.[8]

In Newman's STATIONS OF THE CROSS we also find the color range reduced to black and white, but references to any of the data of the visible world are eschewed. Instead, the artist presents us with resonating dark and light vertical chords which speak of the interior world of the psyche. In the case of these paintings, as well as other twentieth-century abstract expressionist paintings, the form (or composition) is so inextricably a part of the content that the moment we move beyond the actual description of the physical attributes of the painting—its measurements, texture, values, distribution of light and dark pattern, etc.—we must inevitably speak of content.

CONTENT

Returning now to the succession of works of art discussed in the separate chapters, let us summarize briefly what has been noted in regard to meaning, or content. It has been noted that Thomas Eakins' CRUCIFIXION pictures the biblical event with directness and a skill in the delineation of detail. The artist's vision of the dying Christ is presented with a justness in the choice of light and dark values and with a fidelity to the physical facts of the scene which eliminates sentimentality, melodrama, and pathos. Rather than calling forth what Huizinga calls "the religious shudder" caused by such paintings as Grünewald's Isenheim CRUCIFIXION, Eakins' neutral descriptive style evokes a more contemplative response. But the response is one awakened within the mind and spirit of the individual spectator, and is not addressed to corporate worship. Eakins' CRUCIFIXION was not painted as an altarpiece, nor would it serve in a liturgical setting as Grünewald's or Velásquez' masterpieces did (to name two paintings which are entirely different in style, but each appropriate to corporate and liturgical worship).

Although Eakins retained the titulus "Jesus of Nazareth, King of the Jews" scrawled in Greek and Latin, none of the other iconography often seen in paintings of the Crucifixion is in evidence. No halo marks this as the Son of God. The painting thus becomes a demythologized representation of the death upon the cross. An enlargement of meaning is suggested, pointing to the many daily cruci-

[8] *Giacomo Manzù*, p. 104.

fixions in all places and at all times. In diminishing the historical and liturgical significance of the Crucifixion, Eakins has given it an immediacy in relation to individual lives. As was noted previously, this CRUCIFIXION is not sacred art in the ancient meaning of the term—art for the temple. Like the art of the great Protestant painter of the seventeenth century, Rembrandt, it communicates by involving the spectator in a thoughtful response, by evoking a sense of identification. Neither were Rembrandt's etchings and paintings of biblical events sacred art in the sense of being created for corporate worship. They too were addressed to the sensibility of the individual spectator.

Derain's LAST SUPPER, as we have seen, is influenced by Cubism, and his iconography is an amalgam of the traditional details and disposition of forms together with some new and individual details such as the vase of lilies. But the resulting composition has an interestingly liturgical flavor to it. The simplified forms, the transparent planes, the anonymous faces, and the trancelike figures communicate a sense that these apostles are indeed present at an event which is at once unique and significant for all time.

Chagall's WHITE CRUCIFIXION presents the image of Jesus of Nazareth at the center of a world in chaos and destruction, a world which is recurrently convulsed by hatred and violence, a world which again and again sends forth its Jewish peasants, priests, and prophets into exile. Jesus of Nazareth on his tilted cross has a great nimbus about his head, and a shaft of light breaks from the heavens above to bathe his body in its effulgence. Yet the more secure and stable element in the painting is the menorah. The stylistic characteristics of the painting and the iconography seem to suggest that the Christian and Jewish forms are conjoined, yielding meanings which lie deeper than the assigned meanings of the symbols and images of the two religions. Again, these meanings are accessible to the individual, thoughtful, probing viewer.

Manzù's DOOR OF DEATH for St. Peter's is the one commissioned work of art in this study. The size of the work and its medium and function were dictated by the place in which it was to be located. And the original subject matter was also predetermined by the terms of the competition. Therefore the conditions under which the artist began work on his commission were more akin to the traditional relationship of the artist vis-à-vis the church. And stylistically Manzù is the most traditional of the artists considered in this study. Yet of all the works here reproduced, in content his religious works seem to be the most humanistic and secular in spirit. Carlo Levi, a friend of Manzù, wrote of the portal, "Deprived of sin and therefore of redemption, Death appears in that unique moment, that fixed instant in which the violence of nature turns to harmony; a unity of expression which embraces the dead and the living, the victims, the witnesses, and the killers." [9] John Rewald also tells that Cesare Brandi, Manzù's friend of many years, said that during the eighteen months from the end of 1962 to the beginning of 1964 when Manzù was working on the portals, he achieved a distance from his work "which almost bordered on animosity. Being forced to tackle themes to which he was bound by general feeling but not by specific faith, a kind of cold rage was released in him which explains the violent directness of creation and the gripping freshness of execution." [10]

As for Picasso, we have seen that in THE MAN WITH A LAMB the ancient themes of Hermes Criophoros, who is both the giver of fertility to field and flock and also conductor of the souls of the dead to Hades, is re-created and becomes the one who has made the descent into Hell and returns as a disturbing presence in our midst.

[9] *Ibid.*, p. 96.
[10] *Ibid.*, p. 85.

In Jung's words, "this man stands opposed to the man of the present [the "now" man, in current jargon] because he is the one who ever is as he was, whereas the other is what he is only for the moment." He stands before us utterly naked in flesh and spirit—one who has endured all that spirit and flesh can bear and yet survive. The grim assertion of life itself, minimal but somberly strong, is all that remains to this man. It is the large-scale horrors of Auschwitz and Buchenwald rather than the drama of Job's suffering which are evoked by THE MAN WITH A LAMB.

In regard to "intrinsic meaning" or content for the CORRIDA CRUCIFIXION drawings, it is well to remember that Picasso is a Spaniard. Though he has made his permanent home in France since 1905 and is included among the artists of the School of Paris, he is nonetheless Spanish in temperament and cultural heritage. Not only have all the Spanish critics and commentators reminded us of this, but also his American friend, biographer, and patron, Gertrude Stein, insisted on the importance of Spain as his natal land in understanding his art. And in Spain the relationship between Christianity and the corrida has a long history. Marrero tells that in

antique Spain, there was not a canonization, transfer of the Blessed Sacrament, the first Mass of a new priest, or even a procession in a minor or major rite without the celebration of a corrida to accompany it. The canonization of St. Theresa cost the lives of more than two hundred bulls; every convent founded by her gave its own corrida. After the canonization of St. Ignatius, the Jesuits petitioned in the chapter at Seville cathedral that a bullfight be celebrated immediately following the ceremonies. . . . But it is the very quintessence of the corrida which Christianity has assimilated, transforming and accrediting it. . . .

The attitude of the Christian populace of Spain to the corrida is analogous to the attitude of the Middle Ages in reading the classics; rather than a historic truth, the readers sought a symbolic one. . . . They employed instead the medieval method of allegoric and spiritual interpretation.[11]

These comments may appear extravagant or fanciful to those who know the bullfight through the debased versions which now are presented as tourist attractions, or to those who are supporters of the S.P.C.A. But Spanish sensibilities have responses nourished by the ancient liturgies of the church and of the corrida. Thus, Unamuno, in his volume of verse entitled The Christ of Velásquez, has a poem entitled "Bullock," in which the poet addresses Christ on the cross with these words, "Thou, white bullock of the crescent-shaped brow," and continues:

Thou art
calf of the atonement, head of the herd, (Lev. XVI, 6)
Thou, who art both priest and victim, that dost
offer Thyself to Thyself; of Thee, who (Heb. VII, 27)
dost ruminate upon our sad afflictions
and with thy cloven feet dost plow the valleys . . . (Lev. XI, 3, 4)
of Thee we may eat, for thy flesh is pure.[12]

In the piling up of these images we hear the reiterated identification of Christ with the bull—the head of the herd, both priest and victim, and a later line, "Thou, the calf of flesh." Marrero speaks of the Spanish Christian view in which man has within him an angel and a beast, "a torero and a toro." He goes on, and these words might

[11] Picasso and the Bull, pp. 41-43.
[12] The Christ of Velásquez, p. 36. The biblical references are published, as noted here, adjacent to the lines in which the images appear.

have been written by Picasso's friend, the bullfighter Dominguin: "All men must give battle, and all must come to the final hour of truth, the hour to make the kill. The bull must be prepared so he does not reach the final stage in his full pride and prowess. The passions must be fought with the lance, made vertiginous with the cape, weakened with the banderillas and dispatched with brilliant incision. Our Bull, who art in our heart." [13]

And finally, returning to Barnett Newman's STATIONS OF THE CROSS, it should be noted that for many it is the simplification of artistic means which paradoxically becomes the barrier to comprehension. Many people are baffled by the large unarticulated areas of dark and light (and, in the case of Rothko's art, color areas). They are embarrassed by their own incomprehension, irritated to have no familiar forms for their recognition, and finally exasperated with the titles of paintings which seem to confound rather than to clarify. These responses are more likely to come from those whose sensitivities operate through the verbal level and through the visually descriptive modes that most Western educational patterns have utilized until quite recently. It should be noted again for those who have not actually *seen* Newman's paintings that photographs and reproductions of all the abstract expressionist works of art are more distorting of the original than perhaps any other style of the past or present. So much of their communicative power is in their size and texture that only those who have seen a great many paintings by these artists can imaginatively re-create, on the basis of the illustrations, a vision of what the original must be like.

It should be noted that the vertical bands and vibrating black and white zones in Newman's STATIONS OF THE CROSS *can* speak equally directly to atheist and to believer,

Christian and Jew. No special knowledge of iconography or biblical and historical background or even liturgical usage need be known for the paintings to communicate their content, their burthen of meaning.

To see in these abstract expressionist works of art a reduction of human values and an evidence of the dehumanization which has infected life and culture of the twentieth century is to be only very superficially engaged in their meaning. Newman has said that "the self, terrible and constant, is for me the subject matter of painting and sculpture" and that "the artist's intention is what gives the work of art a specific form." "My purpose is to create a place, not an environment, to deny the contemplation of the objects of ritual for the sake of that ultimate courtesy where each person, man or woman, can experience the vision and feel the exaltation of 'His trailing robes filling the Temple.' " [14]

THE RELIGIOUS PROBLEMS OF A
NEW CONTENT

Sacred art, or art for the temple, was by definition art for contemplation in the setting of corporate worship and its expression in liturgy and ritual. The twentieth-century artist, living in a pluralistic and secular world, attempts to create an art and a "place" which addresses "each person, man or woman," inviting their participation in the vision and exaltation of "His trailing robes filling the Temple." The work of art thus becomes evocative of the encounter which in the past occurred in the setting of worship and liturgy.

The more the work of art is separated from the religious drama, the more it must carry in itself evocative elements.

[13] *Picasso and the Bull*, p. 44.

[14] *Barnett Newman, The Stations of the Cross*, pp. 36, 37.

Thus in itself art becomes a religious totality, in a way that it never was in the past. When alienated from traditional forms, the work of art must express a new integrity and independence which demands of the beholder a new recognition in its own right. The more the work of art is separated from the religious drama of worship and liturgy, the more it has to carry a religious totality within itself. By entering into the dynamics of art of this kind, we find a new form of celebration takes place. And the beholder may experience "a sense of the cry," to use Newman's words.

Much of the great religious art of the past was created for a specific setting within the place of worship. When the religious tradition is strong and unembattled, religious art can be illustrative without losing its communicative power in didacticism or in story telling. But when the tradition becomes weakened and confused, as it now is, art with religious subject matter becomes banal or merely decorative.

This situation means that the old questions of definition are now rendered meaningless. The question, What is Christian art? has no more meaning than what is Christian music, what is Christian literature, what is Christian drama. The larger question, What is religious art? has more possibilities simply because it is less precise and more nebulous in meaning, and less likely to be understood in any limited sense. If a neat answer could be given to either of these questions, it might gratify some theologians and logicians, but it would be irrelevant to the artist *and* to the believer.

This, of course, means that there is a new content within this art. This new content is finding expression in the works of artists like Newman and Rothko. These artists *do* express a new spirituality, which is tenuously related to the Judeo-Christian heritage. They have trans-formed the problem of the Crucifixion into the problem of death. They have transformed the problem of style from the description of the external event to the evocation of an interior reality. For some viewers, this new content may not be sufficiently and explicitly Christian, and they will continue to be preoccupied with the question, Is it Christian art? There is an analogy to this problem in the theological realm. Reflecting on the changing contours of Christian thought, John Dillenberger has written:

Theological work and thought in the future may not look like anything we have recognized as theology before. Indeed, theology may have to become nontheology, just as much art has become nonart. This leaves open the question, as it does in art, whether it is theology at all—and how shall we know? We shall not. A world is being born and the risk is that we shall stand outside it, or that we shall be too much a part of it. But the courage and risk it demands of us cannot be avoided. . . . For some, what is here accepted will mean that the logos of theology has disappeared, that theology has come to an end. But not all form need have the form of the older logos. The new emerging forms are strange to the eye and to the ear, and for many they appear as if they had no form at all. Some of the new is formless, decadent, and chaotic. But much of it represents affirmations and styles as valid as anything that has yet appeared in creation.[15]

Hence, these artists have shown us that in a secular world the question can no longer be put in the older form. Christian art belongs to a Christian culture. Now, in a

[15] John Dillenberger, *Contours of Faith* (Nashville: Abingdon Press, 1969), pp. 151-52.

secular world, the question of style and content for Christian art is one which resides within the beholder, what the beholder brings to the encounter with the work of art. Even then, what is brought to this seeing of the sculpture or painting must accept the integrity of the work of art and not violate its canons as a work of art or burden it with unwarranted, explicit, or other meanings.

It is at this point that the methodology of the art historian comes to a halt, leaving further questions and answers to the historians of culture and further interpretations to the theologian, each according to his own lights. Of course I myself have speculated on present meanings and future possibilities and, for whatever interest they may have for the reader, offer them here. Two recent commissions to distinguished American artists by Roman Catholic Church bodies give hope of a more courageous relationship between the church and the artist in our day. Richard Lippold has been commissioned to create a sculpture to hang over the high altar in the cathedral in San Francisco. The preliminary drawings show a complex, light and airy cross-like form—an insubstantial nimbus of reflected and refracted light rays. It is in fact composed of a multitude of fine silver and gold wires, but it exultantly sings forth glory and praise like a shower of light suddenly shining in darkness.

Another history-making commission is the chapel soon to be built at the University of St. Thomas, Houston, Texas. As the result of the vision, persistence, and generosity of Mr. and Mrs. John de Menil, the abstract expressionist painter Mark Rothko was asked to do a series of wall paintings for a college chapel.[16] In this case the

[16] The donor of this chapel has informed the author that it will not, after all, be built under the auspices of the Roman Catholic Church. Instead, (and I am indebted to the artist Mark Rothko for the information) the chapel will be, in all probability, an interdenominational structure, adjacent to Rice University in Houston.

chapel is to be built to the scale of the paintings rather than the reverse. Philip Johnson was commissioned as architect. Rothko undertook the commission with some hesitancy but for two years devoted himself wholly to the task. The fourteen paintings which he created for the chapel have great dark expanses of richly textured canvas, and they convey a sense of majesty, quietude, and solemn joy.

Let us add to these two commissions Newman's STATIONS OF THE CROSS, which await an architectural setting. These paintings also cry out for their own space—with walls proportioned to the paintings and light controlled for their viewing. Such a space would be a space appropriate for worship and for meditation.

These three distinguished examples of religious art were created (in the case of Lippold's sculpture, the execution is not yet complete) during the past decade. Two are commissioned for a particular place, and the other cycle was created out of what Kandinsky called "inner necessity." Though they differ in their medium, they have certain characteristics in common. They are not figurative or representational, and they have no iconography in the traditional sense of the word. Their communication therefore does not depend in any way on allusion or identification. The historical events of Crucifixion or Resurrection, for instance, are not to be sought within descriptive forms, as in Grünewald's famed Isenheim Altarpiece, or deciphered in symbolic forms, as in Wallace Harrison's stained glass windows in the Presbyterian church at Stamford, Connecticut, known to many as the "fish-shaped" church.

The paintings of Rothko and Newman and the sculpture of Lippold speak directly to the visual and kinesthetic experience of the individual. Since no special knowledge or training is required of the spectator, atheist and believer, old and young, the intellectually sophisticated and the un-

trained, naïve spectator can experience the joy of beholding, each at his own level of sensibility and with his own rewards. These works of art go beneath the fabric of daily life and the accidents of the historical here and now to elementary perceptions. When we surrender ourselves without prejudice to the power of these visions created by the most sensitive spirits of our own day, we experience the wealth and depth of life available moment by moment to all men.

As a historian who lives in the present out of the past, I admit to experiencing the depth and power of Rothko's and Newman's paintings partially through knowing them within the fabric of history. Indeed, part of their resonance is felt in terms of the recognition of their place vis-à-vis the interior of Chartres Cathedral or the golden mosaics of San Vitale. This is not to diminish their power as they stand alone, but rather to affirm that even when style and content can be comprehended at purely visual and emotional levels, the fabric of history still provides illumination.

The theologian can similarly affirm that though biblical events and theological doctrines are not the subject matter of these paintings, they are profoundly "Christian" insofar as the Christian's heritage resonates in the depths discerned in the encounter with the paintings. They carry the beholder outside the finite circle of his own imprisonment in the present into the presence of a transcendence which does not violate the finite and concrete, but gives expression to actualities in nonrepresentational styles.

Because in Him all passions find a logical In-Order-That, by Him is the perpetual recurrence of Art assured.[17]

[17] Words spoken by Simeon in W. H. Auden's Christmas oratorio, "For the Time Being."

bibliography

The books and articles listed below are given not as a general bibliography on twentieth-century religious art, but as a carefully winnowed selection for those who want to pursue some of the problems this text uncovers. Not all the sources mentioned in the text are repeated here, and a few sources are noted which will not be found in the body of the book.

BOOKS, ARTICLES, AND MONOGRAPHS
ON THE ARTISTS

Chagall, Marc. *My life.* Translated by Elisabeth Abbot. New York: Orion Press, 1960.
The artist's autobiography of his early years, his family life in a Russian village, written in poetic and evocative language. His recollections provide sources for some of the imagery in his paintings.

Cassou, Jean. *Chagall.* Translated by Alisa Jaffa. New York: Frederick A. Praeger, 1965.
An inexpensive, profusely illustrated study (plates of uneven quality) by the chief curator of the Musée d'Art Moderne in Paris. It contains a chapter entitled "Chagall as a Religious Painter."

Lake, Carlton. "Artist at Work: Marc Chagall." *Atlantic Monthly,* July, 1963.
In 1962, Lake visited the stained glass studio at Reims, France, where Chagall was working on the windows for Sainte Étienne in Metz with Charles and Brigitte Marq, craftsmen in stained glass. The artist's way of working, his personality, his views on iconography are conveyed in this article.

Meyer, Franz. *Marc Chagall.* Translated by Robert Allen. New York: Harry N. Abrams, 1964.
A massive volume with many fine illustrations, plus a descriptive catalog. The organization of the volume is complicated, but the text is readable and informative. Chagall's youthful drawing for the CALVARY, the CALVARY itself, and the WHITE CRUCIFIXION are reproduced here.

"Eleven Europeans in America." *Museum of Modern Art Bulletin,* Vol. XIII, Nos. 4-5, 1946.
During World War II, America had the privilege of playing host to many leading artists of our time. The Museum of Modern Art in New York held an exhibit of eleven of these artists' works and

prepared a catalog with brief biographies and informal interviews with the artists. Chagall was one of the eleven, and it was in this interview that he said, "I am against the terms fantasy and symbolism Our whole inner world is reality perhaps even more real than the world of appearances."

Bell, Clive. "The Authority of M. Derain," in *Since Cézanne.* New York: Harcourt, Brace, 1923.

Written in the early part of the century by one of the first modernist critics, this essay on Derain appreciatively evaluates the genius of the artist, saying that above all his contemporaries he had "the art to mould, in the materials of his age, a vessel that might contain the grand classical tradition." Yet this English critic, like some of Derain's artist friends, suggests a certain puzzlement about Derain's art and his personality.

Diehl, Gaston. *Derain.* New York: Crown Publishers, n.d.

This is one of the few easily available studies of the artist in English. Many illustrations are given, including a color plate of Derain's LAST SUPPER. A full biographical chart and bibliography are included.

Goodrich, Lloyd. *Thomas Eakins, His Life and Work.* New York: Macmillan, 1933.

The first definitive study of Eakins' life and art, by the Whitney Museum of American Art director. It has a descriptive catalog of Eakins' paintings.

Greenberg, Clement. "Thomas Eakins," in *Art and Culture.* Boston: Beacon Press, 1967.

This well-known critic's appreciative statement about Thomas Eakins is included in this collection of essays. Readers of this book will be interested also in his essays on Chagall and Picasso. Though no entire essay is devoted wholly to Barnett Newman, there are frequent perceptive comments on his paintings in a number of the articles. See the index for references.

Hendricks, Gordon. Forthcoming book on Thomas Eakins, publisher and title not known.

Note: Mr. Hendricks states that he has a "dozen or so pages of largely new material" on Eakins' CRUCIFIXION. He declined my request to see the material or to answer any queries about it.

Pepper, Curtis Bill. *An Artist and the Pope.* New York: Grosset & Dunlap, 1968.

Written by an American news correspondent who lives in Rome, this book tells of Manzù's encounters with the Pope, during the years when he made a series of portraits of the pontiff and while

he was engaged in the commission for THE DOOR OF DEATH. The mutual friend and confidant of the two men, Don Guiseppi de Luca also appears. The author uses the novelist's technique of recording not only words and deeds, but thoughts and emotions, making the account more "readable," but less valuable as a document.

Rewald, John. *Giacomo Manzù.* Greenwich, Conn.: New York Graphic Society. 1967.

A beautifully designed volume, with plates which give the texture and form of the sculptor's major works. The text, by a friend and patron of the artist, who is also a well-known art historian, is pleasant reading. It is informative without being heavy.

The Bronze Reliefs for the Door of Saint Peter's by Giacomo Manzù. New York: Paul Rosenberg & Co., 1965.

Catalog of an exhibition with seventy-five plates showing both sides of the entire doors and many details and studies. It includes two essays on the doors and excerpts from Carlo Ragghianti's monograph on Manzù.

Alloway, Lawrence. *Barnett Newman, The Stations of the Cross.* New York: The Solomon R. Guggenheim Museum, 1966.

The Guggenheim Museum exhibited the fourteen STATIONS OF THE CROSS in April and May, 1966. Though the artist's work had been widely exhibited and discussed previously in the press, this was his first one-man exhibition in America. The catalog reproduces the fourteen paintings and an additional one, BE, II (exhibited earlier under the title RESURRECTION); it also contains an essay by Lawrence Alloway, a detailed bibliography, and a succession of quotations from the artist.

Calas, Nicolas. "Subject Matter in the Work of Barnett Newman." *Arts Magazine,* Vol. 42. November, 1967.

An interpretation of the STATIONS OF THE CROSS by a well-known art critic: "Newman's crosses are crossless since the cross, besides being the symbol of the crucified, is also the emblem of God. Barnett Newman identifies himself with the agony of a compassionate man who was crucified, not with the transfiguration of a mortal being."

Hess, Thomas B. *Barnett Newman.* New York: Walker and Co., 1969.

A book about Newman which came out at the time of his recent large New York exhibit, the first large showing of his paintings in ten years. The book tells affectionately of Newman's life and times, and the development of his style as one of the

New York abstract expressionist painters. His discerning discussions of the paintings are interlarded with the artist's own pithy statements and his own conversations with the author, who is a well-known critic and editor of *Art News* magazine. Many good color plates, a list of exhibitions held to date, and also a detailed bibliography.

Barr, Alfred H., Jr.. *Picasso, Fifty Years of His Art.* New York: Museum of Modern Art, 1946.

Though published over twenty years ago, this volume remains an invaluable source for the first fifty years of Picasso's works. The author, acknowledging the vast literature on Picasso, felt that a book which documented Picasso's work, neither arguing an interpretation nor drawing any general conclusions was needed. He gives us "a balanced, condensed survey of Picasso's art," by reproductions and by a running commentary closely integrated page by page with illustrations. Picasso's most extensive statements on art are also included, as well as interesting early photographs of the artist and his studio.

Dominguin, Luis Miguel. *Pablo Picasso, Toros y Toreros.* New York: Harry N. Abrams, 1961.

Several of Picasso's sketchbooks of bullfight scenes and motifs created in 1957 and 1959 are magnificently reproduced—many in brilliant primary colors, others in black and white. The publisher reproduced the drawings with a breathtaking veracity in tone and texture, showing "the quick release of the swarming images . . . whether pages were upside-down, smudged and splattered, thumbprinted or rubbed." The bullfighter Luis Miguel Dominguin wrote an essay on the *corrida* for this volume. In an essay on the drawings Georges Boudaille refers to the CORRIDA CRUCIFIXION as "a strange allegory indeed, and an unexpected expression of Spanish mysticism in a notorious atheist!" (p. 31.) The CORRIDA CRUCIFIXION drawings reproduced in this book were chosen from a group of nineteen drawings on this subject done on March 2, 1959; seven more drawings on the Crucifixion theme were done on the following day.

Gilot, Françoise, and Lake, Carlton. *Life with Picasso.* New York: McGraw-Hill, 1946.

Though Gilot's book has been criticized by Picasso and a number of the persons who appear in its pages, I agree with Robert Motherwell's assessment: "The world is more indebted that it seems to know to Françoise Gilot's *Life with Picasso*. It, perhaps more than any other book, should be required reading for every aspiring modern artist." Written by a woman artist who lived with Picasso for ten years and bore him two children, this engrossing account of their life together and their discussions about painting gives information and insights for which artists and art historians are grateful. Françoise Gilot, according to her collaborator, Carlton Lake, is gifted with "total recall," and thus "her direct quotations from Picasso are exactly that."

"Picasso," a special double issue of *Life* magazine, December 27, 1968.

Two years ago, the editors of *Life* planned this issue devoted wholly to the art and life of Picasso because they "reasoned that this giant is the Michelangelo or Da Vinci of our time, a massive cultural force." The issue has many color illustrations of uneven quality, articles on Picasso's art, and photographic records of his environment during the various phases of his creative activity. All of these are generously interlarded with commercial advertisements exhibiting more technical expertise in color reproduction than is the case in the reproductions of Picasso's art. The result is a puzzling pastiche of flamboyant "now" advertising, with content intended to be a generous tribute to the genius of Picasso.

The most lamentable error is the inclusion of part of the malicious "confession" attributed to Picasso, which was, in fact, confected by Giovanni Papini. In 1951, Papini published a book entitled *Il Nero Libro*, which contained imaginary interviews with persons as varied as Hitler, Huxley, and Picasso. Picasso's false "confession" originated there. Since that time it has been printed and reprinted as if the words were indeed Picasso's own. Picasso repudiated the statement and scholars and critics have repeatedly denied it, yet *Life* magazine's researchers accepted it as genuine. After William Rubin, Curator of the Museum of Modern Art, New York, informed the editors of the true source, *Life* published an apology in a subsequent issue. Inevitably far fewer readers saw the retraction, modestly placed in a later issue, than saw the conspicuously placed statement in the December 1968 issue. The part of the bogus statement which *Life* published reads, "When I am alone with myself, I have not the courage to think of myself as an artist in the great and ancient sense of the term. Giotto, Titian, Rembrandt and Goya were great painters; I am only a public entertainer who has understood his times and has exhausted as best he could the imbecility, the vanity, the cupidity of his contemporaries. Mine is a bitter confession, more painful than it may appear, but it has the merit of being sincere."

Apparently there are a large number of reactionaries like Papini, the concocter of the false "confession." The repeated reprinting of the bogus statement must result from the wish of such persons for an admission of exploitation and cupidity from an artist whose

success is known to all. But it is extraordinary that the editors of *Life* were hoodwinked by the false "confession" which degrades Picasso when the issue was intended as a tribute to a contemporary genius who, in their own words, is "the giant, the Michelangelo or Da Vinci of our times."

Jung, Carl G. "Picasso," in *The Spirit in Man, Art, and Literature.* Translated by R. F. C. Hull. New York: Pantheon Books, 1967.

A large exhibit of Picasso's paintings held in Zurich in 1932 provoked a vigorous public response. Jung saw the paintings and published this brief article, which elicited replies in the press. The psychiatrist states that he was not discussing Picasso's art but the psychology of the art and notes the growing tendency in Picasso's work to "withdraw from the empirical objects" to "an 'inside' situated behind consciousness." (p. 136.)

Marrero, Vincente. *Picasso and the Bull.* Translated by Anthony Kerrigan. Chicago: Henry Regnery, 1956.

Written by a Spaniard who has studied the mythology of the bull and the bullfight, this book gives interesting data on these, as well as an interpretation of Picasso's use of these themes in GUERNICA and other paintings. Readers of this book will be interested in the chapter entitled "Christianity and the Running of the Bulls."

Stein, Gertrude. *Picasso.* Boston: Beacon Press, 1959.

This little volume, first published in French in 1938, remains one of the most perceptive, affectionate, oblique, yet readable of all the writings on the artist. Picasso, Gertrude Stein concludes, "understands what is contemporary when the contemporaries do not yet know it, but he is contemporary and as the twentieth century is a century which sees the earth as no one has ever seen it, the earth has a splendor that it never has had, and as everything destroys itself in the twentieth century and nothing continues, so then the twentieth century has a splendor which is its own and Picasso is of this century, he has that strange quality of an earth that one has never seen and of things destroyed as they have never been destroyed. So then Picasso has his splendor." (p. 49.)

"Symposium on GUERNICA," November 25, 1947. Typescript of addresses and discussion; Museum of Modern Art, New York.

In 1947, ten years after Picasso painted GUERNICA, a distinguished panel of artists and critics met at the Museum of Modern Art to honor the painter and address themselves to two questions: first, the value of the painting in the light of Picasso's intention; and second, the symbolic meaning of the painting. Alfred Barr was chairman, Jerome Seckler, Juan Larrea, Jose Sert, Jacques Lipchitz, and Stuart Davis were the speakers. The typescript can be consulted at the Museum of Modern Art, New York.

BOOKS AND ARTICLES ON ART, CULTURE AND THEOLOGY

Apollinaire, Guillaume. *The Cubist Painters: Aesthetic Meditations, 1913.* New York: George Wittenborn. 1962.

Apollinaire (1880-1918) met Picasso and his friends in Paris in 1905 and was part of the group involved in the creation of Cubism. As a poet and writer he rationalized Cubism's direction and enthusiastically championed its development. He also coined the word "surrealism," literally "superrealism," as a subtitle for a play he had written.

Cope, Gilbert. *Symbolism in the Bible and the Church.* New York: Philosophical Library, 1959.

The thesis of this book is that "the imagery and symbolism of the Bible and the Church are valid and effective still—perhaps even more so now that the rational analysis of human consciousness and natural environment has disclosed such a vast realm of mystery and ineffability." This is an interesting source for iconography, and for readers of this book "Archtypes of Suffering: The Two Brothers" (Cain and Abel are discussed) and the passages on sacrifice and the shepherd in Old and New Testaments will be of special interest.

Dillenberger, Jane. *Style and Content in Christian Art.* Nashville: Abingdon Press, 1965.

Studies of masterpieces from early Christian times to the twentieth century. Each painting or sculpture is seen as reflecting the style and content of its own period. Readers of this book will be interested in the final chapter, which deals with religious art by Émile Nolde, Georges Rouault, and Henri Matisse.

Dillenberger, John, *Contours of Faith: Changing Forms of Christian Thought.* Nashville: Abingdon Press, 1969.

Viewing our age as one in which a new style is coming to birth, this theologian points to analogies in the arts as being instructive for present-day theologians. In the arts, "the traditional forms have disappeared. The boundaries do not exist. . . . The new gropings are not without their form, nor without their formative power. But the new form is not yet recognizable or, if so, is not yet one to which we are accustomed. Today there is a randomness which bespeaks life itself with its contours of meaning and of dynamics.

We live in a waiting, forming period. The expressions of faith and thought must utilize the vitality of new forms strange to our eyes and to our hearing, hardly familiar or lasting, but somehow speaking in and to our time." (p. 154.)

Fry, Roger. "An Essay in Aesthetics," in *Vision and Design.* Gloucester, Mass.: Peter Smith, 1947.

This essay has a lucidity and charm which makes it attractive reading. Roger Fry defines basic terms of aesthetics with deceptive ease and treats the relationship between paintings and our response to them with a combination of analysis and anecdote that is illuminating.

Goldwater, Robert and Treves, Marco, Eds. *Artists on Art from the XIV to the XX Century.* New York: Pantheon Books, 1958.

A compact anthology of statements by artists on how they see the role of the artist. It ranges from Leonardo and Ghiberti to Franz Marc, Paul Klee, Picasso, Chagall, Kandinsky, giving a brief biographical statement about each.

Hazelton, Roger. *A Theological Approach to Art.* Nashville: Abingdon Press, 1967.

Roger Hazelton, Abbot Professor of Christian Theology at Andover Newton Theological School, undertook in this little volume "a frankly theological interpretation of artistic endeavor," with the conviction that faith and art each need what the other has to give. He discusses art as disclosure, art as embodiment, art as vocation, and art as celebration. Always sensitive to art as a work of art, never burdening it with extraneous or other meanings, he yet affirms its gifts.

Hemingway, Ernest. *Death in the Afternoon.* New York: Charles Scribner's Sons, 1932.

Like Picasso and Gertrude Stein, whom he knew, Hemingway became an aficianado. In this book he recounts how he became interested in bullfighting and tells of its ritual, lore, and terminology. On the first page he confronts the usual objections to the ancient fiesta: "I suppose, from a modern moral point of view, that is, a Christian point of view, the whole bullfight is indefensible; there is certainly much cruelty, there is always danger, either sought or unlooked for, and there is always death, and I should not try to defend it now, only to tell honestly the things I have found true about it." He affirms the ritual and tragic aspects of the *corrida* and the "feeling of life and death and mortality and immortality" that the engrossed spectator experiences. The relationship of the bullfight to the Church is again affirmed: Many people were killed in the ring when bulls who were not killed in

their first fight were brought into the ring on successive occasions. Hemingway tells that Pope Pius V in 1567 issued a papal edict excommunicating all Christian princes who permitted bullfights in their countries and denying Christian burial to any person killed in the bullring. The Church agreed to tolerate bullfighting, which continued steadily in Spain in spite of the edict, when it was agreed that the bulls should only appear once in the ring. The book has interesting photographs of famous matadors in action and a helpful and readable glossary. In the latter we find the term "quite" defined as "the taking away of the bull from anyone who has been placed in immediate danger by him. It especially refers to the taking away of the bull from the horse and man after he has charged the picadors." It is a "quite" which Christ as matador has executed from the cross to divert the bull from the fallen picador in Picasso's drawing (Illustration 44).

Kahnweiler, Daniel-Henry. *Les Années héroïques du cubisme.* Paris: Braun & Cie, 1950.

Brief statement on Cubism by a famous art dealer and promoter of the Cubist painters of Paris. Derain and Picasso both exhibited in his gallery. His enthusiasm for Cubism speaks from the opening lines: "I was, myself, part of them. I lived these seven crucial years from 1907 to 1914, with my painter friends. They were years of youthful exaltation and of triumphant gaiety." We know Kahnweiler's features from a realistic drawing by Picasso and a distillation of the man in Picasso's famous Cubist portrait in the Chicago Art Institute.

Kandinsky, Wassily. *Concerning the Spiritual in Art.* New York: George Wittenborn. 1947.

Written in 1910 and first published in 1912, this little volume remains one of the important documents of modern art. Kandinsky (1866-1944) was the first artist to create nonobjective paintings. He articulates the abstract artist's position, sometimes discursively, other times epigrammatically; e.g., "Nature creates its form according to its ends; art creates its form according to its own."

Klee, Paul. *On Modern Art,* with an introduction by Herbert Read. London: Faber & Faber, 1948.

This short treatise was prepared as the basis of a lecture at the opening of an exhibit at the museum in Jena in 1924. Klee had taught for four years at the famous Bauhaus School of Design at Weimar. Herbert Read, in his introduction, evaluates the treatise as "the most profound and illuminating statement of the aesthetic basis of the modern movement in art ever made by a practising

artist." Much has been written and said by artists in the twenty years since, but Read's assessment remains true today.

May, Rollo. "The Nature of Creativity," in *ETC.: A Review of General Semantics,* Vol. XVI, Spring, 1959.

In this paper presented in 1958 at a symposium on creativity, this well-known psychiatrist says that "to understand the real psychological temper of any historical period, you can do no better than to try to understand its art, for in the art the underlying spiritual meaning of the period is expressed directly in symbols"; he considers Picasso the spokesman par excellence for our time.

Michalson, Carl, ed., *Christianity and the Existentialists.* New York: Charles Scribner's Sons, 1956.

In this volume is John Mackay's essay on Miguel de Unamuno and Paul Tillich's "Existentialist Aspects of Modern Art." In the latter, Tillich discussed religious art and Christian art; it is one of many places where he referred to Picasso's GUERNICA as "the best present-day Protestant religious picture."

Motherwell, Robert, and Reinhardt, Ad, *Modern Artists in America.* New York: Wittenborn Schultz, 1951.

Important documents by the New York artists who were known as abstract expressionists, Barnett Newman among them—typescripts of their discussions of the place of subject matter in their art, when a work of art is finished, the use of titles, etc.

Rubin, William S. *Modern Sacred Art and the Church of Assy.* New York: Columbia University Press, 1961.

The author quotes the *Partisan Review* symposium of 1950, "Religion and the Intellectuals": "There is no doubt that the number of intellectuals professing religious sympathies, beliefs, or doctrines is greater now than it was ten or twenty years ago, and that this number is continually increasing or becoming more articulate." He then proceeds to a study of the first significant commissioning of great artists of the twentieth century by a church body, the little church at Assy, France. He discusses the ecclesiastical setting and controversies, the iconographic program, the works of art by Matisse, Chagall, Rouault, etc. He concludes that it is not part of a renaissance of sacred art, but an anomaly which will probably never take place again.

Schapiro, Meyer. "The Liberating Quality of Avant-Garde Art," *Art News,* Summer, 1957.

By one of our foremost scholars and critics, this incisive essay is an excellent analysis and defense of abstract art: "This art is

deeply rooted, I believe, in the self and its relation to the surrounding world. . . . [These paintings and sculptures] induce an attitude of communion and contemplation. They offer to many an equivalent of what is regarded as part of religious life; a sincere and humble submission to a spiritual object, an experience which is not given automatically, but requires preparation and purity of spirit." (p. 40.)

Stein, Gertrude, *Autobiography of Alice B. Toklas.* Vintage Books; New York: Random House, 1960.

Written by Gertrude Stein, this witty and irreverent account of her life in Paris from 1905 to 1932 brings the artists and writers of that era vividly before the reader—Picasso, Derain, Matisse, Hemingway, even Alfred North Whitehead, and many others. The book is, in fact, an autobiography of Gertrude, rendered through the medium of Alice B.'s conversational style. The affection of Gertrude Stein and Picasso for each other comes through the anecdotes and descriptions. "As I say Gertrude Stein and Pablo Picasso immediately understood each other. . . . Picasso in those days was what a dear friend and schoolmate of mine called a good-looking bootblack. He was thin, dark, alive with big pools of eyes and a violent but not rough way. He was sitting next to Gertrude Stein at dinner and she took up a piece of bread. This, said Picasso, snatching it back with violence, this piece of bread is mine. She laughed and he looked sheepish. That was the beginning of their intimacy." (p. 46.) Soon after this first dinner together, Gertrude began to pose for the portrait by Picasso which now hangs in the Metropolitan Museum in New York. "How it came about they do not know. Picasso had never had anybody pose for him since he was sixteen years old, he was then twenty-four and Gertrude Stein had never thought of having her portrait painted, and they do not either of them know how it came about. Anyway it did and she posed to him for this portrait ninety times and a great deal happened during that time." (p. 45.)

Unamuno, Miguel de. *The Christ of Velásquez.* Translated by Eleanor L. Turnbull. Baltimore: The Johns Hopkins Press, 1951.

A long verse poem by the Spanish writer and philosopher Unamuno (1864-1936) inspired by Velásquez' painting of CHRIST ON THE CROSS (see illustrations in this book). The writer addresses the Crucified created "by the brush of Don Diego, the great master Velásquez," and in several passages he uses imagery of the bull and the *corrida* when referring to the Crucified.

van der Leeuw, Gerardus. *Sacred and Profane Beauty: The Holy in Art.* Nashville: Abingdon Press, 1963.

A classic study of the relationship between the holy and the

beautiful, expressed in a flowing and readable style. Dance, drama, music, architecture, sculpture, and painting are discussed, their sacred origins examined, and their history traced down to their break with religion. The author develops the thesis that there was no real schism between the arts and religion, for most secular art retains deep theological significance.

FOR RESEARCH

Finally, briefly noted below is information on two research tools of importance that are not as widely known as they should be:

The Index of Christian Art, Princeton University (photographic copies of the Index are located in this country at Dumbarton Oaks Research Library in Washington, D.C., and at the University of California, Los Angeles). An invaluable tool for tracing the transmutation of imagery in religious art. Its files cover all known examples of early Christian and medieval representations related to Christianity; they are arranged according to biblical subject matter, by chapter and verse, and each entry (over 500,000 cards) refers to photographs (over 100,000 of them) of the particular work of art described. I myself used the files to find during what periods the Good Sheperd was represented in art, and what forms the image had taken; similarly for the history of the Cain and Abel imagery.

The Archives of American Art, Detroit, Michigan, and New York City. The central archive at Detroit has many original documents and additional information on American art and artists—exhibition catalogs, letters, journals, clippings, arranged according to artist. A microfilm center in New York City has copies on film of all these materials. I located Thomas Eakins' letters and those of his wife through the Archives. Though at present their files on Barnett Newman are inadequate, in the future his work will be fully documented there.

sources of photographs

index